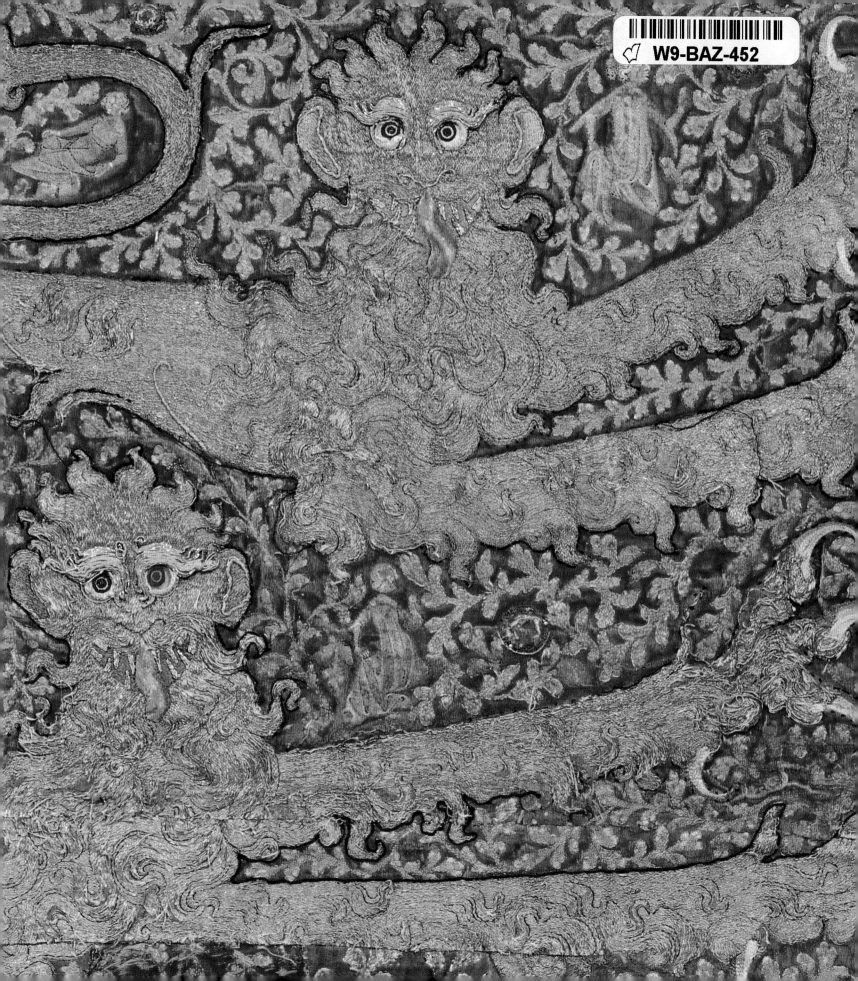

Flowers, Birds, and Unicorns
MEDIEVAL NEEDLEPOINT

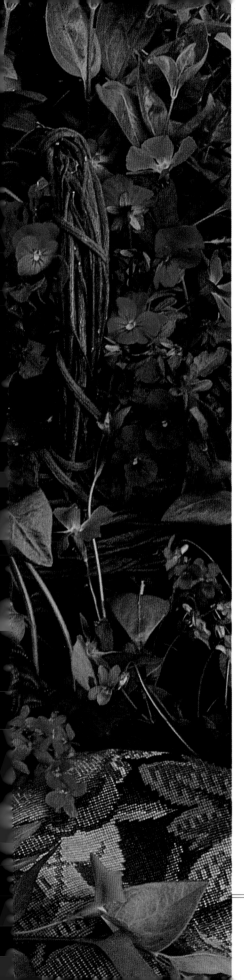

Flowers, Birds, and Unicorns
MEDIEVAL NEEDLEPOINT

CANDACE BAHOUTH

SPECIAL PHOTOGRAPHY BY CLAY PERRY
FOREWORD BY LINDSAY CLARKE

HARRY N. ABRAMS, INC., PUBLISHERS

FOR

LISA · MARK · PETER

AND

JOSEPH

Library of Congress Cataloging-in-Publication Data

Bahouth, Candace.

 Flowers, birds, and unicorns: medieval needlepoint/Candace
Bahouth; with photography by Clay Perry; foreword by Lindsay
Clarke.

 p. cm.

Includes index.

ISBN 0-8109-3316-0

 1. Needlework – Patterns. 2. Decoration and ornament, Medieval.
3. Art, Medieval – Themes, motives. I. Title.

TT753.B35 1993

746.44'2041–dc20 93-3043

First published in 1993 by Conran Octopus Limited, London

Published in 1993 by Harry N. Abrams, Incorporated, New York
A Times Mirror Company

Art Editor Sue Storey
Project Editor Louise Simpson
Consultant Editor Sally Harding
American Editor Eleanor Van Zandt
Chart Illustrator Colin Salmon
Picture Researcher Pippa Lewis
Diagrams Alison Barratt
Endpapers Musée Cluny, photo Reunion des Musées Nationaux

Printed in Hong Kong

CONTENTS

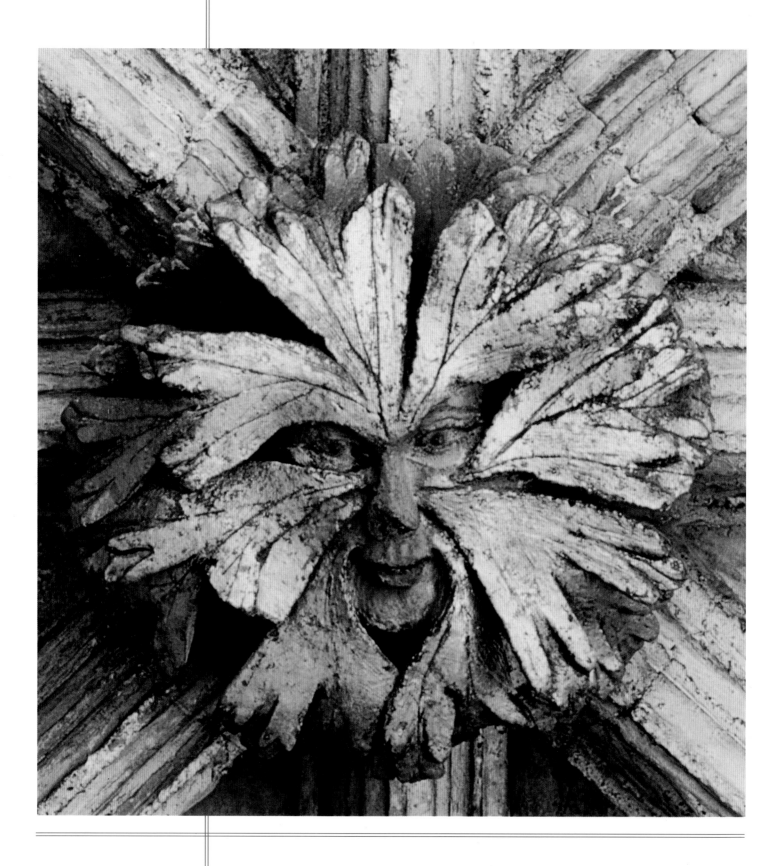

FOREWORD

Astir among the trees: you turn and, for an instant so brief you wonder afterwards whether it really happened, the Green Man is looking down at you – questioning, assessing, whispering that it's time to renew yourself, to change your life. Once glimpsed, you begin to see him everywhere – as here, famously, in the cloister-vault of Norwich Cathedral, where his leaves shine golden and his gaze has the rapt quality of one surprised into poetic inspiration.

The Green Man always appears as companion to a goddess figure, whether in the form of a wild woman, the Virgin Mary, or Mother Earth. Together they celebrate both the replenishing energy of the natural order – green spring unfurling from the deeps of winter – and the creative power of the human imagination by which we shape our lives. That was the promise I saw in the Green Man when I first learned to love the emblems, poems, and stories of the Middle Ages. Much later, as a working novelist, I became excited by the contemporary possibilities of the kind of tale he figured in – the medieval high romance. Through those marvelous adventures of the imagination the old storytellers once sought to strike new balances between the female principle and the male, between the waking and the dreaming minds, and between a powerful collective orthodoxy on the one hand and a lively, heretical dissidence on the other. These were all hot issues in the Middle Ages, and remain so today. Such themes preoccupy me as a writer still.

If a barrier of changed language stands between us and the subtle way in which the medieval tales were told, we have also inherited from those prolific centuries a treasury of images which need no words. Candace Bahouth's beautiful book offers a profusion of such emblems. They are images to contemplate, to marvel over, and to work with – quietly, reflectively, bringing them inwardly alive, with all the associations they may stir. For to enter the medieval world with senses alert is like opening up a half-forgotten wing in your imagination: somehow you knew it was always there, and the more widely you explore its pageantry, the more it turns out to be both familiar and strange. Its discoveries seem to take you out of yourself into a richer, more magical terrain, but they do so precisely because it is also an inward journey where the knights and ladies, beasts and angels, monsters and demons, and the bright, heraldic landscapes which they range, all correspond in intimate detail to energies active and available in every human soul.

Designed to delight us, such images illuminate the ways in which our inner life is continuous with the natural world out there. They enlarge our creative reach, and nourish our dreams. Amidst all our confusions, they remind us that we are involved in patterns of meaning larger than our current ambitions; and, in the vigorous spirit of the Green Man, they counsel us not only to preserve what is valuable from the past, but also to make it fresh and vivid in our daily lives.

LINDSAY CLARKE

AN ARCHETYPAL SYMBOL OF CREATIVE ENERGY AND PARTNER OF MOTHER EARTH – THE GREEN MAN – HERE CAUGHT PEEPING DOWN THROUGH HIS MANTLE OF GOLD LEAVES FROM THE LOFTY PILLARS OF NORWICH CATHEDRAL.

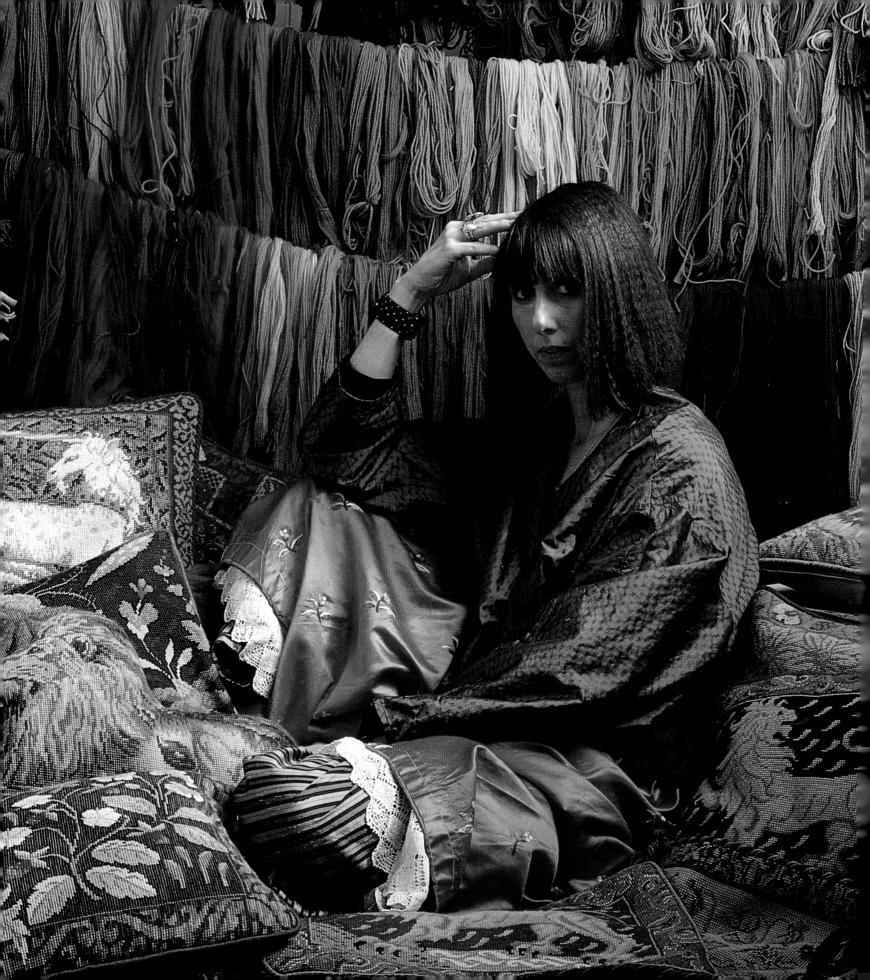

INTRODUCTION

This egle, of which I have you told,

> *That shone with fethres as of gold,*
> *Which that so highe gan to sore,*
> *I gan beholde more and more,*
> *To see the beauté and the wonder.*

The House of Fame by Geoffrey Chaucer, c.1340–1400

C an you remember as a child holding up a kaleidoscope to your eye and watching the cut glass swirl around, creating endless brilliant shapes and patterns? Can you remember gazing into an iced Easter egg – through that tiny window at one end – and seeing a wondrous landscape of hills, trees, lakes and bunnies, all in minute detail?

When I was young I made tiny paper theaters inside cardboard shoeboxes. Looking through a peephole in the box, you could see the heads of the audience ranged in rows, then the drawn-

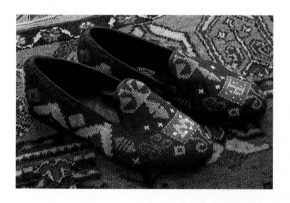

back curtains, the stage, the different characters and actors, and finally layers and layers of backdrops and scenery – each representing a different scene from the play. Everything was painted and cut from different strips of rainbow paper.

Be it in music, art or writing, this is the artist's life – to hold to one's own private world of imagination, keeping one's vision close, as a sanctuary, exploring it and then trying to recreate it. As C.S. Lewis wrote in *The Allegory of Love*: "The poet is free to invent, beyond the limits of the possible, regions of strangeness and beauty for their own sake".

The world that I hope is going to open up and envelop you in this book is the medieval world. This was a time that was both drab and jewel-like in color, muddy and majestic in life, stark and poverty-stricken for some with sumptuous layers of richness and delight for others.

Poems in color – the word "poem" is Greek and means "a thing made." I surround myself with a perpetual spectrum of color and inspiring design.

I chose the medieval world for my inspiration because it was all there, these vivid extremes of terror and joy; the most delicate, detailed, and fanciful craftsmanship alongside crude and grotesque gargoyles, courtly love and peasants "swynking and swyving" in the fields. The social structure was frequently fragmented by bloody wars and turbulent feudal power struggles, and the threat of cholera and plague continually lowered over man. The Church and the nobility, however, maintained a unifying order through the power of religion, ceremony, and artistic patronage. Events were on some occasions frightening, chaotic, and mysterious and on others formal, ritualized, and abstract. Or as C.S. Lewis puts it, with his endearing exactitude:

The fourteenth century has the chaotic attraction of the general store.

I love this world of magnificent colors and dazzling patterns which extend from tiled floors to richly decorated jesters' stockings and layered clothes of silk, brocade, velvet, and damask embroidered with gold; to curling hats and trailing mantles set against a backdrop of *millefleurs* woven tapestries and soft-colored buildings with tiled roofs in complex patterns. Over all these delights hang the blue heavens, filled with constellations and a sun and moon each with its own face.

One finds medieval illuminated pages where art and nature intermingle, where even the splendid initials enclose a world of beasts, birds, and fowl. Everything seeming to be caught up in great swirls and coils of life. Every square inch is packed with incident and observation: ladybugs lying on gold-etched leaves, deer-hunting scenes, lions reviving their firstborn cubs, men with toothaches, scenes from the Bible, a woman giving birth while two men observe the stars for the child's exact astrological setting.

Most medieval pictures illustrate either spiritual stories or tales of courtly love. Sometimes these stories overlap, forming complex layers of meaning. A lily being given by a man to a woman can be simply a floral token; or, when depicted with the Virgin Mary, it can be a symbol of purity. The unicorn can be either a symbol of Christ or of the beloved, captured and bedded. These detailed allegories reveal intricate and powerful stories of heaven, earth, and hell.

Sadly, living in today's world, we have lost so

A CELEBRATION OF JUXTAPOSED OR OVERLAID PATTERNS. HERE MY INDIAN PURSE IS LAID OVER ONE OF MY NEEDLEPOINTS, WHILE SIMILAR RICH COLORS ARE CAPTURED IN A BRANCH OF A CLERODENDRUM *(FARGESII)* TREE, WITH ITS STRANGE BLUE-FRUIT EYES ENCIRCLED BY MAROON PETALS, LAID ON A HAND-BLOCKED FABRIC.

much of that complex wealth. When I look through books of medieval tapestry at masterpieces like the Lady and the Unicorn, and then take only one flower or one exactly observed animal as the basis of a design, much of the significance, intricacy, and complexity of the original is inevitably lost. However hard we try, it is often difficult to produce colors and visions of spiritual intensity in this, our materialistic world. I feel humble in the company of the medieval artist, who ennobled everything in his attempt to show God's omnipresence in the natural world – and I mourn the fact that we have lost the depth of meaning with which he illustrated his life.

In many ways, therefore, I have tried to bring a similar sense of color, eclectic ideas, and finely executed detail to my work as a weaver and needlepoint artist. In fact, I suppose I had a natural head start by being born into a colorful and exotic family. My world began in America. My grandparents were Arab and Italian, and my childhood was full of family, vivid color, and decoration. At Syracuse University I studied Fine Art – painting, drawing, design, ceramics, and

weaving. There, I had the opportunity to steep myself in work and develop an attitude of openness, curiosity, and freedom from convention. When I left, I went to New York City and became involved in textile design.

Later, in the seventies, I moved to a small village in England and made a new world there. My dream was to live in a cottage with a loom! And so I have. My cottage is 400 years old and attached to a chapel, which contains a vertical loom.

A two-week course with tapestry artist Archie Brennan in Edinburgh had inspired me with the potential of woven tapestry, so much so that I struggled home to Somerset squeezing a medium-sized tapestry frame onto the train. The strong sense of design and color which you can achieve with weft-faced textiles continues to enthrall and utterly consume me, as I create portraits and wall hangings in woven tapestry.

One of the most ancient of crafts, tapestry weaving was at its height in the medieval period, and I soon began to cherish the subtlety of colors and exactitude of design detail that those

A LARGE 15 FT X 5 FT TAPESTRY, WHICH I WOVE FOR THE LIBRARY OF A MEDIEVAL PRIORY. THE BEIGE BORDER WAS INSPIRED BY STONE FACES ON THE WALL AND ADDS A CONTEMPORARY TOUCH TO THE DEEP PAINTERLY SWEEPS OF COLOR WITHIN – ALL EMBELLISHED WITH GOLD THREAD.

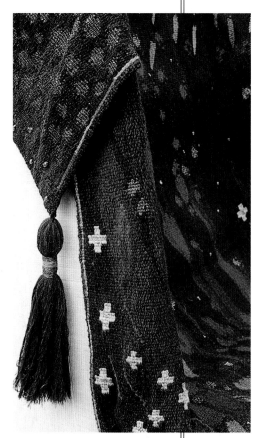

ONE OF TWO TAPESTRIES I WOVE FOR SETTLES BY RICHARD LA TROBE BATEMAN. THE DEEP GREENS, COPPERS, MAROONS, AND BLUES ENVELOP THE INSIDE AND FOLD INTO POINTS CULMINATING IN A LAVISH TASSEL – THE COLORS AND THE DESIGN ARE REMINISCENT OF MEDIEVAL TAPESTRY.

craftsmen and women lovingly wove into their creations.

Needlepoint was a natural extension of my weaving work, as it combines soft, colorful yarns with intricate, crafted detail. And, it was clearly a little easier to carry on trains than my tapestry frame! Having been invited to design for the king of needlepoint, Hugh Ehrman, I continued my intense affair with old textiles, delighting in their fragile charm, deep-rooted images, and intricate pattern. From then on, I was completely under the spell of the medieval period, and it has been the main fountain of inspiration for my work ever since.

If asked to explain the process of artistic creation, I would say that the artist is continually trying to say something about a time we have left behind – art is what the human spirit seeks and yearns for. I also believe one's work runs along two parallel lines. One is the unconscious accumulation and digestion of personal experiences, passions, and interests – of which I have many! This is the content of one's work. The other is the conscious development of one's technique which gives the work its form; genius can never materialize, unless it finds or makes the form it requires.

Every once in a while these two lines converge and a work of art is produced. If you have a well-honed technique, then you can allow your unconscious to come flowing through. All creativity is about being a bit of a child, playing about; it is an act of flying, taking off, losing oneself. My personal philosophy is – do it, play, be

critical with yourself and generous with others. To quote C.S. Lewis yet again:

For poetry to spread its wings fully, there must be a Marvelous that knows itself as myth. The old Marvelous, which was once taken as fact, must be stored up somewhere, not wholly dead, but in a winter's sleep, waiting its time. If it is not stored up, if it is allowed to perish, then the imagination is impoverished.

I am often asked what inspires me. I usually answer "everything," which, in a way, is true.

The medieval word for "pleasure," is "lust," and I have a lust, a thirst, for anything which draws me into its own particular world – for example, old computer innards where you can look into the complexity of lines of colored wire twisting and turning around the shapes of little batteries, microchips, and condensers to form their own graceful pattern and rhythm.

Equally visually seductive to me is the Pitt-Rivers Museum in Oxford, with its crammed, idiosyncratic jumble of looms, votive offerings, shoes, playing cards, dolls, baskets, fans, buttons, masks, charms, textiles, jewelry, puppets, shrunken heads, ceramics, and glass. The atmosphere at the museum is particular – peculiar even – dark like an attic, bringing you into the private world of an obsessive collector.

My lusts extend as well to fairgrounds, old textiles, mosaics, the "human face divine," robots, angels, toys, pataphysics (a science of imaginary solutions), Radio 4 drama, *Hali* magazine, the English Artist Andy Goldsworthy, pantheism, cello music; but, above all, to Nature – primitive, unspoiled, original.

As far as medieval sources go, cathedrals, towns, and museums will always provide rich pickings. As an American living in Britain, I am obviously very appreciative of the wealth of

medieval influences that surround me. Just a few miles from my home is the medieval city of Wells. Here I wander through the porches and gateways of the ancient cobbled streets, passing among the canonical houses and down to the Bishop's Palace and Moat, to emerge in front of the tranquil cathedral green. The West Front of the cathedral, finished in about 1240, is still a breathtaking sight with its myriad of figures and angels, each in their own stone niche, that once shimmered with gold and brightly colored paint. Within is "the Scissors," the main inverted arch which soars above pale columns crowned with stiff-leaved foliage; the fourteenth-century clock and the rippling steps of the Chapter House; a massive oak door decorated with fanciful wrought ironwork; carvings of grimacing men with toothaches and thorns piercing their feet; and a bestiary of dragons, lizards, and green men.

Not everyone is lucky enough to have such marvelous medieval architecture on their doorstep. Yet wherever you live, I hope this book, with its rich designs and resplendent colors, will help you create – within your own private haven or sanctum of enchantment – a world of harmony, spirit, and delight. Possibly one of my favorite quotations will encourage the artist in you:

Your work is unbeautiful, alright let it be unbeautiful. It will grieve you, but it must not discourage you. Nature demands a certain devotion, and she demands a period of struggling with her – it is the experience and hard work of every day which alone will ripen in the long run and allow one to do something truer and more complete. You will not always do well, but the days you least expect it you will do that which holds its own with the work of those that have gone before.

The Letters to Theo, November 1889
by Vincent Van Gogh, 1853–1890

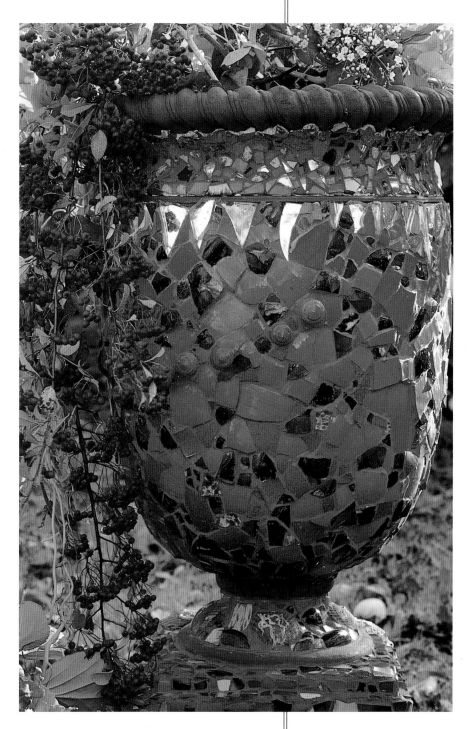

With bits of French blue china, shells, mirror, and Moorecroft shards, I covered a large urn by Steven Morgan, bringing an intense Islamic glow to my garden.

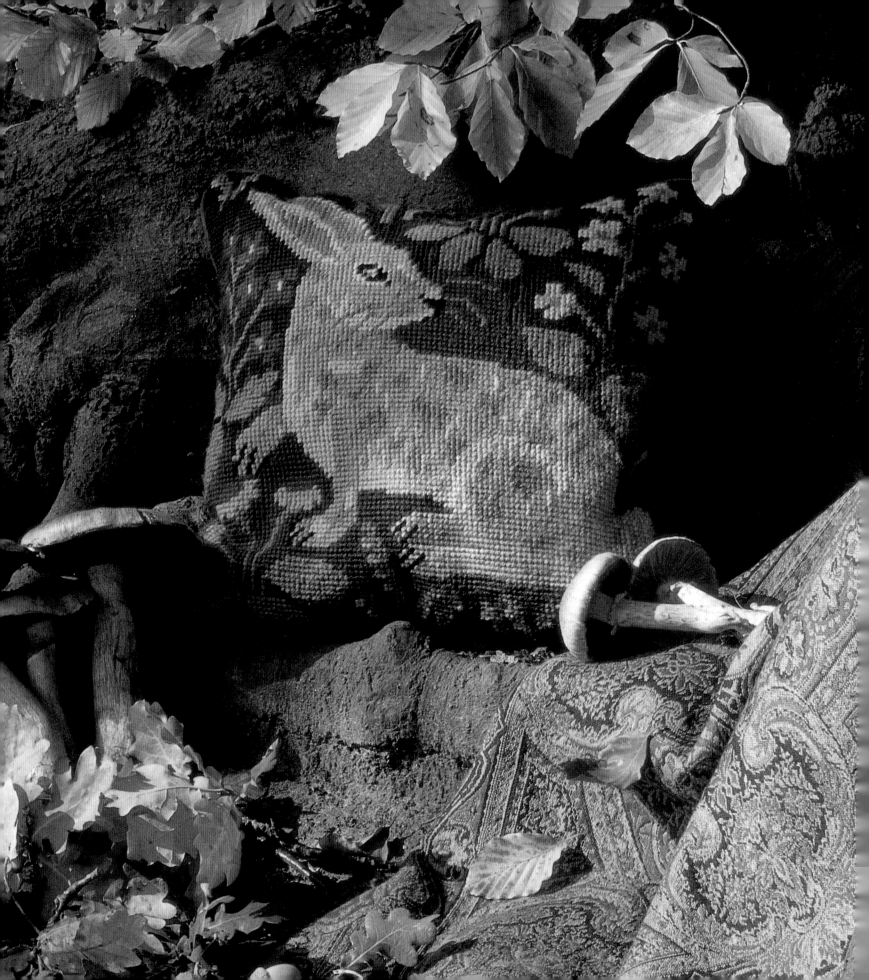

BIRDS AND BEASTS

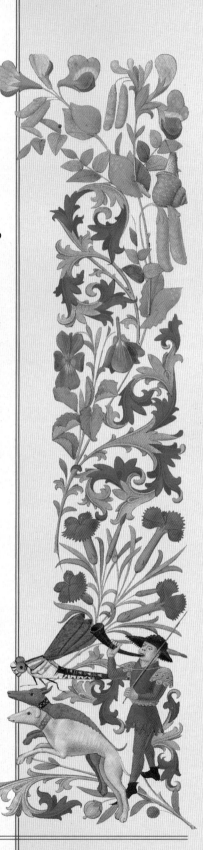

Dreadfull of daunger, that more him betyde,
She oft and oft adviz'd him to refraine
From chase of greater beasts, whose brutish pryde
Mote breede him scath unawares: but all in vaine;
For who can shun the chaunce, that dest'ny doth ordaine?

The Faerie Queen by Edmund Spenser, 1552–1599

Living as I do in rural Somerset, one of the beautiful and gentle parts of England, I feel completely immersed in the quiet, sacred drama of Nature. When I "rise on a morning sweete and faire," I hear the dawn chorus of small songbirds and my doves on the windowsill cooing, full of love. Fresh dew rests on every small twig and blade of grass, and dozens of rabbits scamper in all directions as a fox proceeds slowly, boldly across the field.

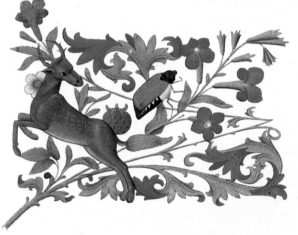

Nearby is Glastonbury, reputedly the burial place of King Arthur and his Queen Guinevere, and the location of a holy thorn bush, supposedly planted by Joseph of Arimathea when he brought the Holy Grail to Somerset. When I stand within the grounds of the romantically decaying abbey in the Vale of Avalon, I feel transported into the mystical world of Camelot, where erotic passion mingled with sacred love and knightly chivalry.

Today, however, the countryside for many people is a place to be visited rather than lived in. Yet, it is important to realize that even as late as the fourteenth century, at least ninety-five percent of the population still lived in the countryside. Apart from London, which was relatively large, the average English town had fewer than five hundred inhabitants. York, the second largest town in Britain, had a population of eight thousand. It is no wonder, then, that medieval art is set against the powerful drama of Nature.

LEFT: *A rabbit, alert, listening, caught in needlepoint.* ABOVE: *A hunting border, teeming with life. Hounds, deer, dragonflies, snail, flowers and strawberries all abound.*

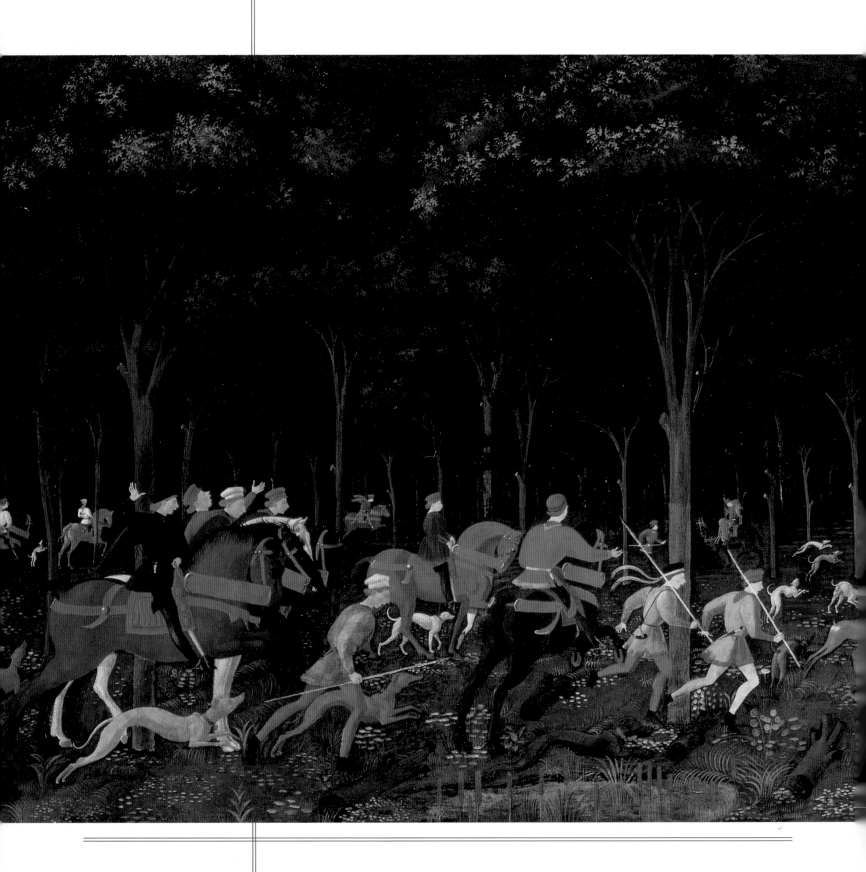

The medieval artist had an extraordinary feel for the golden world of the countryside and its impact on life. In illustrations for the *Très Riches Heures du Duc de Berry* – one of the finest medieval prayer books – we see sheep huddling and being washed and shorn, birds pecking at grain in the field, beehives being carefully tended in the orchards, and pigs in the forest rooting voraciously around for acorns and truffles. The delicate and poetic mood of the countryside is captured with great faithfulness to create a harmony of color, composition, and emotion.

The Medieval Hunt

One of the most important themes in medieval art was the hunt, which signified the wildness and abundance of Nature and the courtly rituals of love. The lover is caught in the net of love and is also the relentless hunter, attempting to ensnare his beloved and win her heart. It was the belief of every great medieval lord that there was no better occupation than "to hunt and hawke and pley in medes."

Although hunting took various forms, deer hunting was regarded as the most noble and marvelous activity. The whole community took part in this highly charged drama: the lord, the huntsmen, lymerers, grooms, pages, and all the peasants and villagers, blowing rustic pipes and horns and banging together pots and pans. It was conducted at a frenzied pace, in a flurry of excitement, charging through the "dark half-wild sylvan grove." This energized scene was portrayed stunningly in many medieval tapestries, which, despite their stylized flatness, seem bursting with noise and movement. The progressing hunt passed through forest and fields packed with a profusion of wildlife, while hawks and falcons

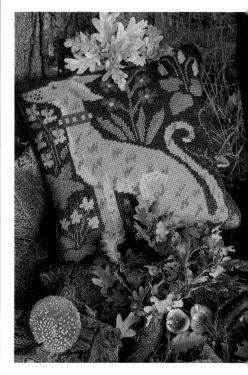

T HE DOG CUSHION BESIDE THE FLY AGARIC MUSHROOM, NOTORIOUS FOR ITS HALLUCINOGENIC PROPERTIES.

THE HUNT, BY UCCELLO (1397-1475). THE MEDIEVAL HUNT STARTED "IN THE STERN MORNING AIR," WITH BAYING HOUNDS RELEASED TO PICK UP THE SCENT OF DEER AND HARES. IN "LA CHASSE" GACE DE LA BUIGNE EVOKES THE DRAMA OF THE CHASE: "WHEN THE HOUNDS GIVE TONGUE, NEVER HAS MAN HEARD MELODY TO EQUAL THIS. NO ALLELUYA SUNG IN THE CHAPEL OF THE KING IS SO BEAUTIFUL – AS THE MUSIC OF HUNTING HOUNDS."

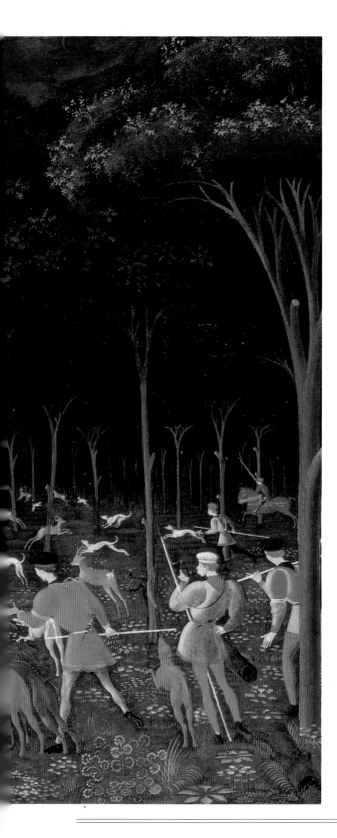

DETAIL FROM THE UNICORN TAPESTRY *(OPPOSITE)* SHOWING BOTH MYTHICAL AND REAL BEASTS OF THE FOREST. THE BIRDS, FLOWERS, ANIMALS, AND EVEN THE FOUNTAIN HAVE BOTH RELIGIOUS AND SECULAR MEANINGS. THUS THE SPIRITUAL AND THE EARTHLY WORLDS WERE ALWAYS INTERLINKED. HERE THE FABLED UNICORN DIPS HIS MAGIC SPIRAL HORN INTO THE STREAM GUSHING FROM THE FOUNTAIN, PURIFYING THE SOURCE, ENABLING THE FOREST ANIMALS TO DRINK.

A COILED AND SCALY GRIFFIN, TUCKED UNDER AN ARCH ON ST. MARGARET'S CHURCH, WESTMINSTER ABBEY, LONDON.

brought down pigeon and dove and plover, and tiny merlins flew from ladies' wrists to catch fieldfare and wheatear.

Then came a sighting of the prey, and the greyhounds were unleashed. The swiftness and baying fury of the dogs commenced as the whole hunt streamed across fields, through forests and rivers, brambles, and woods. A hue and cry accompanied the strenuous chase, which culminated in flashing spears, the red blood gushing from the dying creature, and finally the return to the preparation, cooking, and feasting upon the creatures killed. I can fully appreciate why this colorful, cacophonous, wildly exciting ritual was such an unending source of inspiration for the medieval artist.

The Symbolism of the Hunt

During the Middle Ages aristocrats were fascinated by strange and bizarre creatures, many of which they had never seen but only read about in exotic travelers' tales. Thus in many medieval illustrations of the forest in which the hunt takes place, the glades and clearings are improbably filled with lion cubs, cheetahs, leopards, ostriches, monkeys, camels, panthers, porcupines, and hyenas.

As one looks at the weird and curious medieval beasts, birds, and fish, one wonders what imagination could have dreamed them up! One main source is Epiphanius the Greek, who created the *Physiologus*, later known as the *Bestiaries*, which was a catalogue of animals, real and legendary, that were invested with a remarkable range of symbolism so that they could be used in moral fables. Some were real animals – hedgehogs, lions,

and elephants – and others were fabulous imaginary creatures, with coiled tails, scaly legs, and bulging eyes. There was Caladrius, a bird supposed to foretell the fate of a sick man either by looking at him or turning his head away, and the flying scaly serpent or dragon, which until the fifteenth century had two legs – in English heraldry four. Dragons were depicted with horny heads, forked tongues, and a pair of bat-like wings, and were usually associated with Satan and the temptations he offered.

Other creatures were seemingly more attractive; these included the mermaids with "sweetness of song" who seduced sailors while they slept, then kidnapped them to "do the dede of lecherie." If the mariner refused or was too terrified to perform, the mermaid ate him!

All we are left with today of this extensive medieval bestiary are the gargoyles staring and grimacing down from the roofs and eaves of our churches, spewing out gouts of rainwater at us through their grotesque mouths.

Even the common hunting animals had symbolic meanings in art and literature. An animal could be a symbol of power and authority – as with the stag; of chastity – as with the female white hart; or of sexuality – as with the fox. In this way, renderings of the hunt in medieval tapestries and illustrations evoke not only an actual hunt but a parallel tale of the game of love. Every forest animal played a role in the story of this allegorical hunt or chase – the swan stood for good luck, the leopard for deviousness, dogs for fidelity, the peacock for pride, the young partridge for truth, the owl for wisdom, birds and butterflies for the pysche or soul, and rabbits for fecundity. Even the hounds were endowed with simple virtues of beauty, kindness, and gentleness.

All these animals, with their melodic cries, were

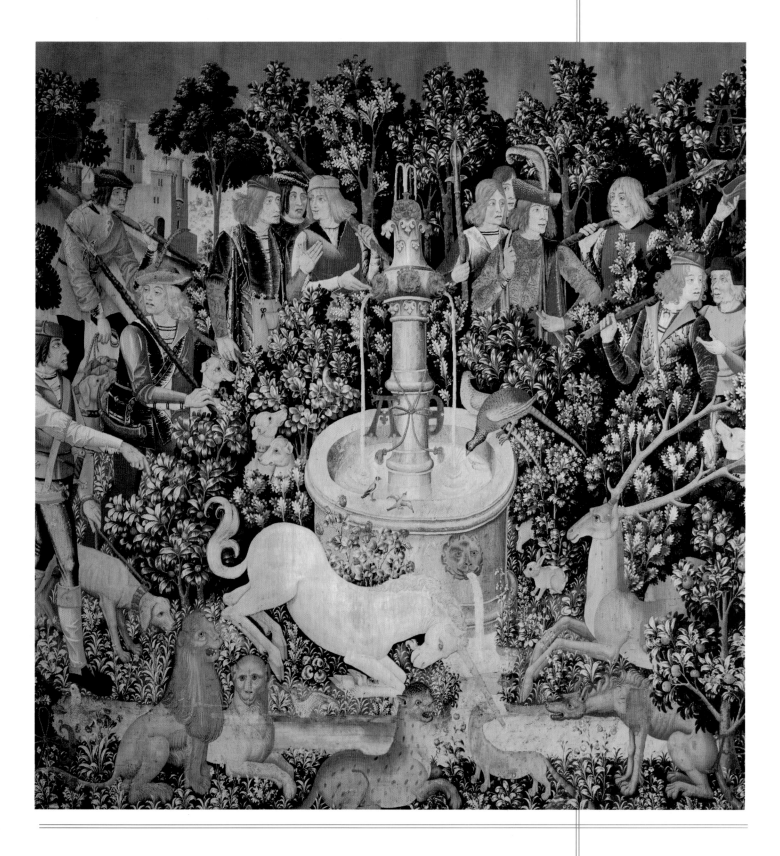

aiding the huntsman, who symbolized the lover, to drive the quarry, or the loved one, captured, into the net of desire. Even then, love enjoyed a full-blooded chase.

Birds of the Forest

It was also common practice to stock the forest with imported game and exotic birds, in order to add color and excitement to the royal hunt. In fact, birds were so familiar a part of medieval life and cooking that many of them were given specific group names, such as a sute of mallards, a sage of herons, a spring of teal, and a gaggle of geese. It is easy to see why birds, with their exotic crests, extraordinary beaks, glorious throats, fine spotted breasts, and sumptuous bright tail feathers, have continued to prove a fertile design source for me.

My Shelduck and Teal Cushion combines medieval colors with later design influences. The main source was actually a handsome book on heath and marshland birds that I stumbled across in a secondhand bookshop. This tome was full of color plates of lovely watercolor birds in dusty hues, including a delightful picture of a shelduck and a little teal with rippling plumage. Once I had worked my design around these two

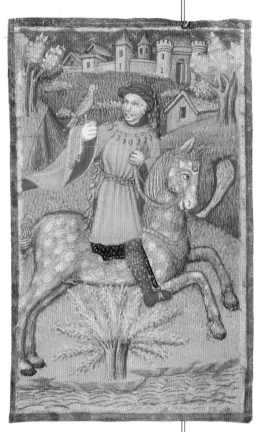

DETAIL OF A FALCONER WITH HIS HAWK, TAKEN FROM *THE BEDFORD BOOK OF HOURS*. FALCONRY WAS A TYPICAL MEDIEVAL HUNTING SPORT, ENGAGED IN BY THE KING AND HIS COURT. MEDIEVAL ARISTOCRATS DEPENDED ON THE INSTINCTS AND SKILLS OF THEIR BIRDS OF PREY – PEREGRINES, GOSHAWKS, SPARROW HAWKS, AND MERLINS – TO PROVIDE DELICACIES FOR THE BANQUET.

RIGHT: Companions on the river. The Shelduck and Teal were inspired by a richly embossed Japanese cup, covered in a swirl of pattern, color, and design detail. This cushion would be perfect for a river picnic.

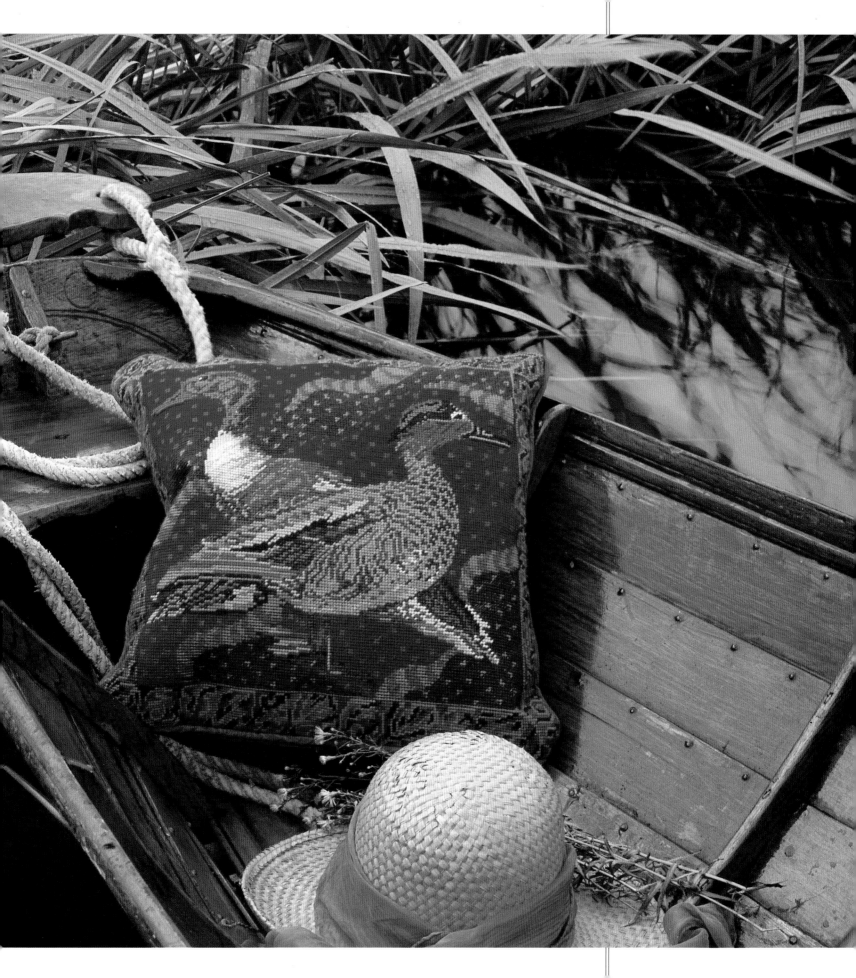

A SERIES OF FLOWER-STREWN TAPESTRIES, THE LADY AND THE UNICORN HAS BEEN A WELL OF INSPIRATION FOR MY WORK, INCLUDING THE HUNTING RUG (OPPOSITE).

waterborne birds, I then needed to find something special for the background. As luck would have it, a friend had just given me the most marvelous embossed Japanese cup. On this small porcelain vessel was a lively world of figures, trees, bridges, dragons, and houses, along with a multitude of spots, stripes, and other patterns. Choosing the more subdued colors from the cup as the main inspiration for my background, but I kept the design simple so as not to conflict with the detailed ducks. I then flecked this background with spots and stripes to complement the ducks'

handsome plumage. The rich border then accented the head of the teal with its rusty tones, muted ochres, and coiled swirls.

The Hunting Rug

Because of my interest in the theme of the hunt, I decided to try to depict the rich diversity of animals and birds peeping out from the flora and fruit of the forest in a Hunting Rug. I was wooed by the Lady and the Unicorn tapestries, and so began playing around with the animals and flowers until I had achieved a composition that worked as a whole. Of course, I had to include an appealing forest rabbit, which I decorated with spots, for a little extra textural interest and to break up the surface of his coat. The red squirrel was also a must, with his bushy tail gracefully curving around his back as he munches away at a nut. The falcon, a highly prized hunting animal, also made a delightful subject, with the jesses and bells tied to his ankles, while the noble pheasant adds color and poise with its long tail and turned neck. I used my son's dog, a lurcher, as a model for the hunting hound. Finally, there is, of course, the monkey – not so much a forest animal, but an exotic creature that often graces the hunt scene in tapestries and painting. He is included later as a cushion project. I have pictured all the animals browsing among the daffodils, bluebells, forget-me-nots, and other flowers of a springtime mead, typical of a *millefleurs*, with a sumptuous garlanded border of acorns, orange blossoms, cherries, oranges, and oak leaves.

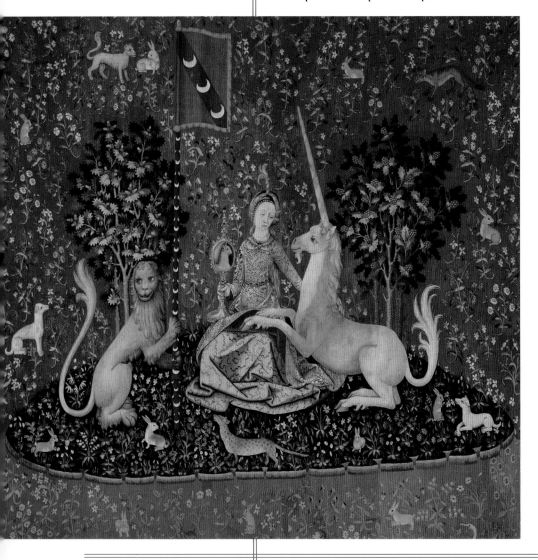

OVERLEAF: *How peaceful it would be to lie on these hunting rug cushions, deep in the dark mysterious forest with shafts of sunlight shooting through the canopy of trees as if in a medieval cathedral.*

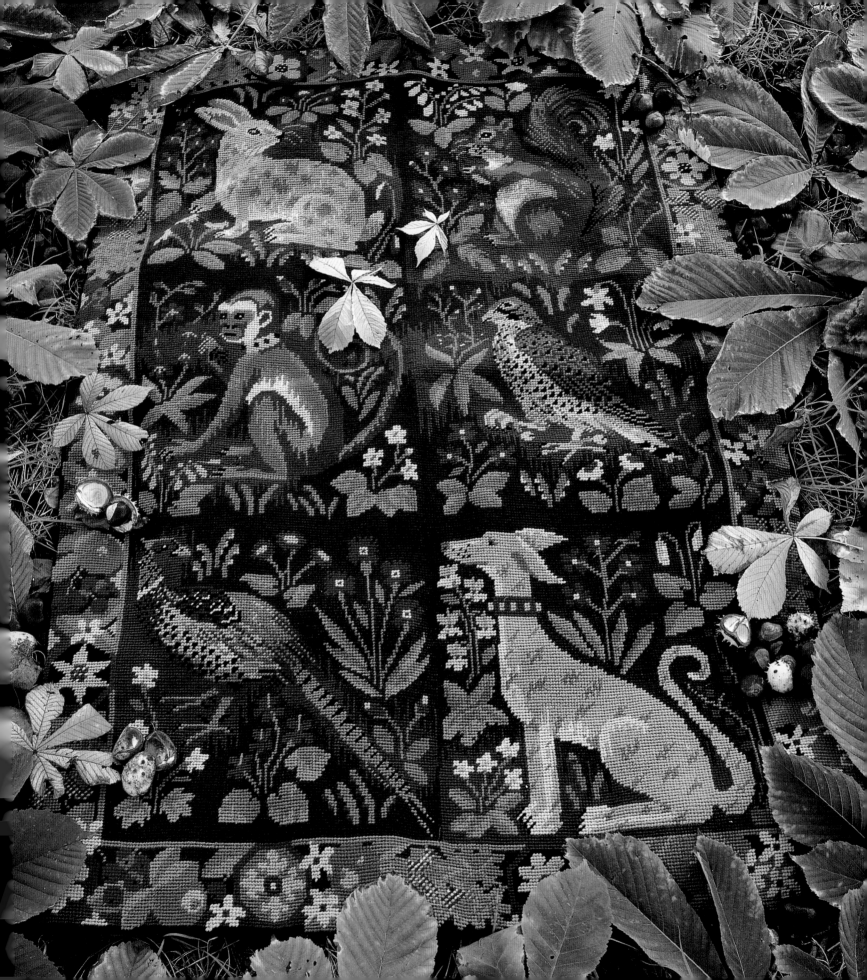

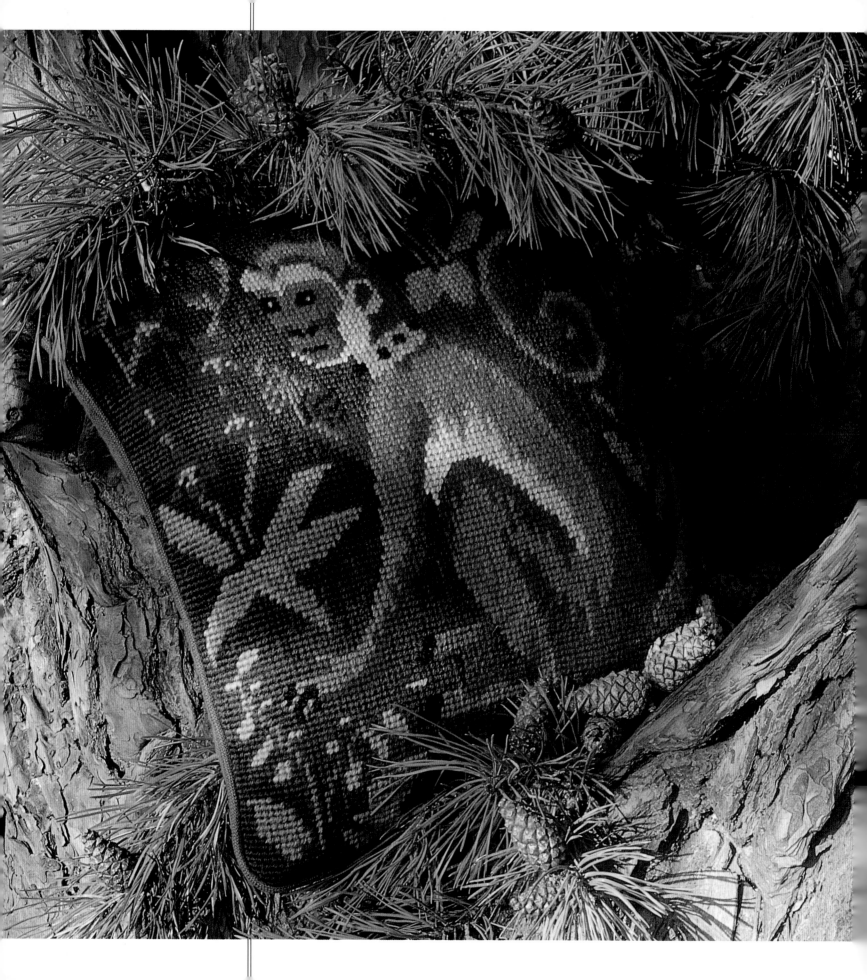

THE MONKEY CUSHION

The monkey has, since the Garden of Eden, been a symbol of trivial worldly attractions, lust, curiosity, foolish joy, paganism, and general folly – sounds fun! He also represents the sense of Taste and is often shown in medieval illustrations sitting arrogantly by a Tree of Knowledge, eating an apple. Turning the world upside down, the medieval jester also used the monkey as star performer, a partner in his burlesque of man's folly and dreams.

In religious symbolism the monkey represents the sin of pride, whereas in secular allegory the monkey is the lover, hopelessly ensnared by his passion for his mistress. Along with squirrels and parakeets, monkeys were often tamed by medieval ladies to be kept as amusing pets.

One of the sources of inspiration that I continue to refer to and find infinitely fruitful is the Lady and the Unicorn tapestry sequence in the Cluny Museum in Paris. Not only is it an astounding feat in the medium of woven tapestry, but also an acclaimed masterpiece in the art world.

Dating from the fifteenth century, the tapestries include five depicting the senses. My needlepoint monkey is inspired by the tapestry representing Taste. Every detail in this tapestry contributes to a dream-like world of such sweet

A MISCHIEVOUS MEDIEVAL MONKEY FROM THE LADY AND THE UNICORN TAPESTRY SERIES DEPICTING THE SENSE OF TASTE. HERE HE IS SITTING AMONG VIOLETS AND DAISIES, TWO FAVORITE MEDIEVAL FLOWERS SYMBOLIZING HUMILITY AND ADORATION.

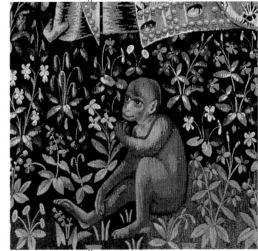

LEFT: *The exotic Monkey hides high amid the branches and cones of a Scots fir pine.*

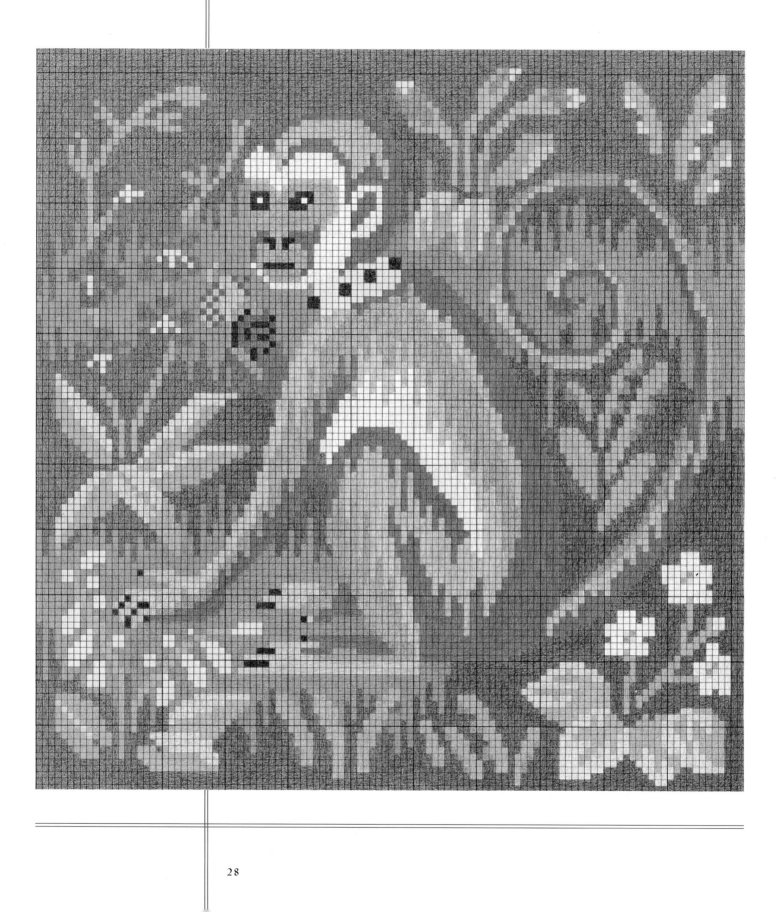

poetry and harmony, with flowering branches on a muted rose background and blossoming fruit trees and tufts of growing flowers peppered over a dark green-blue island.

Amid the flowers are familiar forest animals, including our amicable monkey. My fettered monkey is raising his arm to pop a nut, fruit, or sweetmeat into his mouth and looking straight into the observer's eye. This playful monkey was one of six forest animals, along with the pheasant, the falcon, the squirrel, the rabbit, and the lurcher, that I designed for my medieval Hunting Rug and cushions.

MAKING THE MONKEY CUSHION

Needlepoint Yarns and Materials

- Tapestry/Persian yarn in 12 colors
- 7-mesh écru double-thread canvas 22″ (56cm) square
- Size 16 tapestry needle
- ¾yd (70cm) furnishing fabric for backing and cording
- 2yd (1.8m) filler cord or furnishing cord
- 13″ (33cm) zipper
- Pillow form 16″ (40cm) square

Finished cushion: 16″ (40cm) square

Working the Needlepoint

The chart is 112 stitches wide and 114 stitches high. Mark the outline on the canvas and, if you like, stretch the canvas onto a frame. See page 116 for technical tips and stitch instructions. Using two strands of tapestry yarn, or four of Persian yarn, work the needlepoint in tent stitch. When the needlepoint is complete, block the canvas and sew on the backing and cording as instructed on page 120.

Color Key

This project was made in Appletons' yarn, but you could use Paternayan or the other brands listed on page 124. The alternatives will give a slightly different effect from that shown in the picture.

Ap 327 (Pa 531) – dark blue	16 skeins	
Ap 853 (Pa 501) – blue	1 skein	
Ap 157 (Pa 532) – green-blue	7 skeins	
Ap 643 (Pa 602) – green	5 skeins	
Ap 642 (Pa 604) – light green	2 skeins	
Ap 694 (Pa 733) – light gold	2 skeins	
Ap 912 (Pa 442) – fawn	4 skeins	
Ap 984 (Pa 645) – light beige	2 skeins	
Ap 207 (Pa 870) – brick red	5 skeins	
Ap 124 (Pa 483) – terracotta	3 skeins	
Ap 225 (Pa 931) – rose	2 skeins	
Ap 993 (Pa 220) – black	1 skein	

MADE UP ON A LARGE CANVAS OF 7 HOLES TO AN INCH, THIS MONKEY NEEDLEPOINT IS EASY AND QUICK TO COMPLETE.

A KIND-HEARTED MONKEY NURTURES FLOWERS TO KEEP THEM FRESH AND BEAUTIFUL.

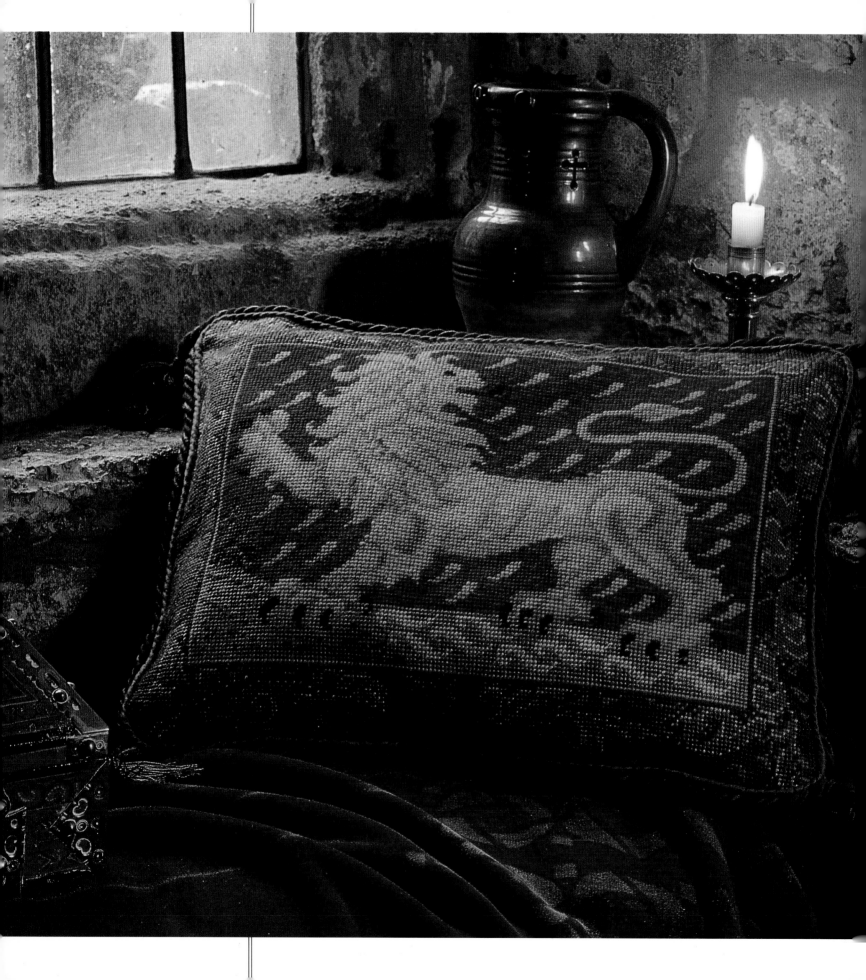

THE STANDING LION CUSHION

The lion was the favorite of medieval beasts and monarch of the animal kingdom. In a society that valued the fierce and noble feats which were the essence of a knight, the lion – the ruler over many beasts – was a perfect animal for coats-of-arms. So, not surprisingly, he was the first creature to feature on shields in the twelfth century.

By the middle of the thirteenth century, the lion had assumed its characteristic heraldic form. Lions adorning textiles from Sicily are considered by some scholars to be the original source of inspiration. Whatever fired the medieval craftsman, he certainly created a beast of unmistakable vigor and ferocity.

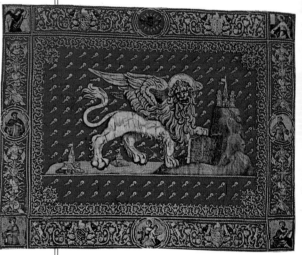

The lion is one of the most frequently used figures in heraldry, so it was there that I looked for the subject for my lion cushion. Looking at medieval illustrations of pageantry and tournaments, I saw lions and fleurs-de-lys scattered lavishly across the pages on banners, shields, and backdrops. I was particularly inspired by a picture of a seventeenth-century Venetian flag with the lion of St. Mark standing half on land and half on water. With its head held aloft, its noble posture suggests protective pride, while its rich colors announce its regal status.

There are fifty variations on the lion's position in heraldry. The lion on the Venetian flag is winged in the *passant guardant* (looking at the

THE ORIGINAL INSPIRATION FOR MY STANDING LION CUSHION WAS THIS SECTION OF A VENETIAN FLAG WITH THE LION OF ST. MARK, SURROUNDED BY GOLDEN RAINDROPS SYMBOLIZING TEARS.

LEFT: *The Standing Lion Cushion – one of 50 variations on the lion's position in heraldry.*

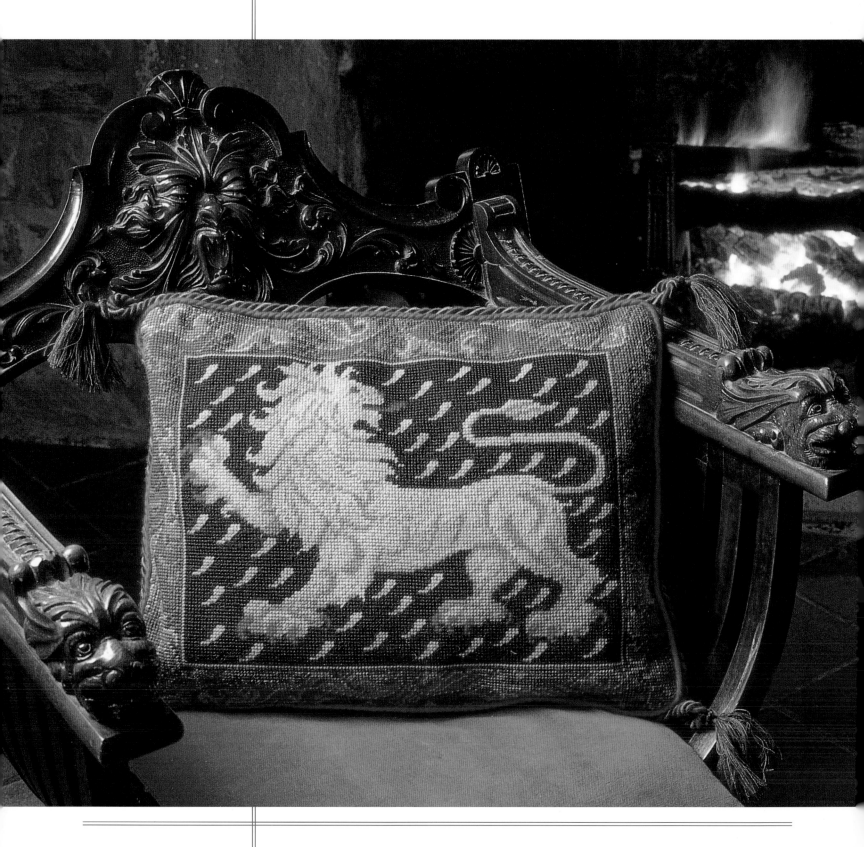

viewer) position. The proud standing lion on my cushion, however, is *passant reguardant* (looking behind himself) and is highly stylized. The stance has been altered, as I wanted a less ornate and more energetic one than the saintly lion of St. Mark with his sleek golden wings and halo. The deep red and gold colors were perfect for the majestic feeling I was trying to evolve.

The border for my standing lion is from an illuminated initial that contains, in minute detail, maids washing each others' hair. Framing this intimate scene are swirling leaves in blue which balanced well with the strong red, golds, and green of the main design.

This is the only cushion in the book for which I have given two colorways for you to choose from. Buzzing with too many ideas has always been my problem, so when I saw an old Franche Comté banner with a powerfully graphic image of a gold rampant lion with bright red claws on a brown ground, I immediately wanted to try the

LEFT: The majestic Standing Lion defends a throne by the fireside.

alternative colorway. Changing the ground on the second colorway to brown and the lion's claws, nose, and tongue to red, as well as eliminating the land and sea, transforms this design from an allegory of national pride to a strikingly elegant composition.

As my agile lion bounds across a background of teardrops, tail flying in the air, one can see why he is such a symbol of strength and how nothing else so expresses a nation's pride and dignity.

MAKING THE STANDING LION CUSHION

Needlepoint Yarns and Materials

- Tapestry/Persian yarn in 13 colors for first colorway or 9 colors for second colorway
- 10-mesh écru double-thread canvas 20 × 24" (51 × 61cm)
- Size 18 tapestry needle
- ½yd (50cm) furnishing fabric for backing
- 2½yd (2.3m) furnishing cord
- 4 tassels
- 15" (38cm) zipper
- Pillow form 14 × 18" (35 × 45cm)

THE BROWN STANDING LION CHART. BY CHANGING THE RED GROUND TO BROWN, ELIMINATING LAND AND SEA, CHANGING CLAWS, NOSE, AND TONGUE TO RED, AND ADDING EXTRA RAINDROPS, YOU CREATE THE DRAMATIC CUSHION SHOWN HERE. FOLLOW THE CHART BELOW FOR THE LOWER HALF OF THE LION AND THE MAIN CHART OVERLEAF FOR THE TOP HALF AND BORDER.

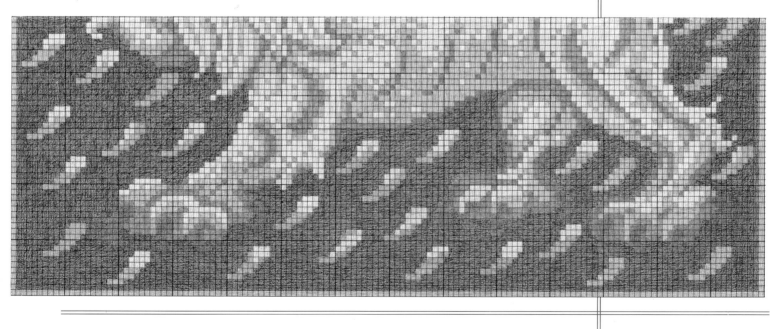

Working the Needlepoint

The chart is 180 stitches wide and 140 stitches high. Mark the outline on the canvas, and, if you like, stretch the canvas onto a frame. See page 116 for technical tips and stitch instructions. Using a single strand of tapestry yarn, or two of Persian yarn, work the needlepoint in tent stitch in either the first or second colorway.

Note: For the second colorway follow the chart of the lion legs and refer to the brackets for skein qualities. The lion and the border remain the same, but the background is changed from brick red to dark brown. Also the lion's claws, tongue, and nose are changed from dark brown to dark coral.

When the needlepoint is complete, block the canvas and sew on the backing, cord, and tassels as instructed on page 120.

Color Key

This project was made in Appletons' yarn, but you could use Paternayan or the other brands listed on page 124. The alternatives will give a slightly different effect from that shown in the picture. Amounts for second colorway are in brackets.

Color	Amount
Ap 208 (Pa 870) – brick red	5 [0] skeins
Ap 866 (Pa 850) – dark coral	2 [1] skeins
Ap 696 (Pa 731) – dark gold	4 [4] skeins
Ap 695 (Pa 732) – gold	4 [4] skeins
Ap 694 (Pa 733) – light gold	3 [3] skeins
Ap 254 (Pa 692) – grass green	1 [0] skein
Ap 642 (Pa 604) – gray-green	1 [0] skein
Ap 351 (Pa 605) – pale green	1 [0] skein
Ap 566 (Pa 500) – sky blue	4 [4] skeins
Ap 324 (Pa 502) – gray-blue	3 [3] skeins
Ap 152 (Pa 534) – pale blue	2 [2] skeins
Ap 588 (Pa 420) – dark brown	1 [7] skeins
Ap 956 (Pa 451) – mid brown	4 [3] skeins

LION OF ST. MARK FROM A CLOCK TOWER IN VENICE. THE WINGED LION IS THE SYMBOL OF ST. MARK, ONE OF THE FOUR EVANGELISTS.

THE RED COLORWAY FOR THE LION CHART.

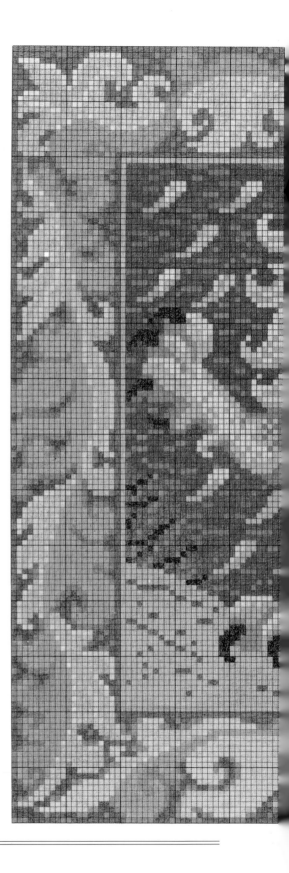

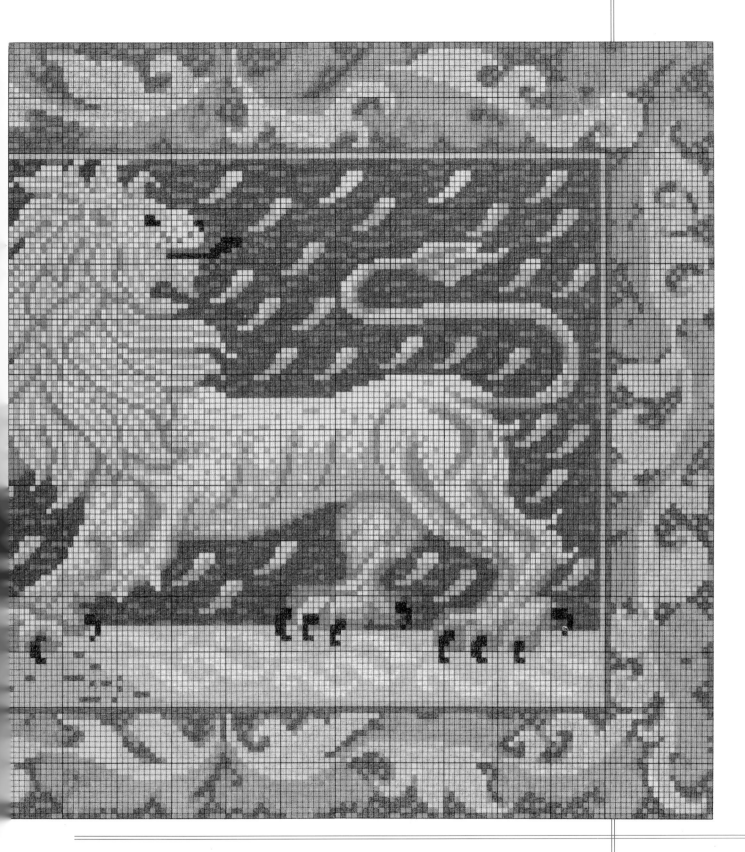

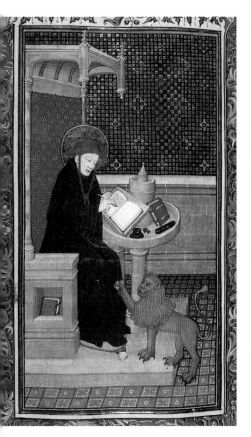

ACCORDING TO LEGEND,
ST. JEROME PULLED A THORN
FROM A LION'S PAW TO RELIEVE HIM
OF PAIN. THE SAINT IS USUALLY
DEPICTED IN HIS STUDY WITH HIS
ATTENDANT LION.

THE SEATED LION CUSHION

I have seen shaped needlepoint cats, ducks, initials, and vases, but never a shaped lion. Two lions proudly facing each other, both in the *couchant* position (lying down but with head erect) conjured up the royal stateliness and splendor I wished to capture. With photographs, drawings, and illustrations of lions by my side, I first developed a stylized design for my shaped lions, though I was never really satisfied with it. Then one day my assistant Julia came in with a large Victorian needlepoint of a lion. Its face was like the gentle lion in *The Wizard of Oz*, but the real attraction was the way the stitching had been worked to create an informal, impressionistic effect, rather than a structured, formal design. The colors were too maroon and pink – definitely not noble or golden enough for my English king – but otherwise he was the perfect inspiration for my final version, which will proudly guard your threshold or protect your hearth.

MAKING THE SEATED LION CUSHION

Needlepoint Yarns and Materials
- Tapestry/Persian yarn in 7 colors
- 10-mesh écru double-thread canvas 25 × 36" (61 × 92cm) for one lion
- Size 18 tapestry needle
- ³/₄yd (70cm) furnishing fabric for backing
- Fabric and stuffing for the inner cushion
- Each cushion measures 12 × 9¹/₂" (30 × 50cm) across the widest points

RIGHT: Alone or with its mirror image, the monarch's quiet yet powerful presence affects his surroundings.

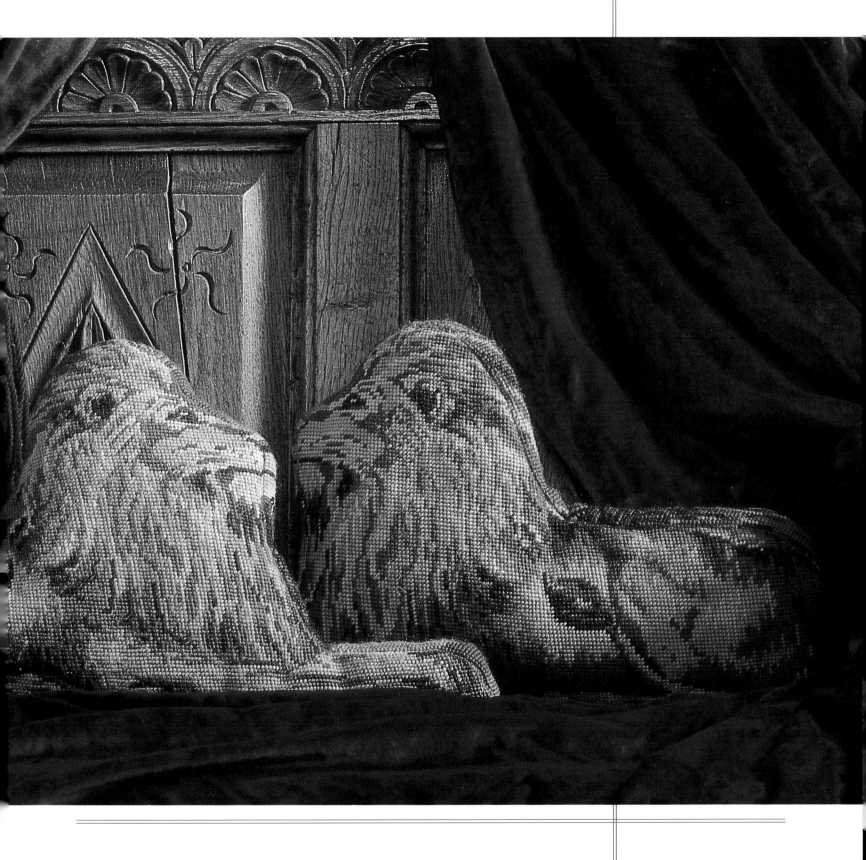

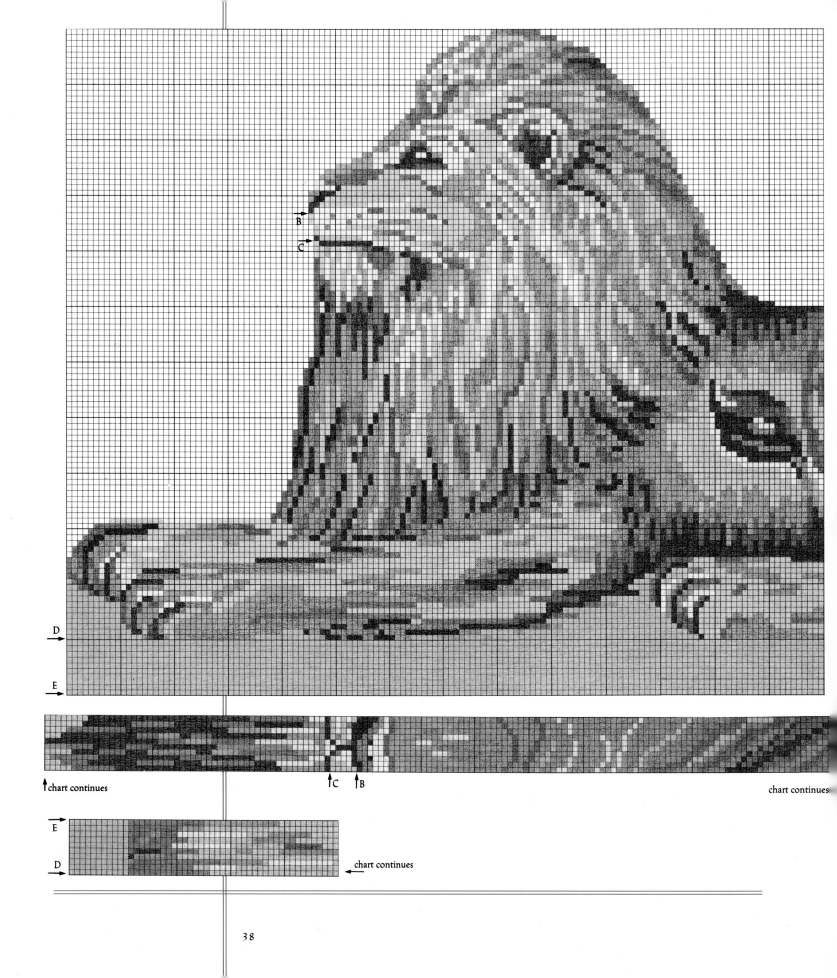

B

C

D

E

chart continues

C B

chart continues

E

D

chart continues

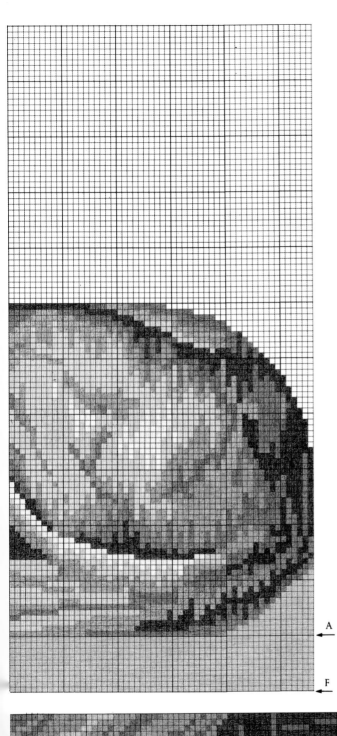

Working the Needlepoint

The lion chart is 196 stitches across the widest point and 120 stitches across the highest point; the gusset chart is 10 stitches wide and a total of 347 stitches long. Mark the lion and gusset outlines on the canvas, and, if you like, stretch the canvas onto a frame. If your canvas is not wide enough for the entire gusset, work it in two separate pieces and join after blocking. Using a single strand of tapestry yarn, or two of Persian yarn, work the needlepoint in tent stitch. To work the gusset, turn the book sideways and work the tent stitch back and forth across the width. When the needlepoint is complete, block the canvas, make the inner cushion, and sew on the gusset and backing as instructed on page 120.

Color Key

This project was made in Appletons' yarn, but you could use Paternayan or the other brands listed on page 124. The alternatives will give a slightly different effect from that shown in the picture.

■	Ap 581 (Pa 470) – dark brown	3 skeins
	Ap 904 (Pa 412) – golden brown	4 skeins
	Ap 913 (Pa 441) – medium fawn	4 skeins
	Ap 695 (Pa 732) – gold	4 skeins
	Ap 694 (Pa 733) – light gold	4 skeins
□	Ap 692 (Pa 735) – pale gold	12 skeins
	Ap 643 (Pa 602) – green	2 skeins

A ←

F ←

GUSSET CHART

F ↓

↑ chart continues

A (begin here) ↑

Chart for the seated lion facing left. When sewing the gusset to the shaped lion, fold the lion along the line "A–D" and match the letters on the gusset to the letters on the lion.

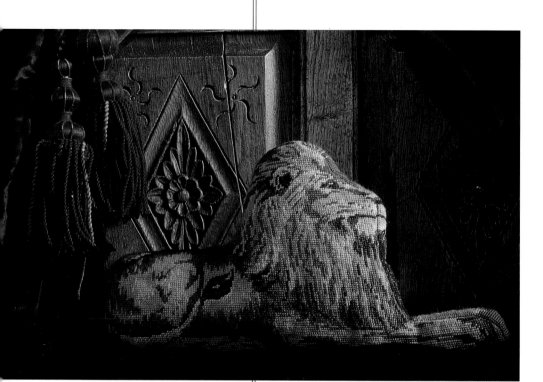

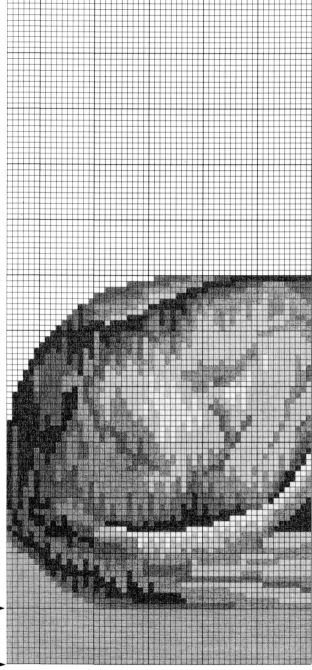

B Y INSERTING A BRICK WITHIN
THE CUSHION TO CREATE A
STABLE FOUNDATION YOU CAN
TURN THE LION INTO A FEROCIOUS
DOORSTOP. IF YOU DON'T WANT A
SHAPED CUSHION, YOU COULD FILL
IN THE BACKGROUND WITH GREEN.

*ABOVE: The gusset, which joins the needlepoint to its
backing and gives the lion some body, can just be seen.*

Color Key

■ Ap 581 (Pa 470) – dark brown	3 skeins	
▓ Ap 904 (Pa 412) – golden brown	4 skeins	
▒ Ap 913 (Pa 441) – medium fawn	4 skeins	
▒ Ap 695 (Pa 732) – gold	4 skeins	A →
▒ Ap 694 (Pa 733) – light gold	4 skeins	
□ Ap 692 (Pa 735) – pale gold	12 skeins	
▒ Ap 643 (Pa 602) – green	2 skeins	F →

GUSSET CHART

↓ F

↑ A (begin here)

chart continues ↑

*RIGHT: Chart for the Seated Lion Cushion facing right.
When sewing the gusset to the shaped lion, fold the lion
along the line "A–D" and match the letters on the
gusset to the letters on the lion.*

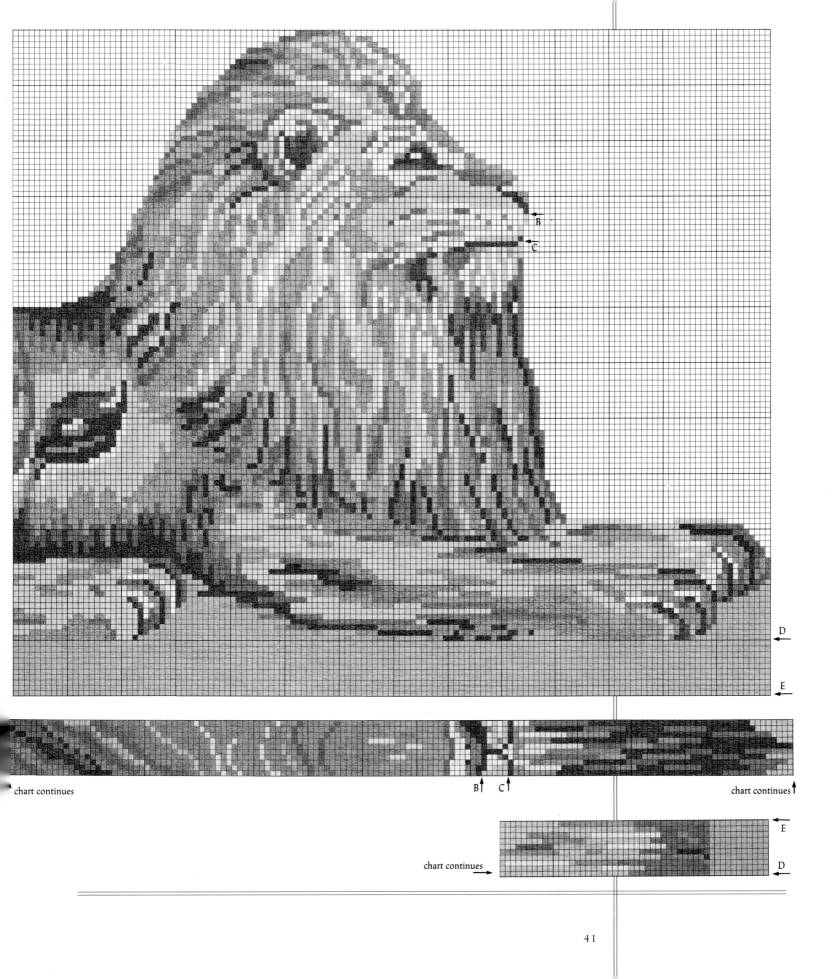

B

C

D

E

chart continues

B C

chart continues

E

chart continues

D

THE UNICORN CUSHION

Now I will believe that there are Unicorns.
The Tempest, Act 3, Scene 3

C HARMED, CAPTURED, AND
CARESSED BY THE MAIDEN,
THE UNICORN REPRESENTS THE
GALLANT MEDIEVAL LOVER, WHO
ENDURED MUCH DANGER AND
MISERY TO WIN THE ACCEPTANCE
OF HIS BELOVED. FROM *LE LIVRE DES
SIMPLES MEDECINES.*

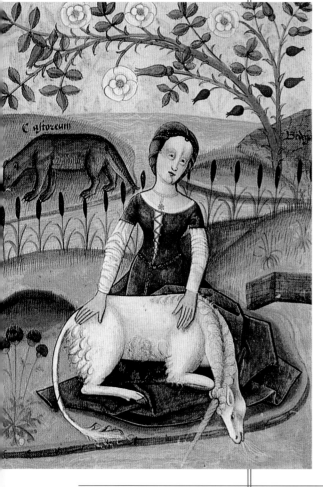

The mythical unicorn captured by an enticing virgin or maiden was a frequent theme in courtly love and in the hunt of medieval folklore. Imagine this handsome, majestic, milk-white, one-horned animal, with the graceful head of a stag, the powerful body of a horse, the plumed tail of a lion, the legs of an antelope, and the hooves and short, curly beard of a goat! It isn't surprising that this creature, born in the imagination of antiquity, is such a powerful image even today.

In the Middle Ages, the lovely, gentle, sorrowful unicorn, with its almost spiritual nature, was thought to have the magical quality of repelling poison with his straight and spiraled horn. When poisoning was an almost constant danger for the king, the fabled unicorn's corkscrew horn was much sought-after.

The medieval world delighted in a mixture of themes, juxtaposing the sacred with the profane in allegorical paintings and tapestries which described virtues most needed in the everyday world and the next – so the God of Erotic Love and the God of Heaven were not incompatible. In the same way, the unicorn, with his creamy body and benevolent nature, was mainly the symbol for purity and Christ, but also for the lover.

To create my unicorn needlepoint design, I made a detailed study of the pictures of the Unicorn tapestries from The Cloisters museum in New York, along with other sources.

I chose the body for my unicorn and the positioning of his legs from a French miniature and the graceful turn of his head from an Italian drawing; and I studied the tapestries for his coloring. The curving oak leaves and the unicorn's spotted coat were drawn from early Swiss tapestries, in which the imaginary unicorn is spotted (a nice decorative touch, I thought) and leaves are crammed into every available space.

I then placed this beautiful creature, with his princely collar, on a background of one of my favorite colors, which I have used in many of my designs – a soft jade green. It conjures up for me elements of the sea, bluegrass, duck feathers, the stenciled design in my chapel, bird's eggs, and aged copper. Curling around my unicorn's body are oak leaves, forget-me-nots, and deep blood-red pomegranate seeds – all symbols of love. The oak leaves are associated with happiness in love, the constancy of lovers, enduring relationships, and "betoken steadfastness." The blue forget-me-nots are a symbol of fidelity. And the pomegranate, more than any other fruit, is a symbol of fertility, with its luscious, bursting, abundant seeds.

I then finished the cushion with a rich maroon border "brocaded" with golden-yellow leaves, inspired by a lavishly embellished gold embroidery. The warmth and strength of the maroon and gold frame the lighter colors of the main design while reflecting the eyes of the flowers and the pomegranate seeds within the

RIGHT: *The Unicorn Cushion includes a border of forget-me-nots, oakleaves, and pomegranate seeds.*

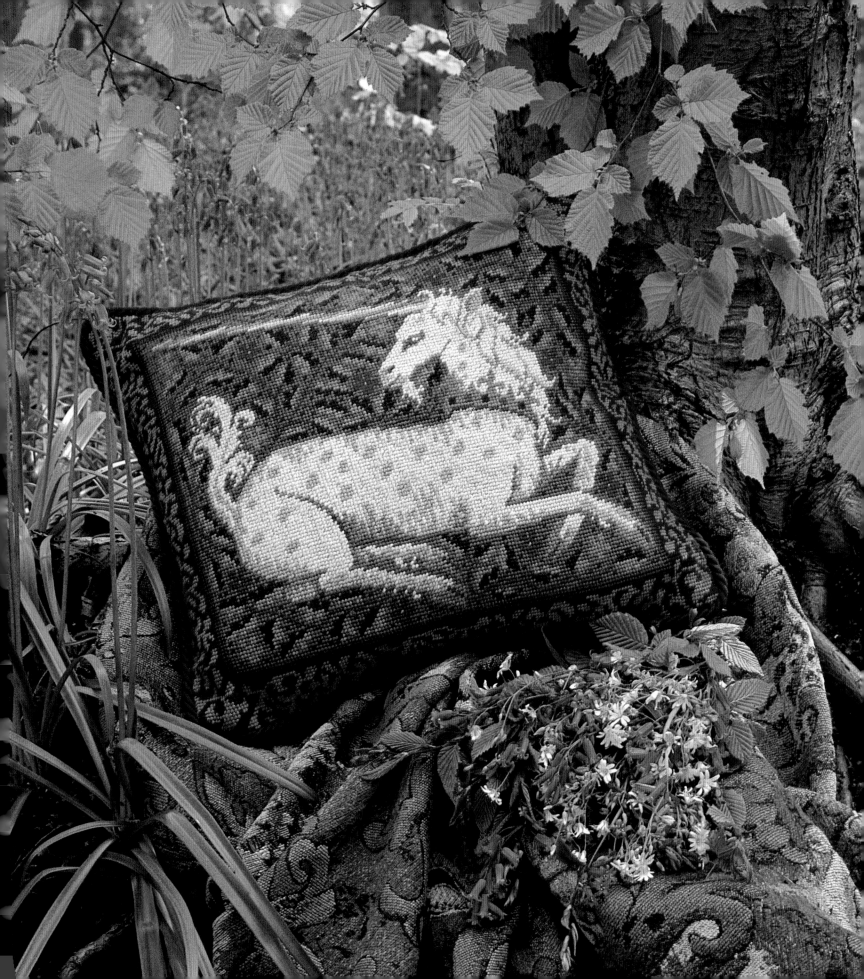

mead. With its creamy white body, surrounded by a bed of enchanting flowers, the unicorn has a romantic and ethereal quality.

MAKING THE UNICORN CUSHION

Needlepoint Yarns and Materials
- Tapestry/Persian yarn in 14 colors
- 10-mesh écru double-thread canvas 21 × 23" (53 × 58cm)

ALL THE POETRY OF THE MIDDLE AGES SEEMS TO BE CAPTURED IN THE REMARKABLE LADY AND THE UNICORN TAPESTRY, WHICH HAS NATURALLY INFLUENCED THE COLORING AND DETAILING OF MY OWN UNICORN CUSHION.

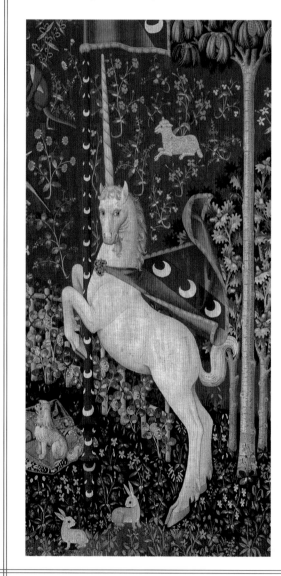

- Size 18 tapestry needle
- ³/₄yd (70cm) furnishing fabric for backing
- 2yd (1.8m) furnishing cord
- 4 tassels
- 14" (33cm) zipper
- Pillow form 15 × 17" (38 × 43cm)

Working the Needlepoint
The chart is 171 stitches wide and 151 stitches high. Mark the outline on the canvas and, if you like, stretch the canvas onto a frame. See page 116 for technical tips and stitch instructions. Using a single strand of tapestry yarn, or two of Persian yarn, work the needlepoint in tent stitch. When the needlepoint is complete, block the canvas and sew on the backing, cord, and tassels as instructed on page 120.

Color Key
This project was made in Appletons' yarn, but you could use Paternayan or the other brands listed on page 124. The alternatives will give a slightly different effect from that shown in the picture.

		
Ap 226 (Pa 930) – rose	6 skeins	
Ap 695 (Pa 732) – gold	5 skeins	
Ap 872 (Pa 715) – pale yellow	1 skein	
Ap 871 (Pa 716) – off white	1 skein	
Ap 691 (Pa 444) – oyster	1 skein	
Ap 902 (Pa 442) – light brown	1 skein	
Ap 901 (Pa 443) – pale brown	1 skein	
Ap 981 (Pa 464) – beige	1 skein	
Ap 315 (Pa 641) – olive brown	2 skeins	
Ap 548 (Pa 600) – dark green	2 skeins	
Ap 643 (Pa 602) – gray-green	5 skeins	
Ap 354 (Pa 693) – green	2 skeins	
Ap 823 (Pa 541) – royal blue	1 skein	
Ap 743 (Pa 562) – light blue	1 skein	

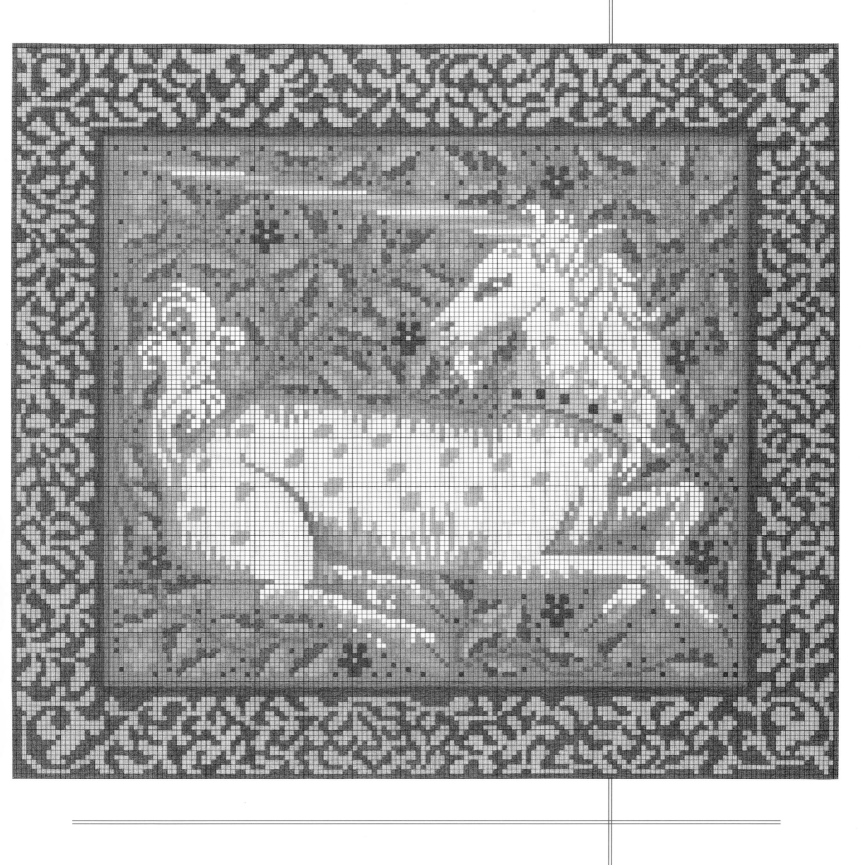

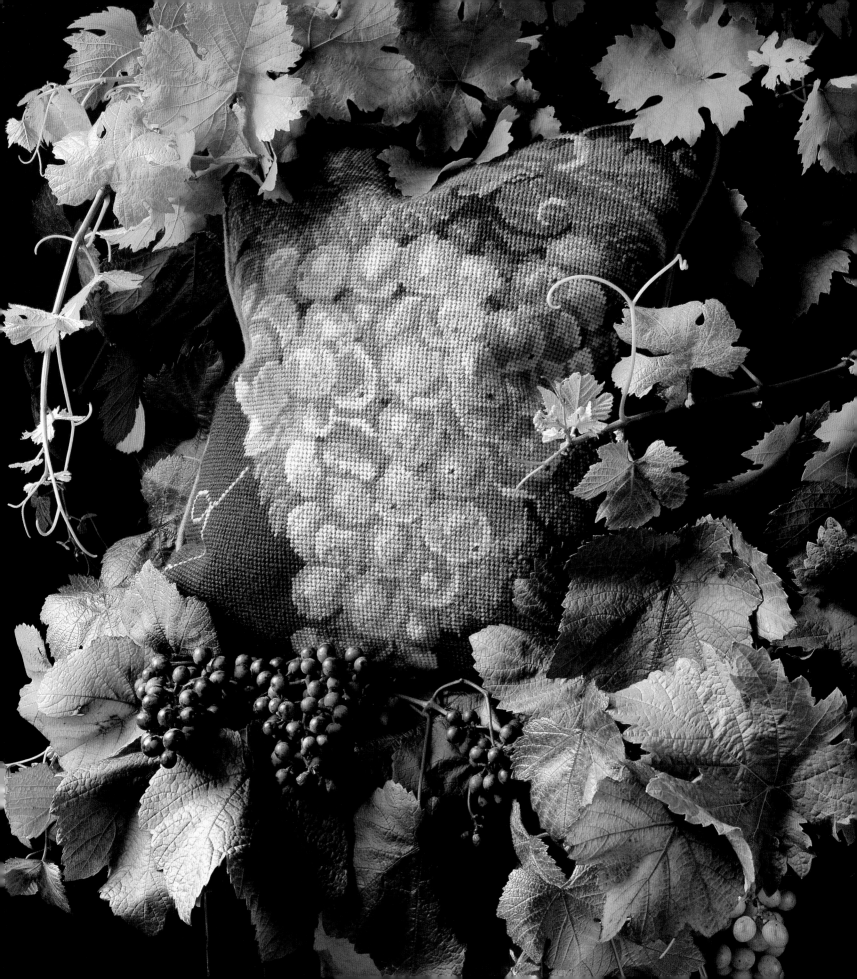

THE ENCHANTED GARDEN

I found me placed in a delightful mede
 Where a thousand flowers, blue, yellow, white and red,
 The dark-green tapestry in profusion spread,
 The violet, the lily of the vale,
 The purple radiance interlaced with pale. Anon., 12th–13th Century

Nature, for me, is one of life's most intense experiences. It is my secret dwelling place, the most perfect of worlds. Whether I am gazing at a fritillary with its checkerboard pattern, snowdrops opening, springtime bluebell woods like a bit of the heavenly sky falling down to earth, or mushrooms in the clusters of little African villages they create, my emotions are stirred. I love the miniature life and awesome detail of leaves, fungi, pinecones, fish, shells, flower-starred grass, speckled eggs, and birds' feathers.

In my personal garden my favorite flowers are hollyhocks, foxgloves, honeysuckle, daisies, the painted petals of *Rosa mundi*, lily-of-the-valley, bleeding hearts, passion flowers, black-

eyed Susans, and poppies. I have boundless enthusiasm for English cottage gardens, where the creative personality comes across most vibrantly in the eclectic glorious choice of flowers.

Nature is also a region of the mind which should be visited often, an area reserved for imagination and love. Poets, artists, and weavers in the Middle Ages used it – in both its wild and cultivated forms – to symbolize many states of mind and feeling. It was for them:

. . . the other world of imagination, the land of longing, the earthly paradise, the garden east of the sun and west of the moon.

 The Allegory of Love by C. S. Lewis, 1898–1963

LEFT: *With its curling tendrils and, mysterious shades of green, the Grape Cushion was inspired by a small margin detail on a medieval illuminated manuscript.*

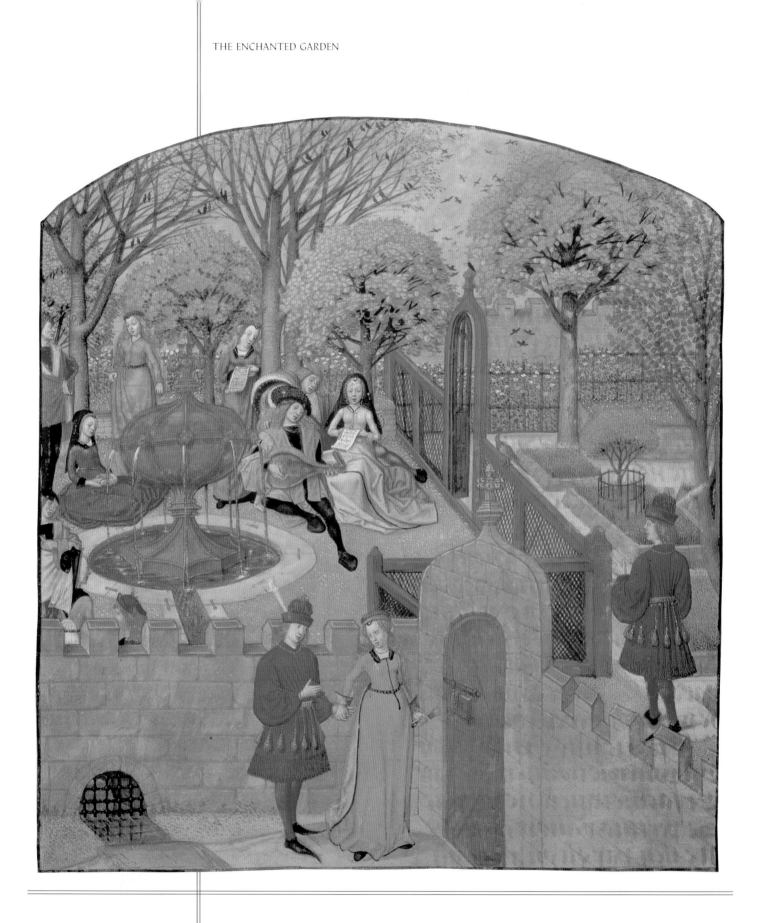

Every medieval poet and artist wished to describe the natural world – from the dramatic sky and its cataclysmic events to the gentle pastures and their passing seasons of beehives and haystacks, to the comparative tranquility of the garden. All the wonders of creation were executed in dazzling detail in illuminated manuscripts, tapestries, and paintings.

The Enclosed Garden

The enclosed garden was a place which perhaps best reflected the cultural climate and closed society of the medieval period, and, for me, is a well of inspiration. The medieval garden was divided into a series of "rooms." One room – known as the "potage" – contained vegetables and herbs for food and drink and another, a dispensary or physic garden, medicinal herbs.

Medieval plant remedies sound to us today akin to the practice of alchemy. Out of small and seemingly insignificant plants it was thought possible to achieve worthwhile remedies, just as with dross and base metals it was believed possible to produce gold. Here is a typical recipe for gout, which struck me as delightfully perverse:

The floures of May Lilies put into a glass and set in a hill of ants close stopped for the space of a month and then taken out, therein shall you find a liquor that appeaseth the paine and grief of the gout being outwardly applied.
Herbal by Gerard, 1597

I am fascinated by the creative and amusing-sounding use of medieval flora. Different plants could cure "worms in the belly" (plantain) or "chaps that are in the seat" (wallflower); "withdraw spots and pimples from the face" (primrose) or "cause the hair to grow in used-up places" (lily); they might make a good salad or be flavorful in a pudding (primrose, violet, and rose).

Sweet-faced periwinkles were often used for nosebleeds and were made into crowns or garlands for criminals who were to be executed on the gibbet. They were also described in a fourteenth-century manuscript as being able "to cure any discord between man and wife and bring them to unite and to love one another in any season." Such a mighty task for such a humble flower! And what a romantic needlepoint it would make with those words possibly inscribed on a ribbon winding around a nosegay of periwinkle flowers tied up with a bow of gold thread.

SURROUNDED BY ALLURING HEDGES, THE ENCLOSED GARDEN WAS A PLACE OF ETERNAL SUNSHINE AND FECUNDITY, AN ALLEGORY OF LOVE FULFILLED. "TRUE LOVE," THE COURT PROCLAIMED, "MUST BE FREE, IT MUST BE MUTUAL, IT MUST BE NOBLE." HERE, THE LOVERS STAND OUTSIDE THE GARDEN OF LOVE IN A SCENE FROM *LE ROMAN DE LA ROSE.*

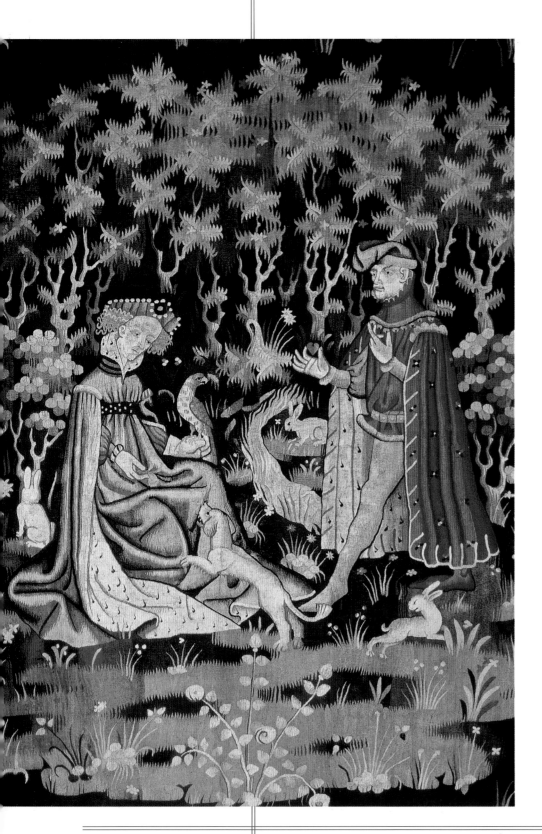

In the Middle Ages plants were also grown for magical purposes – to make potions, creams, and unguents that possessed magical properties, whether for good or evil. Different plants were held to have different powers and influences, and if burned or boiled could release certain forces from within nature into the world outside. Rue was the herb used to ward off witchcraft, and evil powers loosed on May Day could be contained by honeysuckle.

The Secret Garden

Finally, in the center of the medieval garden, came the "lovely place" or secret garden. This was a place reserved for the aristocracy, where – amid beautiful flowers, groves of fruit trees, and sweet-smelling herbs – they could mingle and engage in "affairs of the heart" and the rituals of courtly love.

In this Garden of Paradise or flowery mead, some of the traditional flowers and herbs grown were the rose and the marigold, borage, cowslip (where Shakespeare's Ariel always slept), campion, the daisy, the purple-flagged iris, hollyhocks, the Madonna lily, narcissi, lily-of-the-valley, sunflowers, the violet, the periwinkle, and strawberries – a walled *hortus conclusus*.

Here is Guillaume le Breton extolling such a place:

And I wish that all times were April and May and every month renew all fruits again and every day fleur-de-lis and gillyflower and violets and roses wherever one goes, and woods in leaf and meadows green, and every lover should have his lass, and they to love each other with a sure heart and true, and to everyone his pleasure and a gay heart.

"A Wish" appended to the *Vocabulary* of Guillaume le Breton, c. 1160–1225

The Game of Love

Heavily influenced by medieval Islamic verse, poets started to use the image of the secret garden as a symbol of perfection, conjuring up erotic love and the soul's longing for paradise. Artists portrayed perfumed trees heavy with boughs of gold fruit and blossom, and singing birds dipping their beaks into a central fountain. Around the walls are rose arbors and hanging vines. Elsewhere there are raised turf seats covered with fresh green grass, tiny clusters of flowers, and small, brown rabbits playing.

On a practical, everyday level, such a garden was a perfect area for safe exercise in an often dangerous world. Its vines, boughs, and arbors brought shade on a hot summer's day, while its shelter and color brought relief after a hard, cold winter. There was something to delight each of the five senses: the trickling water of the fountain for Hearing, strawberries and other fruits for Taste, herbs and flowers for Smell and Sight, soft deep grasses and thorny bushes for Touch.

Medieval poets saw this garden as a metaphor for one's conquest in the game of love and an embodiment of woman. Outside would run a deep, wide river. Trees would protect its great and almost impenetrable walls. Only one tiny door would lead to the intriguing secrecy of the enclosure. It could not be broken into with subterfuge or courtesy – in the end only true and selfless love, surrender even, to your true love's feminine powers, would allow you in.

You can imagine the lovelorn dreamer wandering on a May morning, aimlessly at first, beside the river of life. You can imagine him hearing the singing of the birds within the enclosed garden, and his repeated longing look at its high and fortified walls, wondering whether he is ever going to be able to scale them. The lover goes through trials and setbacks to win the lady's love, symbolized by the rose. And all the time he is doing this, he is finding out more about himself, more about his seemingly unattainable loved one. As C.S. Lewis writes:

A man does not need to go to the Middle Ages to discover that his mistress is many women as well as one. And that sometimes the woman he hoped to meet is replaced by a very different woman. The lover in the romance is concerned not with a single lady but with a number of moods or aspects of that lady which alternatively help or hinder his attempts to win her love – symbolized by the rose.

Garden Symbols

Besides being valued and prized for their aromatic, medicinal, and decorative qualities, flowers were also a major subject for all creative artists of the Middle Ages. I empathize with this, as I could spend the rest of my life being inspired by and interpreting the wonder of flowers, their lushness, and their variety of color and pattern.

In medieval woven tapestries more than one hundred different varieties of flora have been illustrated, and in the Unicorn tapestry alone,

THE MEDIEVAL TRADITION OF ROMANTIC LOVE WAS PRACTICALLY INSEPARABLE FROM THE WORSHIP OF THE VIRGIN. IN *THE OFFERING OF THE HEART (OPPOSITE)*, A LATE MEDIEVAL TAPESTRY, WE WITNESS NOT ONLY A CHIVALROUS GESTURE BUT A SYMBOLIC ACT OF ADORATION OF THE MADONNA.

THE TINY SCENE BELOW SUGGESTS THE WEALTH AND BOUNTY OF A MEDIEVAL HARVEST, LOVINGLY DETAILED WITH IMPOSSIBLY LARGE AND HEAVY GRAPES AND PLUMP SNAILS.

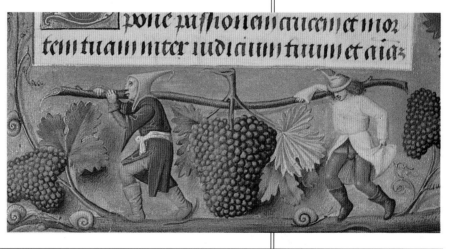

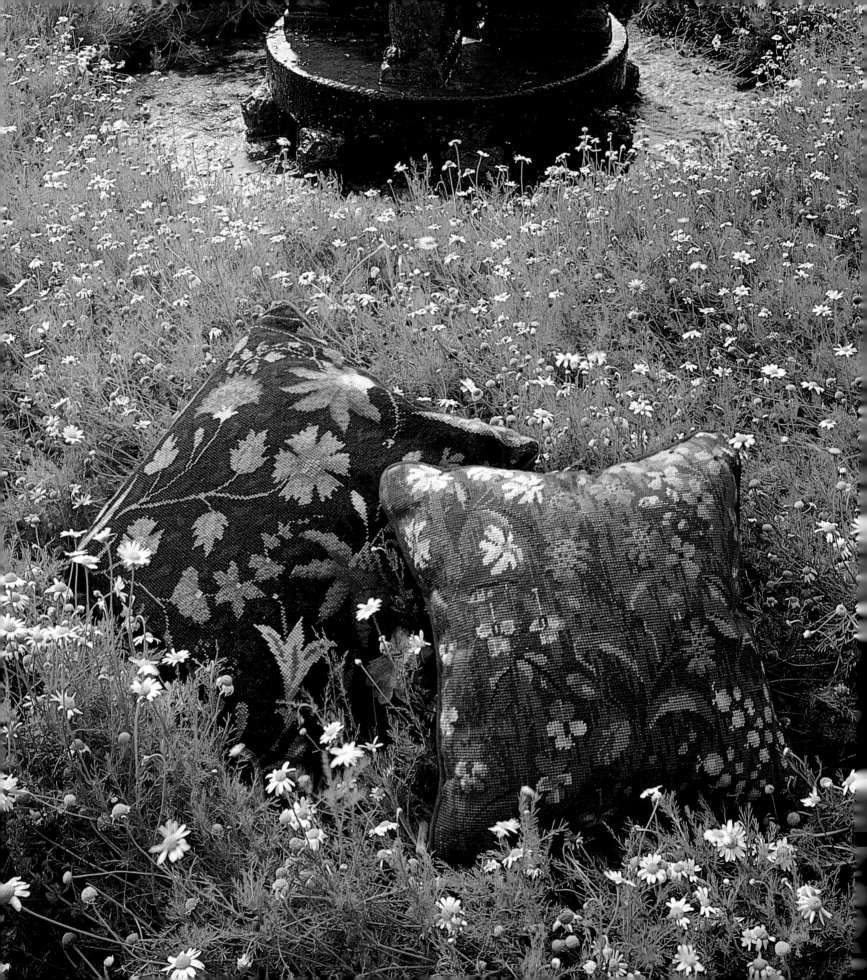

more than eighty-five can be specifically identified. *Millefleurs* ("a thousand flowers") tapestries suggest the custom of strewing the deep grassy ground with cut flowers and petals during festivals and feasts. What a heavenly sight that must have been!

Since pagan times flowers have represented rebirth and, in general, symbolized hope anew. Through the ages of folklore they have gained a popular symbolic significance in the language and art of joyous love and sensual pleasure. Just a few of the meanings given to flowers are:

Snowdrops for hope, violets for faithfulness, modesty, and humility, thyme for sweetness, sweet marjoram for grace, camomile for patience, lilies for purity, lily-of-the-valley for the return of happiness, daisies for innocence, bluebells for constancy, forget-me-nots for fidelity and remembrance, and primroses for earthly youth.

The rose was probably the most loved of all medieval flowers. Sacred to Venus, roses were used in antiquity in pagan rituals to celebrate and revere the female sexual organs. Early church fathers condemned them. However, in the fourth century St. Basil and St. Ambrose wrote that the lily, the violet, and the rose had grown in the Garden of Eden, but that since the Fall the rose had grown thorns and had become the symbol for the Virgin Mary.

LEFT: *Caprice and Anjou Cushions in a medieval herb garden, surrounded by some of the delicate summer flowers that influenced their designs.*

RIGHT: *The Medieval Flowers Rug is based on millefleurs tapestries and shows a variety of symbolic flowers including the pansy for thoughts of the beloved and the rose for earthly love, betrothal, marriage, and the lady's love.*

There's rosemary, that's for remembrance; pray, love, remember: and there is pansies, that's for thoughts There's fennel for you, and columbines, there's rue for you; and here's some for me.

Hamlet, Act 4, Scene 5

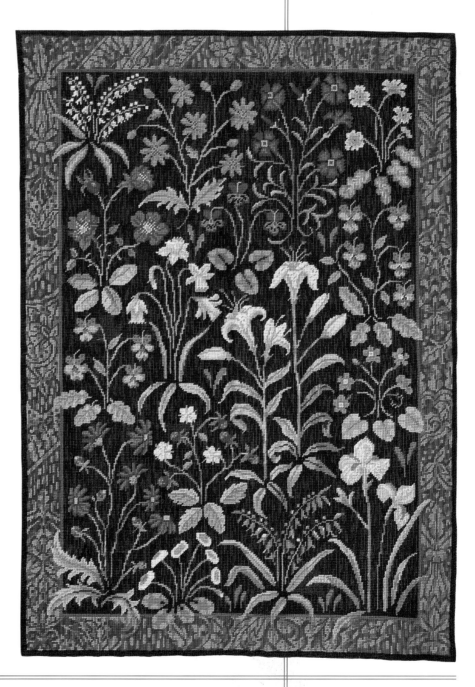

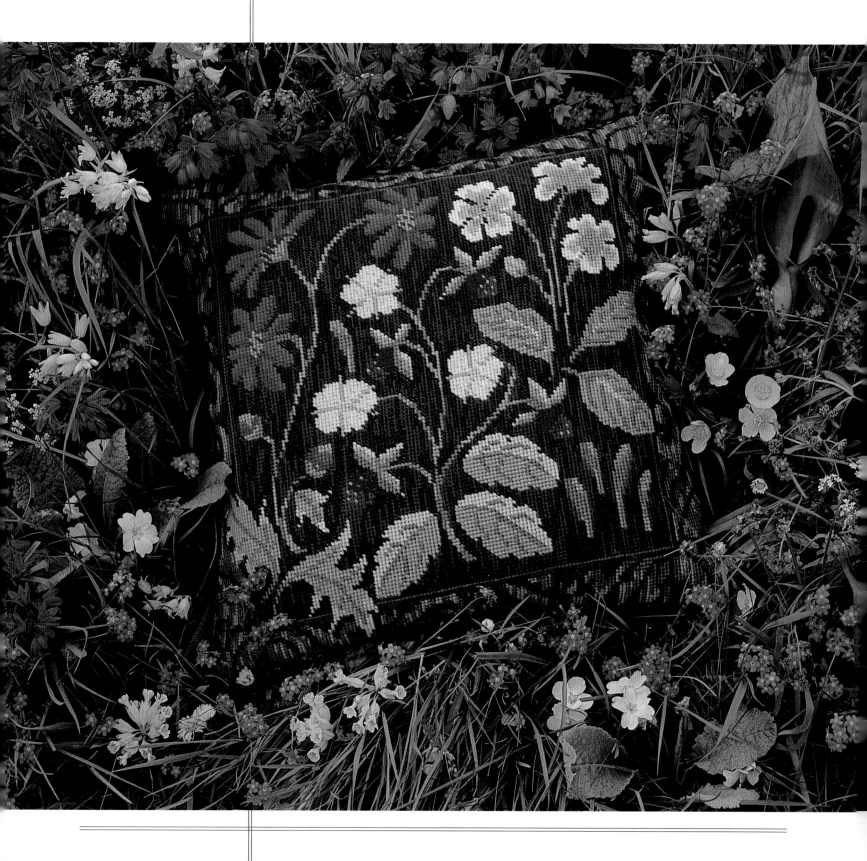

THE MAYTIME CUSHION

The Maytime cushion was one of the two flowery cushions I designed to accompany my Medieval Flowers Rug. The other cushion is called Meadow Garden and features the marigold, pansy, and maiden pink.

The sumptuous border on Maytime was inspired by the lady's richly patterned brocade gown in the Lady and the Unicorn tapestry. I loved playing with the two tones of gold and the two tones of rose to re-create the subtle undulating tones of the folded dress.

The cushion background is also inspired by the Lady and the Unicorn with its dark blue-green island on which tufts of flowers are growing. In order to achieve a soft, aged look I merged indigo and viridian into each other in a random manner.

The flowers displayed in the design are strawberry, primrose, and field daisy. A symbol for fertility, the strawberry was found in hedgerows and woodlands and was celebrated for its succulent taste. Strawberry tarts were said to have been very popular in medieval times! They have also been called the food for the blessed, as the Virgin Mary is said to have had a great fondness for the fruit, and the leaves were meant to symbolize the Trinity. The strawberry leaves and berries were used to cool inflamed wounds and gums, and "the distilled water [of strawberries] takes away spots and makes the face faire and

LEFT: My Maytime Cushion captures both the essence of an illuminated margin and the beauty of millefleurs tapestries – a deep green ground covered with cowslips, buttercups, bluebells, and forget-me-nots.

smooth, and drunk with white wine it is good against the passion of the heart, reviving the spirits."

I have used the not-unusual medieval practice of displaying both the berries and the blossoms of the strawberry in a single design. It is much more decorative and shows the plant in all its splendor, although of course it is completely unnaturalistic.

For these same reasons, artists in the Middle Ages often showed flowers that bloom in different seasons together in the same landscape.

Often referred to as "St. Peter's keys" or "heaven's keys," the creamy yellow primrose is also one of the Virgin Mary's flowers, especially since its buttery bloom is one of the first of spring. The water of distilled primrose was supposed to be a remedy against "mad dogs and venemous beasts and good for woman that beareth child."

My bright sky-blue daisy can be seen quite clearly next to the Lady's head in the Sight tapestry of the Lady and the Unicorn series. I think its pretty brightness lifts the whole design. This daisy was also associated with love, the

Virgin Mary, Venus, and "good women" – I must be in there somewhere! In Germany it was a measure of one's love; so possibly in those early days, too, maidens would pluck the petals one by one repeating the old refrain "He loves me, he loves me not."

MAKING THE MAYTIME CUSHION

Needlepoint Yarns and Materials

- Tapestry/Persian yarn in 19 colors
- 10-mesh écru double-thread canvas 22" (56cm) square
- Size 18 tapestry needle
- ³/₄yd (70cm) furnishing fabric for backing and cording
- 2yd (1.8m) filler cord or furnishing cord
- 13" (33cm) zipper
- Pillow form 16" (40cm) square

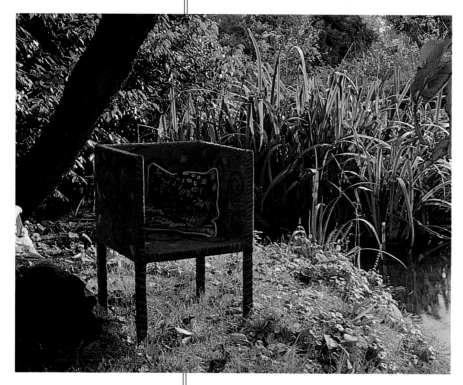

Finished cushion: 16" (40cm) square

Working the Needlepoint

The chart is 160 stitches wide and 160 stitches high. Mark the outline on the canvas, and, if you like, stretch the canvas onto a frame. See page 116 for technical tips and stitch instructions. Using a single strand of tapestry yarn, or two of Persian yarn, work the needlepoint in tent stitch. When the needlepoint is complete, block the canvas and sew on the backing and cording (or furnishing cord) as instructed on page 120.

Color Key

This project was made in Appletons' yarn, but you could use Paternayan or the other brands listed on page 124. The alternatives will give a slightly different effect from that shown in the picture.

Ap 209 (Pa 870) – dark brick	5 skeins	
Ap 225 (Pa 931) – medium rose	4 skeins	
Ap 947 (Pa 902) – rose pink	1 skein	
Ap 755 (Pa 932) – light rose	1 skein	
Ap 142 (Pa 924) – pale pink	1 skein	
Ap 994 (Pa 851) – orange	1 skein	
Ap 903 (Pa 740) – golden brown	6 skeins	
Ap 694 (Pa 733) – light gold	4 skeins	
Ap 472 (Pa 734) – light yellow	1 skein	
Ap 851 (Pa 745) – pale yellow	1 skein	
Ap 841 (Pa 715) – pale gold	1 skein	
Ap 882 (Pa 756) – off white	1 skein	
Ap 954 (Pa 641) – fawn	1 skein	
Ap 292 (Pa 602) – gray-green	2 skeins	
Ap 401 (Pa 604) – light green	3 skeins	
Ap 158 (Pa 531) – dark blue	6 skeins	
Ap 157 (Pa 532) – medium blue	5 skeins	
Ap 821 (Pa 542) – royal blue	1 skein	
Ap 743 (Pa 562) – light blue	1 skein	

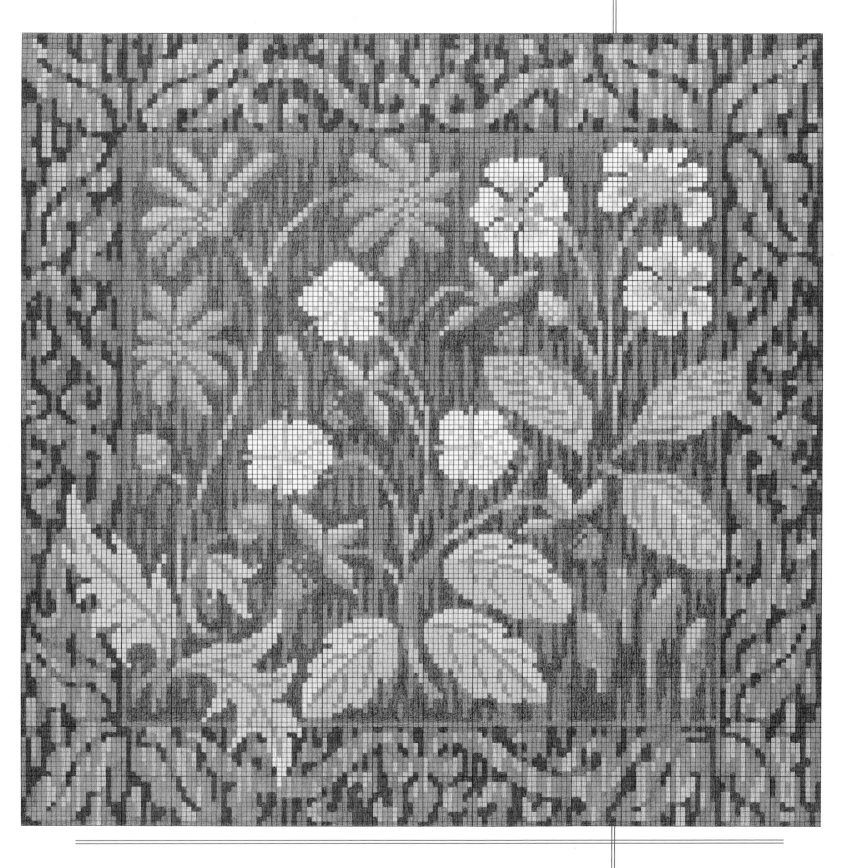

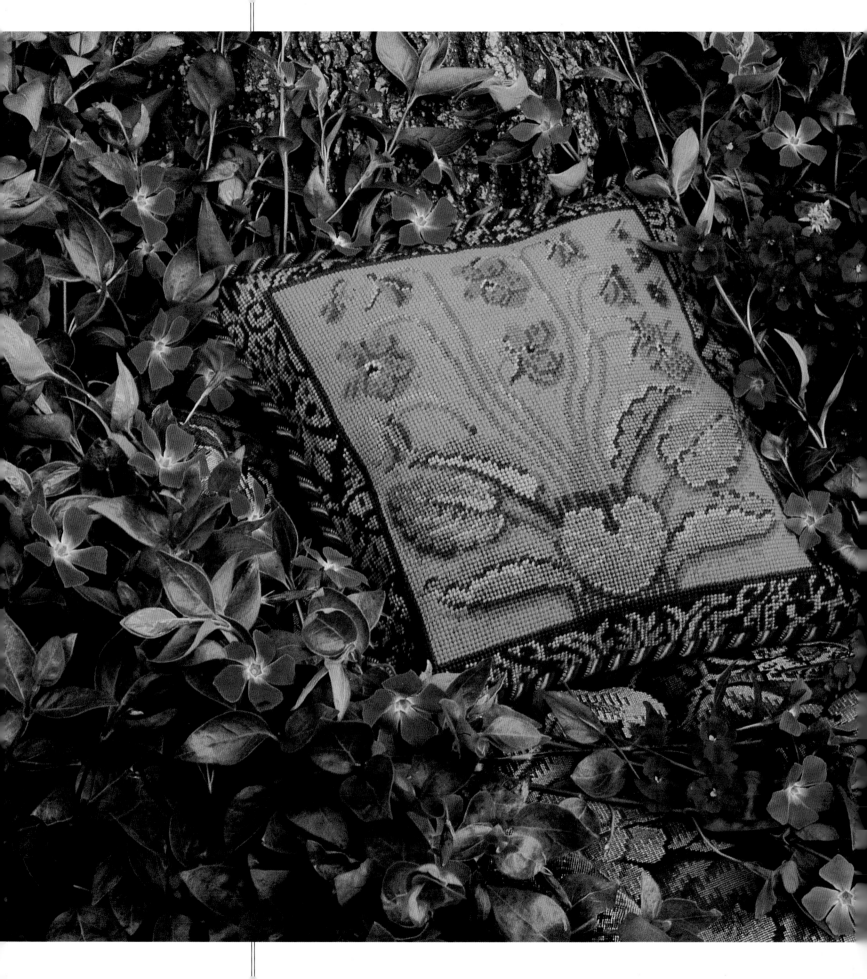

THE SWEET VIOLET CUSHION

Sweet violets can be seen scattered among the other flowers and grasses in most medieval tapestries and paintings. Although the fragile charm and aroma of flowers made them delightful objects in themselves, they were also a reflection and manifestation of the divine. Because it could be both dangerous and mysterious, all of Nature was held in awe. Possibly, by capturing it in illuminated manuscripts, the artist believed he was taming its wild power.

Along with the rose and lily, the dainty violet was associated with the Virgin Mary, as well as with the virtues of humility and faithfulness, and so was a favorite flower used to symbolize both sacred and profane love in poems and art. My theme of violets for this needlepoint was directly inspired by a sixteenth-century French Book of Hours. Whereas the Flemish artists usually portrayed single flower heads or small sprays in an astonishingly realistic way in their borders, the French were inclined to paint whole plants. I marvel at such exquisite paintings and can almost feel the soul of these artists shining out when I look into this world of mesmerizing perfection!

The humble violets in my source were so lovely that I wanted to change very little for my design.

LEFT: Sweet Violet Cushion – a simple yet vibrant design capturing the quiet fullness of nature.

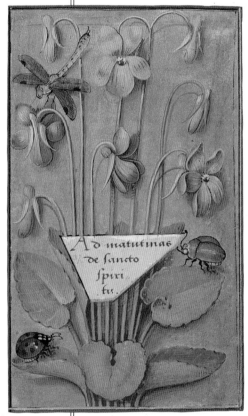

I DREW DIRECTLY FROM THIS BREATHTAKING ILLUMINATED DETAIL FOR MY SWEET VIOLET CUSHION, FROM A FLEMISH BOOK OF HOURS PAINTED ON VELLUM, c.1500. THE VIOLET IS ONE OF THE ILLUMINATIONS THAT ARE INTERLEAVED BETWEEN EVERY SEQUENCE OF PRAYERS.

I transferred them almost directly, and it was comparatively easy to interpret the defined leaves and single flowers that were so beautifully and lovingly observed from different angles. The deep golden background of my Violet needlepoint cushion gives a strong glow and intensity which perfectly sets off the fresh, light shades of violet and mauve flowers. The saturated richness of the golden color is slightly broken up by the deeper shading and a few dots soften the image.

To frame this typically medieval illusionistic (three-dimensional) design, I used a pattern from the background of a painting of St. Jerome by Carlo Crivelli (*Madonna of the Swallow*) as a starting point for my border. I changed the colors to echo the greens of the leaves and introduced more of the maroon from the eye of the violet and some rust to add depth and richness. It looks intricate, but the three shades of green blend to give that appealing, faded tone I adore. Altogether the rather clear, uncluttered feel of this cushion captures perfectly a formal, yet warm and cheerful mood that would gladden any heart.

MAKING THE VIOLET CUSHION

Needlepoint Yarns and Materials
- Tapestry/Persian yarn in 14 colors
- 10-mesh écru double-thread canvas 21″ (53cm) square
- Size 18 tapestry needle
- ³/₄yd (70cm) furnishing fabric for backing and cording
- 2yd (1.8m) filler cord or furnishing cord

OVERLEAF: (From left to right) *Maytime, Bruges and Meadow Garden Cushions in a meadow, nestling in deep green grasses, cow parsley, and hawthorn.*

- 4 tassels
- 12″ (30cm) zipper
- Pillow form 14 × 15″ (35 × 38cm)

Finished cushion: 14 × 15″ (35 × 38cm)

Working the Needlepoint
The chart is 140 stitches wide and 150 stitches high. Mark the outline on the canvas, and, if you like, stretch the canvas onto a frame. See page 116 for technical tips and stitch instructions. Using a single strand of tapestry yarn, or two of Persian yarn, work the needlepoint in tent stitch, working the background last. When the needlepoint is complete, block the canvas and sew on the backing, cording (or furnishing cord), and tassels as instructed on page 120.

Color Key
This project was made in Appletons' yarn, but you could use Paternayan or the other brands listed on page 124. The alternatives will give a slightly different effect from that shown in the picture.

		
■	Ap 759 (Pa 900) – dark maroon	4 skeins
■	Ap 208 (Pa 870) – brick red	2 skeins
■	Ap 914 (Pa 440) – dark fawn	1 skein
■	Ap 696 (Pa 731) – dark gold	2 skeins
▦	Ap 695 (Pa 732) – gold	6 skeins
☐	Ap 984 (Pa 645) – light beige	1 skein
■	Ap 646 (Pa 650) – dark green	2 skeins
■	Ap 832 (Pa 662) – sea green	3 skeins
▦	Ap 355 (Pa 602) – dark gray-green	3 skeins
▦	Ap 402 (Pa 612) – medium green	4 skeins
☐	Ap 342 (Pa 643) – light drab olive	2 skeins
■	Ap 895 (Pa 340) – dark violet	1 skein
▦	Ap 102 (Pa 312) – light purple	1 skein
▦	Ap 893 (Pa 343) – light violet	1 skein

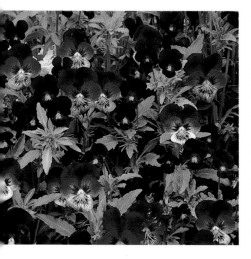

D ETAIL OF VIOLAS – BESIDES THEIR BEAUTY, FLOWERS ALSO HAD SYMBOLIC USE IN THEIR ROLE OF ESTABLISHING, MAINTAINING, AND ENDING RELATIONSHIPS.

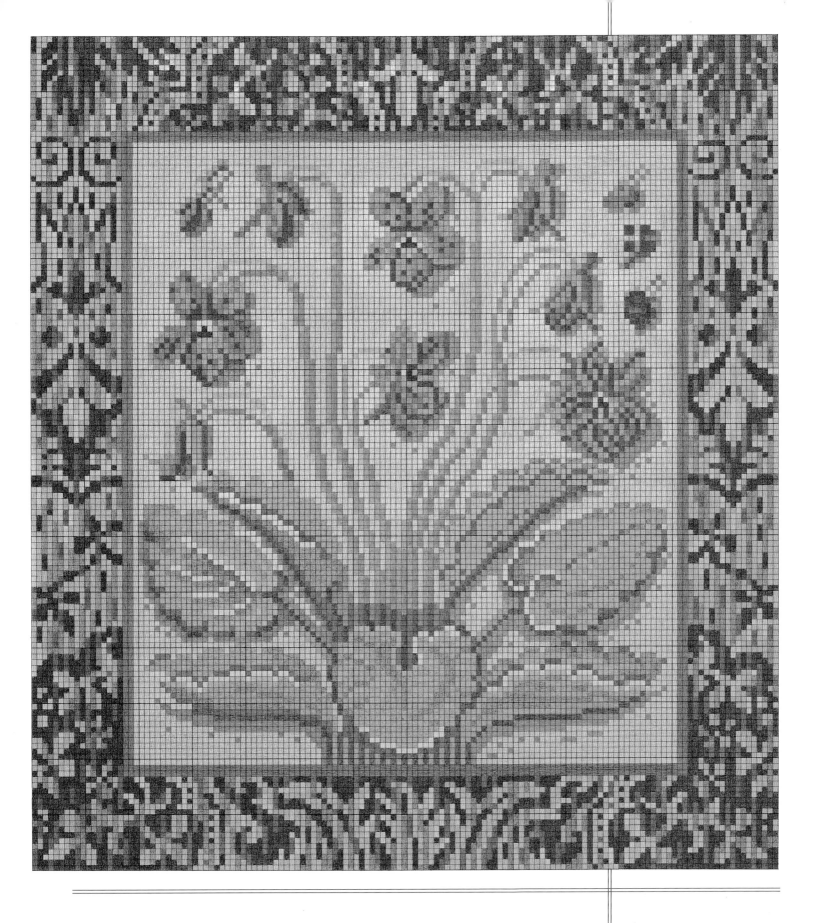

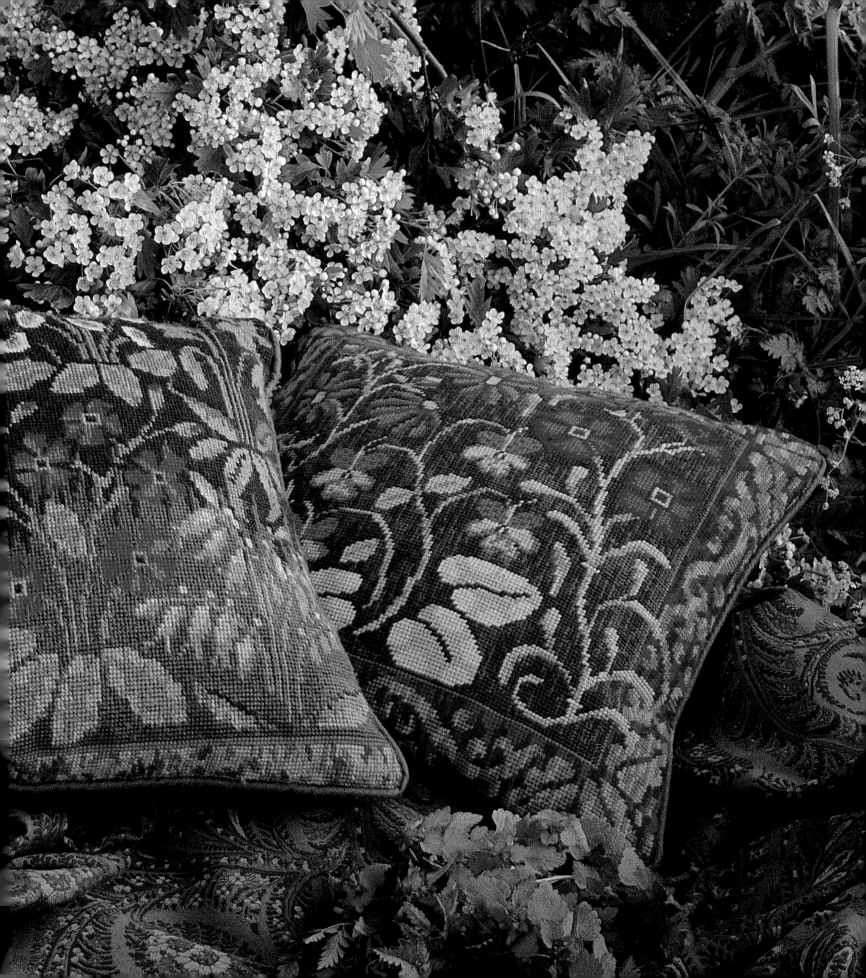

THE ORANGE BLOSSOM CUSHION

And in the midst a springhead and fair well
 With thousand conduits branched and shining speed,
 Wounding the garden and the tender mead,
Yet to the freshened grass acceptable.
And lemons, citrons, dates, and oranges,
 And all the fruits, whose savour is most rare,
Shall shine within the shadow of your trees;
 And every one shall be a lover there;
Until your life, so filled with courtesies,
 Throughout the world be counted debonair.

June by Folgore da San Geminiano, 13th Century

The Lady and the Unicorn tapestry series has probably stimulated my imagination more than any other piece of medieval art. As a source of design material it is seemingly endless – the flowering branches and tufts floating in a sea of harmonic colors; the appealing and softly colored forest animals; the patterns on the tent, banners, baskets, organ cloth, bejeweled gown, and headdress of the Lady; the flowing manes and tails of the lion and the unicorn; and the highly stylized oak, pine, holly, and flowering orange trees.

What captivated me when looking at the orange tree in the tapestry depicting Taste were the dark outer leaves of the tree contrasting boldly against the slightly faded red ground and the bright, star-shaped, white blossoms nestling into and adorning the soft apricot and green

RIGHT: The Orange Blossom Cushion, with its sumptuous soft-colored leaves and bright white blossom, contrasting with dark outer leaves and a deep rose background.

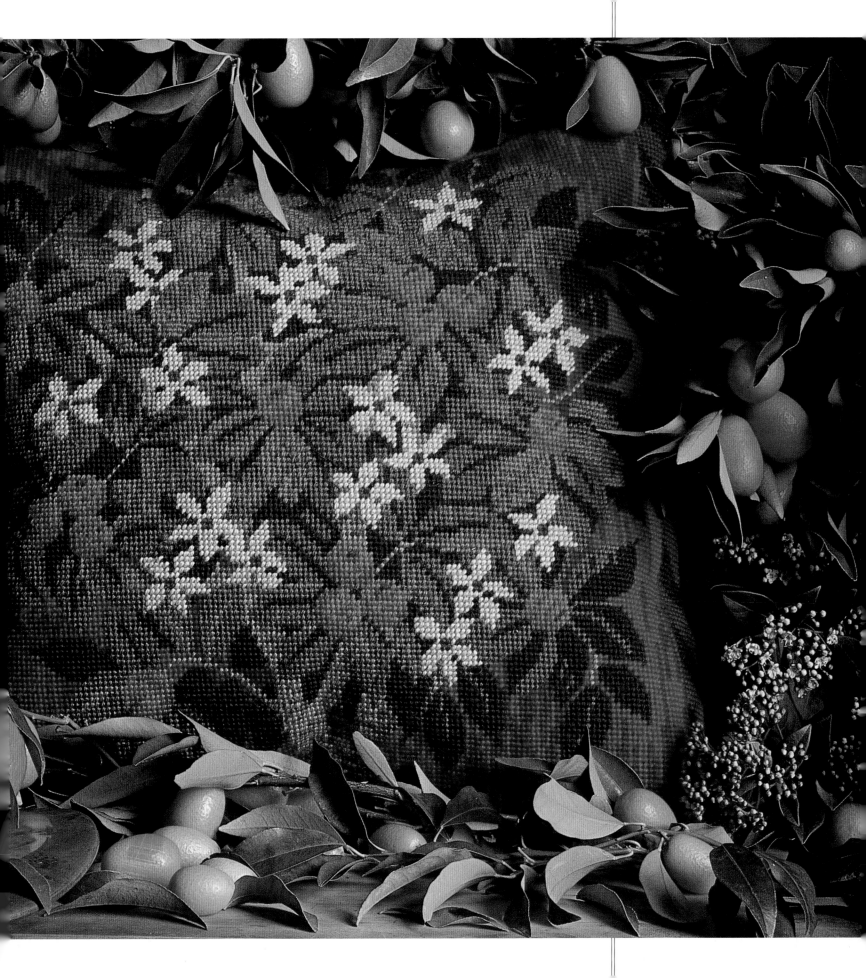

center of fruit and leaves. This seductive blossom and heavy fruit, evoking the perfumed magic of Moorish nights, proved an irresistible subject for my needlepoint.

In translating the design onto canvas, I was determined to preserve the abundance of the fruit and the sculpted roundness of the tree, with its brilliant and intoxicating blossom.

For the background I have employed my usual technique of drifting two colors into each other to add interest, depth, and movement, to mottle both hues, and to create an illusion of age.

The tree needed only the most restrained of borders, so I chose this heraldic diagonal design, which I like to think suggests a garden enclosure around the lushness within.

MAKING THE ORANGE BLOSSOM CUSHION

Needlepoint Yarns and Materials

- Tapestry/Persian yarn in 11 colors

A BORDER OF CURLING GOLDEN LEAVES AND SWEET FLOWERS – ANOTHER MEDIEVAL CELEBRATION OF WONDERFUL COLOR!

- 10-mesh écru double-thread canvas 23″ (60cm) square
- Size 18 tapestry needle
- ³/₄yd (70cm) furnishing fabric for backing and cording
- 2¹/₄yd (2m) filler cord or furnishing cord
- 14″ (36cm) zipper
- Pillow form 17″ (43cm) square

Working the Needlepoint

The chart is 170 stitches wide and 170 stitches high. Mark the outline on the canvas, and, if you like, stretch the canvas onto a frame. See page 116 for technical tips and stitch instructions. Using a single strand of tapestry yarn, or two of Persian yarn, work the needlepoint in tent stitch, working the background last. When the needlepoint is complete, block the canvas and sew on the backing and cording (or furnishing cord) as instructed on page 120.

Color Key

This project was made in Appletons' yarn, but you could use Paternayan or the other brands listed on page 124. The alternatives will give a slightly different effect from that shown in the picture.

Ap 207 (Pa 870) – brick red	6 skeins	
Ap 224 (Pa 930) – rose	5 skeins	
Ap 765 (Pa 495) – biscuit brown	1 skein	
Ap 695 (Pa 732) – gold	1 skein	
Ap 841 (Pa 715) – pale gold	3 skeins	
Ap 315 (Pa 641) – olive brown	5 skeins	
Ap 333 (Pa 643) – light dusty olive	1 skein	
Ap 158 (Pa 531) – dark green-blue	12 skeins	
Ap 643 (Pa 602) – gray-green	6 skeins	
Ap 973 (Pa 451) – gray-brown	1 skein	
Ap 951 (Pa 454) – pale fawn	1 skein	

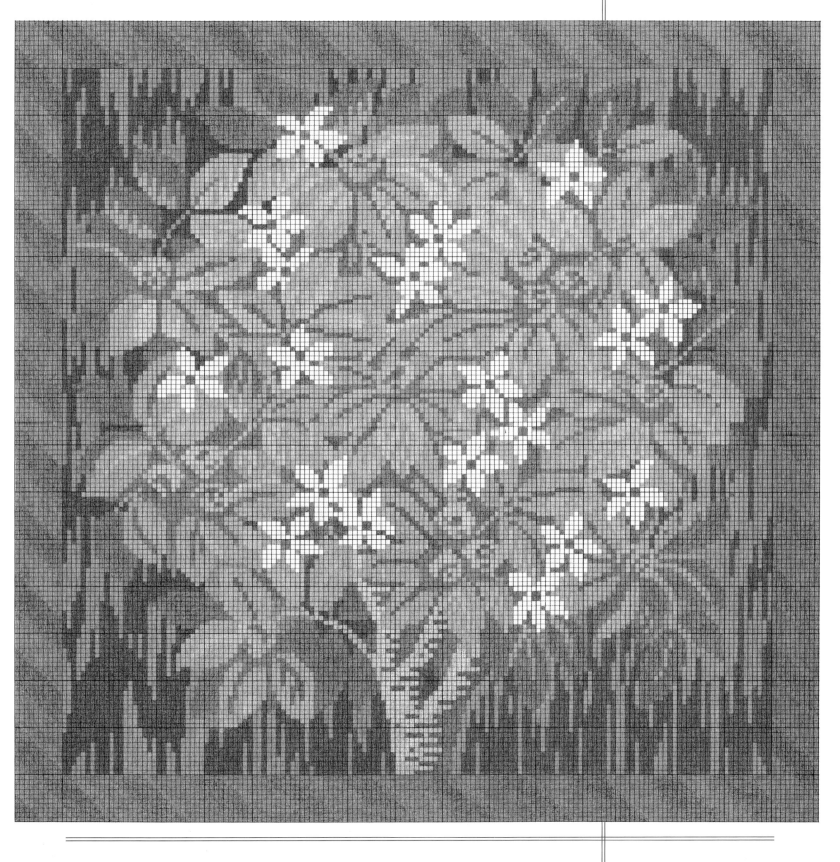

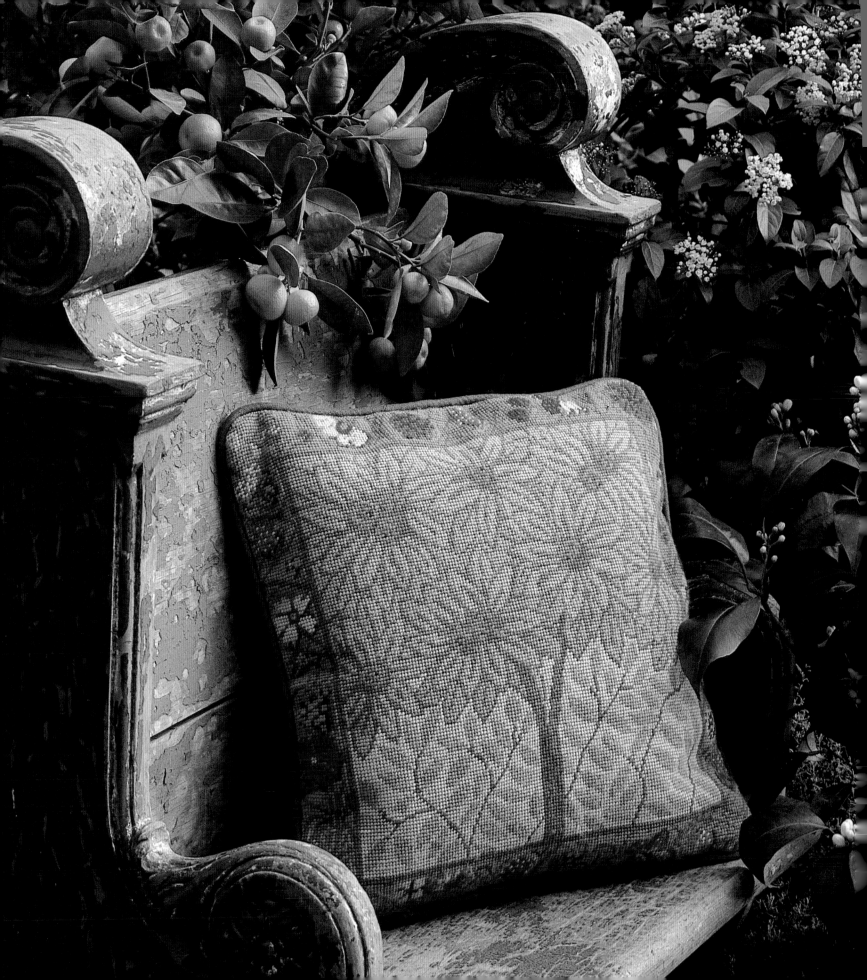

THE ORANGE TREE CUSHION

The orange tree attracted medieval painters and tapestry weavers not only because of its beautiful fruit but also because of its exoticism and symbolic significance. Several tapestries and paintings of the period depicting allegorical scenes feature orange groves as symbols of fertility. The citrus fruit was also thought to

OPPOSITE: I can easily imagine resting on this seat with the Orange Tree Cushion, in a light airy conservatory.

alleviate symptoms of morning sickness when taken by pregnant women.

Browsing through books of medieval masterpieces, I came upon a quite splendid fourteenth-century fresco of the *Dream of Life* by Orcagna. It depicts a most exquisite utopian earthly paradise – women resting under a grove of orange trees playing and speaking softly to each other and their falcons, hawk, and lap dog, while minstrels play sweet music. I was especially drawn to the delicate shades of green and the decorative quality of the golden fruit depicted in the painting.

Borders are a very important element in design, holding, binding, finishing, and enriching a

THE ORANGE TREE CUSHION WAS INSPIRED BY *THE DREAM OF LIFE* BY ORCAGNA, A MEDIEVAL FRESCO THAT FASCINATES ME WITH ITS DELICACY OF PATTERN, SUBLIMITY OF HUE, AND ALLEGORICAL RICHES.

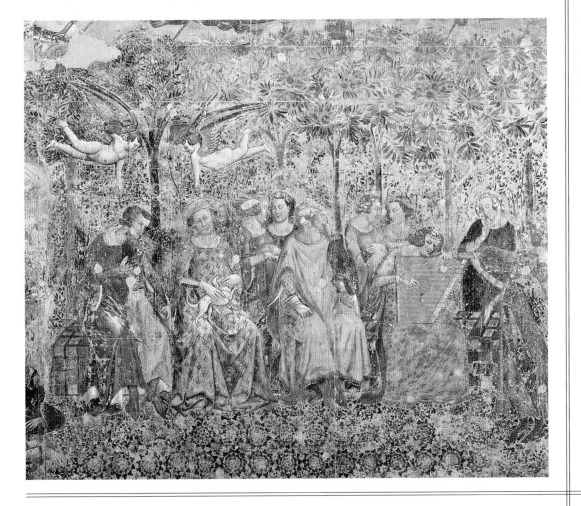

composition. The medieval illuminators were masters at creating lively borders of flowers and swirls to frame their words and worlds. The whole *mélange* of medieval ornament – embroidery, tiles, stained glass, and the geometrics and diapers of heraldry – can be used as starting points when designing a border. The simplest, smallest bit of reference can be repeated and extended around the edge of your composition. Sometimes I soften the edge, by letting some of the main design flow into the border, as the Maytime cushion. Borders frame a composition by either uniting or continuing the feeling within, or setting off the main picture with an opposing mood.

I decided that this tranquil and soothing needlepoint design could take an elaborate border of trellis, with strawberries, snails, butterflies, and flowers connected to the twig-like divisions. The use of brilliant colors and a three-dimensional effect in the border make an effective contrast with the delicate and serene design it surrounds.

My inspiration for the border was a conglomeration of illusionistic borders on medieval manuscripts which are strewn with naturalistic items. Some of these margins contain more than three hundred plants, all rendered with care and skill and of such exceptional delicacy that one feels one could pick them fresh from the page.

MAKING THE ORANGE TREE CUSHION

Needlepoint Yarns and Materials
- Tapestry/Persian yarn in 13 colors

LEFT: An exquisite trellis border enclosing a profusion of daisies and strawberries within its leafy joints – a veritable medieval garden in miniature.

- 10-mesh écru double-thread canvas 23" (60cm) square
- Size 18 tapestry needle
- ⁵/₈yd (50cm) furnishing fabric for backing and cording
- 2¹/₄yd (2m) filler cord or furnishing cord
- 14" (36cm) zipper
- Pillow form 17" (43cm) square

Working the Needlepoint
The chart is 170 stitches wide and 170 stitches high. Mark the outline on the canvas, and, if you like, stretch the canvas onto a frame. See page 116 for technical tips and stitch instructions. Using a single strand of tapestry yarn, or two of Persian yarn, work the needlepoint in tent stitch, working the background last. When the needlepoint is complete, block the canvas and sew on the backing and cording (or furnishing cord) as instructed on page 120.

Color Key
This project was made in Appletons' yarn, but you could use Paternayan or the other brands listed on page 124. The alternatives will give a slightly different effect from that shown in the picture.

	Color	Amount
■	Ap 865 (Pa 831) – coral	1 skein
▨	Ap 755 (Pa 932) – light rose	1 skein
■	Ap 914 (Pa 440) – dark fawn	1 skein
▨	Ap 696 (Pa 731) – dark gold	3 skeins
▨	Ap 695 (Pa 732) – gold	6 skeins
☐	Ap 692 (Pa 735) – pale gold	1 skein
▨	Ap 643 (Pa 602) – dark gray-green	7 skeins
▨	Ap 293 (Pa 603) – dusty green	4 skeins
▨	Ap 543 (Pa 693) – light green	6 skeins
▨	Ap 401 (Pa 604) – pale green	4 skeins
▨	Ap 351 (Pa 605) – pastel green	4 skeins
■	Ap 747 (Pa 540) – dark blue	1 skein
▨	Ap 821 (Pa 542) – royal blue	1 skein

SYMBOLS AND PATTERNS

To-morow ye shall on hunting fare,
And ride, my doughter, in a chare;
It shall be covered with velvet red,
And clothes of fine gold al about your hed,
With damask white and asure-blewe,
Wel diapred with lillies newe;

Diversions for an Unhappy Princess, Anon, 15th Century

I feel very strongly that our contemporary world of art and design is deprived of the powerful meanings and mythologies which ancient people instinctively integrated into their work. In the pre-literate, largely visual world, paintings and artifacts carried vital and rich layers of symbolism that now no longer resonate for us. We have lost the sense of awe and conviction of the divine, which was the essence of a vanished, Nature-embracing era. We are remote from and starved of the beliefs of this bygone time.

As artists we have a responsibility to conceive confidently and energetically new and

significant worlds for today. But even while creating for today, we should never lose sight of the past. In order to understand what we are in the present day, we have to explore what we once were. Throughout history, artists have borrowed from ancient civilizations, making them a starting point for their own inventive gestures. If one is alive and open to everything, one has the privilege of moving forward without ever having to leave anything behind. All the worlds we have traveled in, even in our minds, through dreams, books, or music, have left traces of their own. These shards of memory and time are the building blocks for our artistic endeavors.

LEFT: The Mosaic Cushion, inspired by medieval and Moorish pattern. "Mosaic" comes from the Arab word meaning "decorated." This is one of my favorite cushions with its soft tones of custard yellow, apricot, grays, creams, and blues.

F OLIO FROM *THE POWELL ROLL OF ARMS*, A RECORD OF THE HERALDIC DEVICES USED DURING THE REIGN OF EDWARD II. THESE ANCIENT, BOLD HERALDIC EMBLEMS ARE COMPELLING IMAGES FOR AN ARTIST.

Symbols of Ancient Times

Since prehistoric times, artisans have used symbols to represent concepts, transforming them into "poetry to delight the eye." They have developed visual alphabets which simultaneously and poetically express the metaphysical, the subconscious, and the mundane. An example of this can be seen in the work of so-called "primitive" people who painted symbols of hunted animals on cave walls to gain power over those animals in the hunt. Also, many different peoples throughout the ages have painted and decorated themselves in the most fantastic, colorful, and imaginative ways to give themselves magical powers over others, to protect themselves against evil forces, and to express a variety of emotions.

Personally, my favorite artifacts of lost societies are the remarkable designs of the native North American peoples and the hieroglyphic signs of ancient Egypt. I love totem poles, Navajo rugs, and kachina dolls, all carrying legendary memories of their own and their ancestors' achievements, experiences, and triumphs. The spirits of the sun, rain, thunder, earth, and animals were creatively represented and celebrated.

As for Egyptian hieroglyphics, I find their expressive linear quality quite beautiful. There is a certainty, a confidence that gives them a wonderfully rhythmic and sensuous quality. They are an illustrated encyclopedia of a magnificent and highly evolved culture.

All such "primitive" arts have the fascinating quality of a child's work despite their sophistication. Their figures and symbols rely on the sparest, simplest of motifs, but at the same time contain great complexity. All through history such artifacts and symbols have imparted information and emotion, expressed people's spiritual feelings, and described their sense of personal power and prestige within the world.

Medieval Heraldry

It could be said that medieval heraldry is an extension of the simple graphic imagery of ancient and primitive civilizations. Heraldic devices were invented in the Middle Ages and became an important element in all medieval ornament. Although symbolism flourished in all secular and religious art and literature during the period, it is most prominent in heraldry. Time-honored symbols were organized into a specific system which was used to denote hierarchy and heredity and to enhance feelings of tradition and prestige.

The heraldic artists placed their skillfully designed symbols or messages on shields, horse trappings, banners, flags, crowns, helmets, robes, walls, windows, sails of ships, plates, and vessels. This was an ideal way to convey direct and immediate messages – often expressions of the king's and the nobility's power and wealth.

Before heraldry, armor made friend and foe indistinguishable in battle or tournament. With the advent of heraldry, knights became easily recognizable to their fellow warriors and enemies. In the beginning, because these "signs" had to be seen from a distance and possibly at speed, by knights with sweat and dust in their eyes, they were made up of pure, bold, geometric design – simple strips, blocks, chevrons, and heraldic beasts in startlingly contrasting patches of color.

De la maniere et ordonnance de la grant feste et Joustes que le noble Roy

They were symbolic rather than realistic – visually powerful, direct, accessible, and highly decorative.

The iconography was capable of carrying layers of meaning. A "fess" or plain horizontal band across a plain ground was the most common geometric shape. If the coat-of-arms appeared diagonally on the band, it often suggested the bearer's bastardy. An upside-down V on a shield implied some deviation from the norm. Sharp points indicated danger. Battle shields could also denote the position of the son in the family hierarchy: a crescent moon was worn by the second son; a fleur-de-lys by the sixth, and a rose by the seventh.

Heraldic symbols were of central importance for tournaments and pageants which were held to rally and inspire troops. The colorful banners and inscriptions carried stirring messages and images

MEDIEVAL TOURNAMENTS WERE EXUBERANT FESTIVE DIVERSIONS, PAGEANTS OF POWER AND MAGNIFICENCE, WHERE KNIGHTS DISPLAYED THEIR COURAGE AND STRENGTH IN ORDER TO WIN HONOR, RESPECT, AND MOST IMPORTANTLY, THEIR LADY'S LOVE.

F RAGMENTS OF POTTERY FROM A 14TH-CENTURY PRIORY – SHARDS OF MEDIEVAL LIFE.

A SPLENDIDLY ATTIRED HORSEMAN AND HIS LADY, ROMANTICALLY CAPTURED IN THE DEVONSHIRE HUNTING TAPESTRY (OPPOSITE).

to spur the participants on and to cheer the hearts of the onlookers. Medieval people seem to have had a voracious appetite for these exuberant and flamboyant, conspicuously passionate displays. Emotive values were attached to particular colors: red for love, blue for fidelity, green for hope and freedom, purple for majesty, yellow for understanding, white for innocence, wisdom, and joy.

Special heralds or messengers were needed to supervise tournaments and identify opponents in war and at court. The heraldic device of a coat-of-arms was a man's unique property and had great symbolic and social importance. Since literacy was far from universal, a colorful and vivid coat of arms proclaimed immediately the power and majesty of the nobility.

Heraldic Symbols

The grammar of heraldry began in the first half of the feudal twelfth century and developed its

characteristic picture-language for the next two centuries. Many now think the thirteenth and fourteenth centuries were unsurpassed in craftsmanship.

The symbols available for medieval artists were plentiful and wonderfully suited to ornament. Bees stood for the poorer classes; the cross represented Christendom in the West; the raven was a symbol of death on the battlefield; the deer was for swiftness in the chase; and the lily and the eagle were marks of royalty. The wild boar represented fierceness, the greyhound wind, and the pelican parental love. The mythical griffin (half eagle, half lion) stood paradoxically for both luxury and restraint. Two other mythical creatures, the Harpy (with a vulture's body and the head and bust of a woman) and the Centaur (half man, half horse), both connected man and earth, humanity with its passions, and the yoking together of the physical and the spiritual.

Stars, planets, sun, and moon appeared in heraldry both as simple decoration and as objects of great spiritual and worldly power. Even before medieval times, men had understood that there are vast natural forces loose in the world and within their own psyches. Because they considered creation to be a single, integrated whole, they naturally looked up in awe to the heavens, seeing it as an astrological map of those variously creative and destructive powers.

Before people could write, they knew the phases of the moon, which were the basis of their calendar and which were frequently associated with mysterious influences on human lives. The moon not only adorned the heavens but also was seen as the celestial gardener. In the agricultural calendar, sowing and growing were associated with the rising of the moon, ripeness with its fullness, and gathering and picking with its wane.

A potent symbol, the moon is still a recurrent visual theme today.

Patterns of the Middle Ages

It is no surprise that with such an all-encompassing interest in pattern I would find in medieval decorative arts a treasure trove of visual delights. Illuminated manuscripts immediately spring to mind with the mention of medieval pattern. "Diapers" were one of the main forms of ornament. These are small repeated patterns which enliven a flat surface. They consist of foliated ornament, which is either stylized and abstracted representations of flora, or circles, lozenges, zigzags, and other geometrics.

The tapestries of the Middle Ages abound with tantalizing pattern. I regularly pay homage to the Devonshire hunting tapestries at the Victoria and Albert Museum in London, which are an excellent example of this. Monumental backdrops, they have unique vigor and complexity accomplished with the use of only two or three subtle tones in each of green, yellow, blue, red, and brown. A plain field of color is rarely found. These tapestries are a feast of entrancing pattern next to enchanting pattern: the heavy drapery of a brocade gown next to a man's sleeve showered with dots, beside a cape of raindrops (symbolizing tears) in front of the dappled rump of a horse!

Like me, numerous artists throughout history have freshly interpreted these images in their work. It is a paradox of human nature that one must lose oneself in interests, concerns, and obsessions in order to find oneself, and artists have always used the rich subterranean currents of earlier art forms to provoke and inspire their creativity. Not only other visual work, but also poems and music can spark off ideas for a painter

or designer. One of my favorite pieces of music is *Carmina Burana* – bawdy and mystical medieval songs and poems discovered and set to grand and celebratory music by the twentieth-century composer Carl Orff.

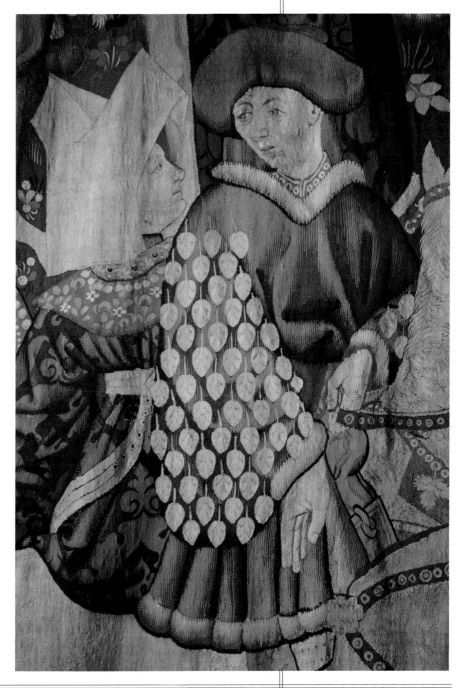

The Victorians, however, were the main reinterpreters of the medieval period, incorporating soaring gothic arches in their town houses, recreating gargoyles and ornamentation in their cornices and ceiling rosettes, and turning to the romanticism of Camelot in their poetry and art. Among the most notable medieval revivalists were William Butterfield, Christopher Dresser, William Morris, and Augustus Pugin. They revived the art and designs of the Middle Ages, re-interpreting them in the modern spirit and reasserting the value of beauty and reverence for Nature.

Even today, we can perhaps see traces of the artistic medieval past in the British creative spirit. Their wild untamed spontaneity comes across most beautifully in their lush and eccentric gardens. As an American my enthusiasm for their particular English use of shapes, textures, and colors in their gardens knows no bounds. What a treat the local flower show is for me! Six sweetpeas in a vase with perfectly matched hues, miniature gardens using moss, single flowers and pebbles, and tiny arrangements in thimbles or shells.

I could not have chosen a more inspirational world than the medieval one – it sings with color, it is diverse, alluring, spiritual, visionary. It was the last time that artists accepted anonymity in their work and devoted it wholeheartedly and entirely to the greater glory of God. It was also a time when Nature and Art interwined, when artists felt no limitation, no apology, no shame in the celebration of decoration, and when the grandeur of the imagination was at its height.

F ANCIFUL IRONWORK ON A MEDIEVAL DOOR.

THE FLEUR-DE-LYS CUSHION

Opinions are divided as to whether the fleur-de-lys is a stylization of the lily or of the stately iris. Whatever its origin, the fleur-de-lys, along with the rose, was the most important stylized flower in medieval art. It was a symbol for the Virgin Mary and the Holy Trinity, and a flower of the nobility. But most notably it was the chief emblem of the kings of France, probably first used for Louis VII's coat-of-arms in the twelfth century.

Because of the French influence in the Middle Ages – through wars, royal marriages, and language – the *Fleur-de-Louis* – later fleur-de-lys – became one of the most dominant and significant heraldic ornaments. For me the medieval period inevitably conjures up visions of flamboyant festivals, pageants and tournaments, of flowing banners and cloths, and of gaily caparisoned knights, all emblazoned with fleurs-de-lys.

Reflecting on the beauty and symmetry of the fleur-de-lys, I came across a sumptuous wall hanging from the furnishings of Charles the Bold, Duke of Burgundy, which accompanied him to the battle of Granson in 1476. On the hanging, the explosion of gold fleurs-de-lys against a royal blue background was very evocative and easily translated into my design idea for a cushion. I changed the border of the French hanging from horizontal and vertical bands to diagonal ones. I then created a subtle movement within the checkerboard border by using different tones of cream and scarlet. With tonal variation, the squares take on a sense of movement.

RIGHT: The Fleur-de-lys Cushion in blues and terracotta. Tassels give it a supremely regal feel.

MAKING THE FLEUR-DE-LYS CUSHION

Needlepoint Yarns and Materials

- Tapestry/Persian yarn in 10 colors
- 10-mesh écru double-thread canvas
 19 × 22″ (48 × 56cm)
- Size 18 tapestry needle
- ³/₄yd (70cm) furnishing fabric for backing
 and cording
- 2yd (1.9m) filler cord or furnishing cord
- 13″ (33cm) zipper
- Pillow form 14 × 18″ (35 × 45cm)

Working the Needlepoint

The chart is 164 stitches wide and 136 stitches
high. Mark the outline on the canvas, and,
if you like, stretch the canvas onto a frame.
See page 116 for technical tips and stitch
instructions. Using a single strand of tapestry
yarn, or two of Persian yarn, work the needlepoint
in tent stitch. When the needlepoint is complete,
block the canvas and sew on the backing and
cording (or furnishing cord) as instructed on page
120. Alternatively, finish with ready-made cord.

Color Key

This project was made in Appletons' yarn, but you
could use Paternayan or the other brands listed
on page 124. The alternatives will give a slightly
different effect from that shown in the picture.

Ap 209 (Pa 870) – brick red	4 skeins	
Ap 866 (Pa 850) – dark coral	3 skeins	
Ap 865 (Pa 831) – medium coral	2 skeins	
Ap 695 (Pa 732) – gold	6 skeins	
Ap 472 (Pa 734) – yellow	3 skeins	
Ap 692 (Pa 735) – pale gold	3 skeins	
Ap 841 (Pa 715) – pale yellow	2 skeins	
Ap 645 (Pa 661) – green	1 skein	
Ap 465 (Pa 571) – dark blue	9 skeins	
Ap 824 (Pa 541) – royal blue	7 skeins	

A COLLAGE OF MEDIEVAL IMAGES –
THE FLEUR-DE-LYS CUSHION
JUXTAPOSED WITH TILES AND
DAMASK OF THE SAME TONES.

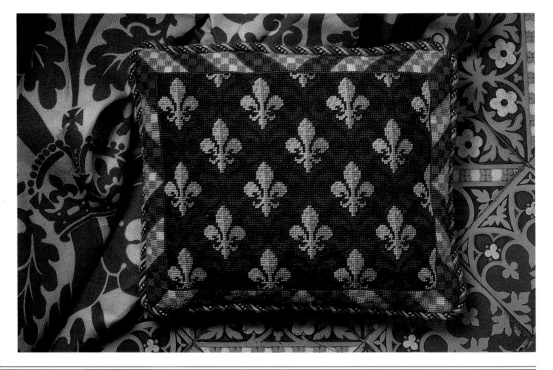

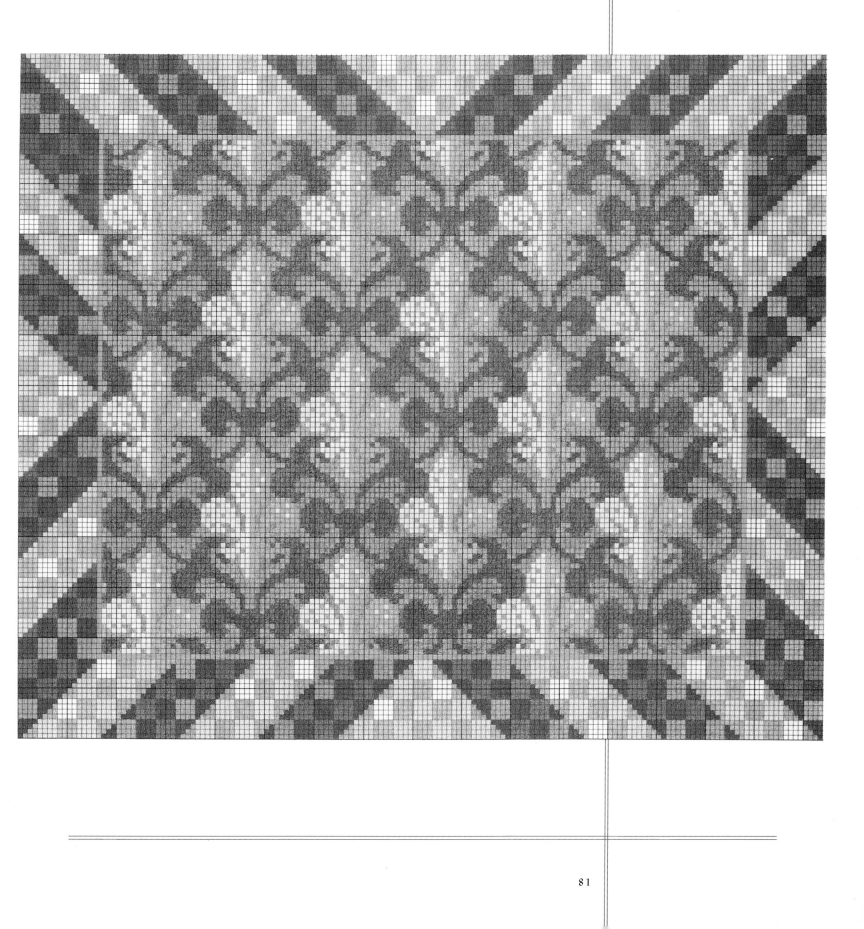

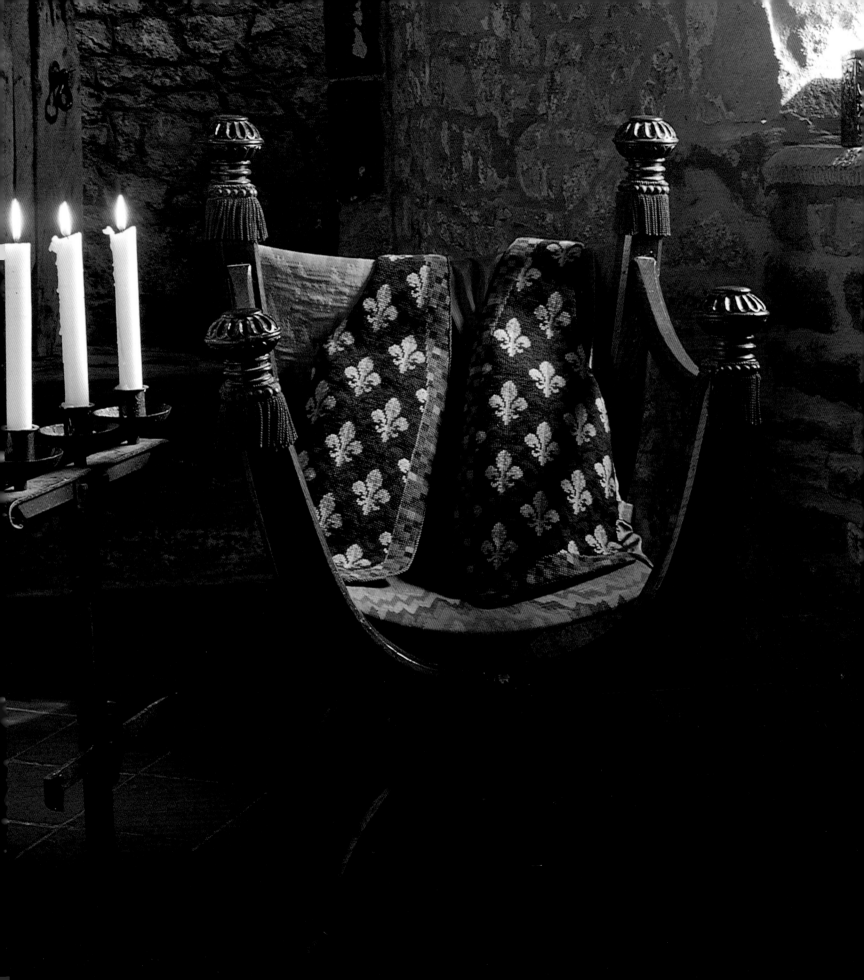

THE FLEUR-DE-LYS VEST

The fleur-de-lys has also lent itself beautifully to my vest design. Vests are a wonderfully expressive and comfortable form of clothing. To frame the striking motifs I again added a border of repeating squares which gently and rhythmically change colors. The resulting vest is very adaptable. It could be worn informally with big baggy trousers, jeans, or a short pleated skirt. It would also look magnificent worn formally with a tuxedo.

For my fleur-de-lys chair cover (page 88), I eliminated the border and used the maroon and chocolate brown background of the vest to give the pattern a deep medieval feel. This color combination would add warmth and elegance to any interior. I made the needlepoint chair cover for a generous Pugin chair, but the design would look equally impressive on a bench, footstool, or kneeler. Using the French blue background of the cushion it would also look very attractive on a Georgian chair.

Of course, you could extend the fleur-de-lys pattern to cover practically anything, even a sofa. How sumptuous that would look, and what an act of love to make! Or what fun it would be to stitch a cover for a motorcycle seat – a Harley-Davidson perhaps?

OPPOSITE: *The Fleur-de-lys Vest.*

RIGHT: *A medieval scene of a coronation with richly patterned robes of Archbishops, Cardinals, Kings, and Princes.*

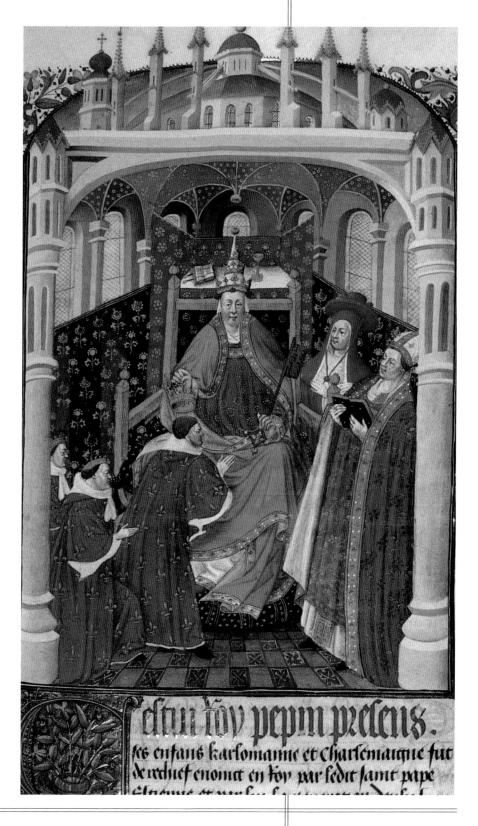

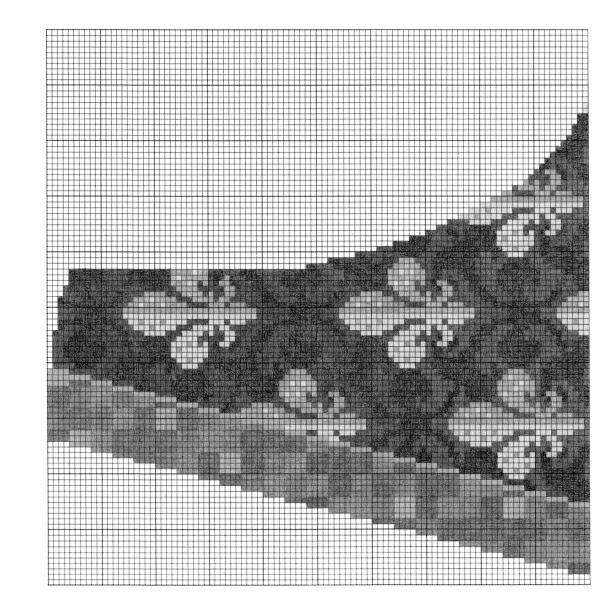

A STAINED GLASS WINDOW IN WELLS CATHEDRAL MADE UP FROM FRAGMENTS OF AN ORIGINAL MEDIEVAL WINDOW.

CHART FOR THE LEFT SIDE OF THE FLEUR-DE-LYS VEST. THIS VEST CAN EASILY BE ADAPTED TO FIT DIFFERENT SIZES – SIMPLY TAKE IT IN AT THE SIDES OR UP FROM THE SHOULDERS.

MAKING THE FLEUR-DE-LYS VEST

Needlepoint Yarns and Materials
- Tapestry/Persian yarn in 9 colors
- 10-mesh écru double-thread canvas 32 × 30″ (82 x 76cm)
- Size 18 tapestry needle
- ³/₄yd (70cm) of 36″ (90cm)-wide fabric for back

- 1¹/₂yd (1.4m) of 36″ (90cm)-wide fabric for lining
- 4¹/₄yd (4m) narrow cord for edging
- Buckle for back belt (optional)

Finished vest: approximately 42″ (107cm) around bust/chest at underarm

Working the Needlepoint
Each chart is 100 stitches across widest point and

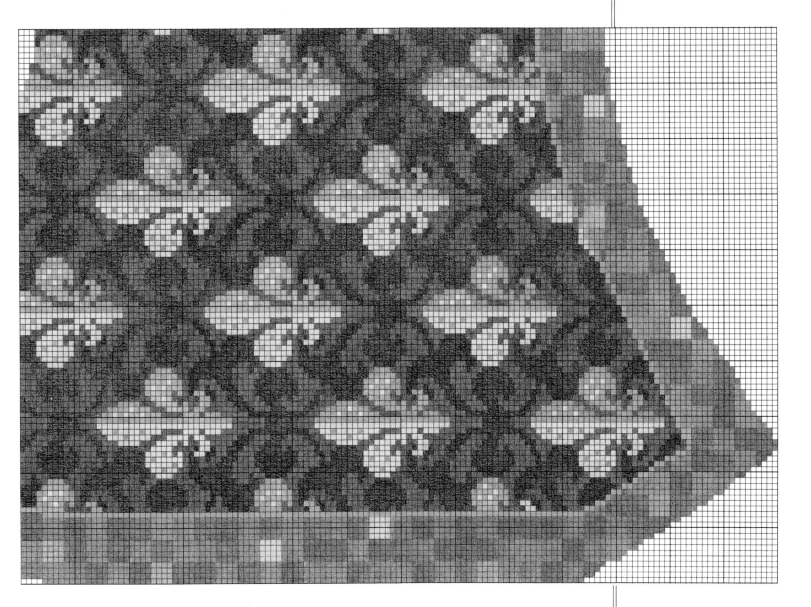

240 stitches across longest point. Mark the outlines on the canvas and stretch the canvas onto a frame. See page 116 for technical tips and stitch instructions. Using a single strand of tapestry yarn, or two of Persian yarn, work the needlepoint in tent stitch, working the background last. When the needlepoint is complete, block the canvas and complete the vest as instructed on page 122.

Ap 759 (Pa 900) – dark maroon	15 skeins	
Ap 696 (Pa 731) – dark gold	6 skeins	
Ap 695 (Pa 732) – medium gold	8 skeins	
Ap 472 (Pa 734) – light gold	6 skeins	
Ap 588 (Pa 420) – dark brown	18 skeins	
Ap 315 (Pa 641) – olive brown	5 skeins	
Ap 832 (Pa 662) – sea green	2 skeins	
Ap 158 (Pa 531) – dark green-blue	3 skeins	
Ap 156 (Pa 532) – green-blue	3 skeins	

Color Key

This project was made in Appletons' yarn, but you could use Paternayan or the other brands listed on page 124. The alternatives will give a slightly different effect from that shown in the picture.

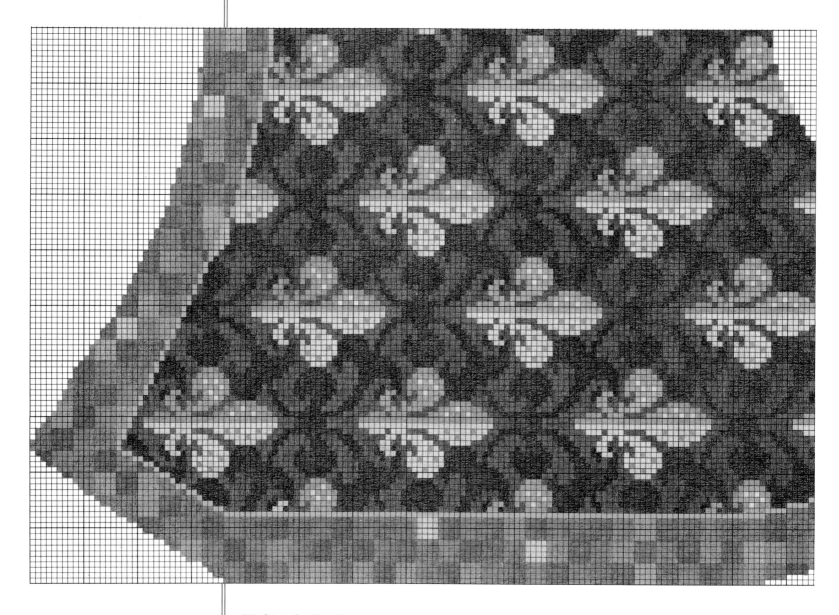

Working the Needlepoint

Each chart is 100 stitches across widest point and 240 stitches across longest point. Mark the outlines on the canvas and stretch the canvas onto a frame. See page 116 for technical tips and stitch instructions. Using a single strand of tapestry yarn, or two of Persian yarn, work the needlepoint in tent stitch, working the background last. When the needlepoint is complete, block the canvas and complete the vest as instructed on page 122.

Color Key

This project was made in Appletons' yarn, but you could use Paternayan or the other brands listed on page 124. The alternatives will give a slightly different effect from that shown in the picture.

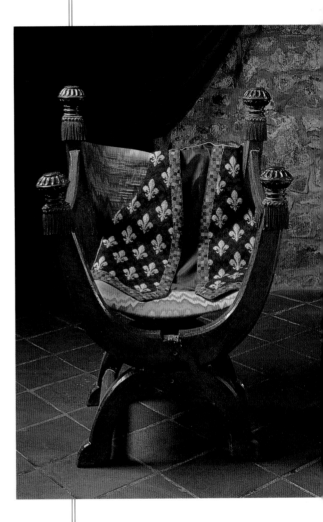

- ■ Ap 759 (Pa 900) – dark maroon
- Ap 696 (Pa 731) – dark gold
- Ap 695 (Pa 732) – medium gold
- Ap 472 (Pa 734) – light gold
- ■ Ap 588 (Pa 420) – dark brown
- Ap 315 (Pa 641) – olive brown
- Ap 832 (Pa 662) – sea green
- Ap 158 (Pa 531) – dark green-blue
- Ap 156 (Pa 532) – green-blue

OVERLEAF: *The Fleur-de-lys design is extended to cover a stately Pugin chair. You could also use the blue colorway from the Fleur-de-lys Cushion as an alternative, which would look very pretty on a Georgian or country chair.*

CHART FOR THE RIGHT SIDE OF THE FLEUR-DE-LYS VEST. THE FLEUR-DE-LYS VEST WOULD MAKE A HANDSOME AND STRIKING ADDITION TO ANY WARDROBE.

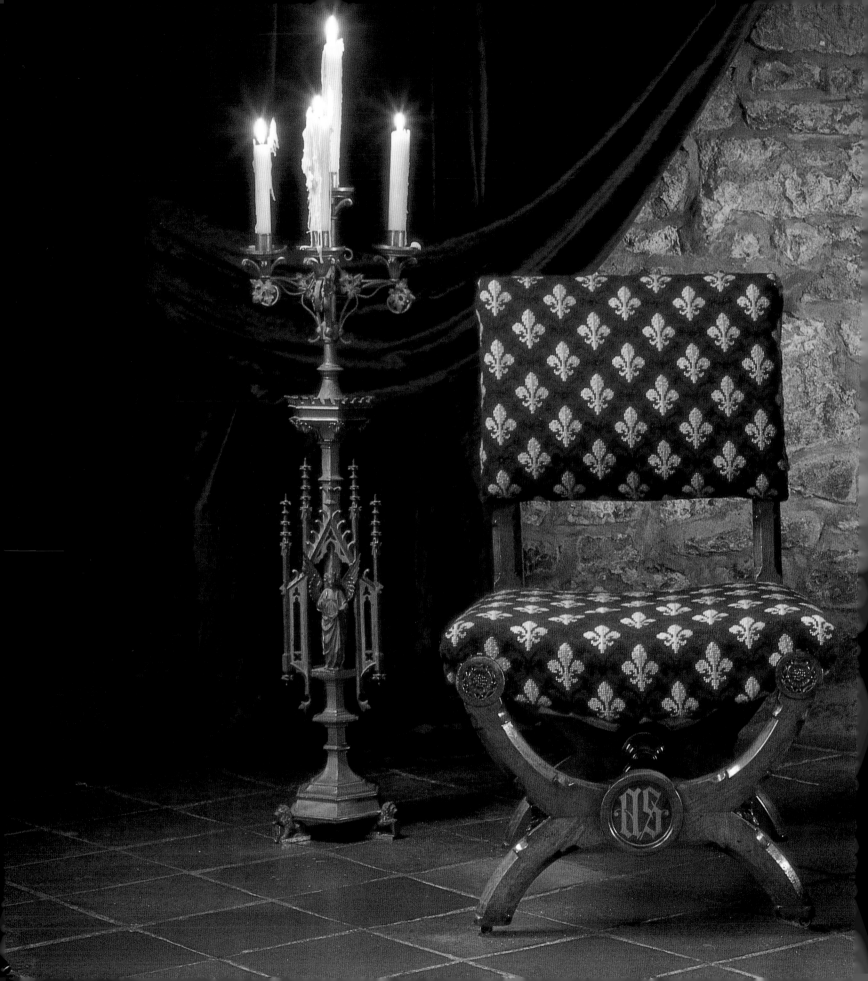

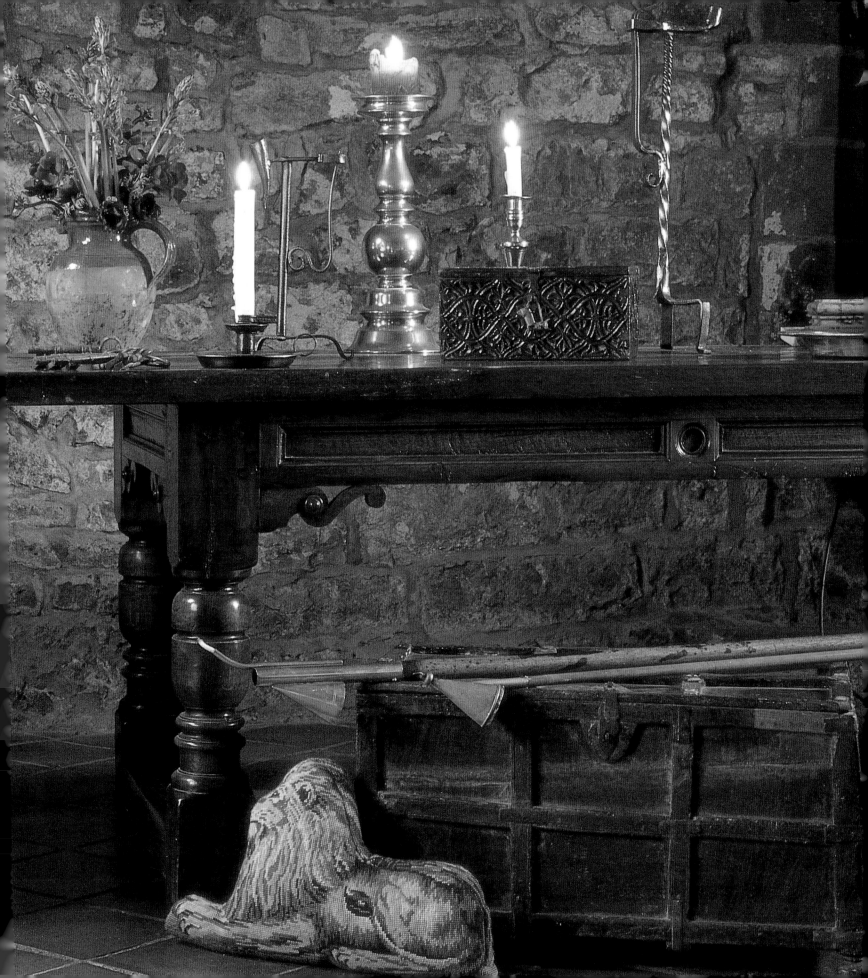

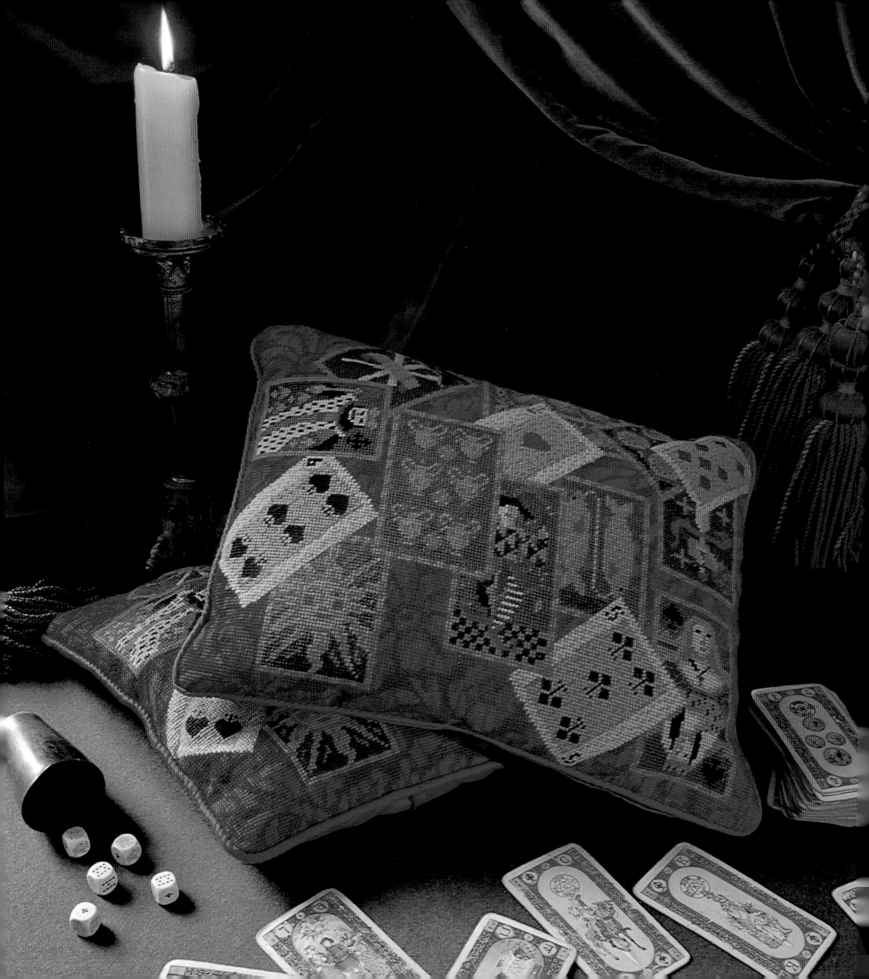

THE PLAYING CARDS CUSHION

The earliest form of cards known in Europe was the Tarot. The pictures of the Tarot illustrate archetypal experiences, celestial forces, virtues and vices, and the whole game of life – love, marriage, ambition, friendship, luck, hatred, despair, hope, death, resurrection – which was presided over by the god Mercury. In the Tarot, the marks of the four suits are Cups (later Hearts, which symbolize family, friendship, and love), Spades (or Swords, which stand for bad fortune), Clubs (or Batons, standing for money matters), and Denarii (or Coins, later Diamonds, which stand for business undertakings, journeys, and messages). The Joker, or Fool, represents Everyman on the path of life, which is variously shown to be folly, a dream, an illusion, frivolity, or just a game of chance.

In the past, playing cards were made of ivory, cardboard, china, wood, mother-of-pearl, bone, cloth, or deerskin. They could be circular, square, or rectangular and were printed from woodcuts, stenciled, or engraved. The colors were often enhanced with gold.

Most probably, gypsy tribes or the Crusaders introduced cards to Europe in the fourteenth or fifteenth century, and by the middle of the sixteenth century they were favored by great nobles. The earliest mention of cards in England was in 1463, when Edward IV banned any cards coming from abroad, saying they could be manufactured only in England.

LEFT: The Playing Card Cushion – inspired by the diverse history of playing cards, including the Tarot.

Wanting to evoke all this fascinating history and iconography in a needlepoint design, I started with a rich raspberry-red damask background. I then laid various cards horizontally, vertically, or diagonally (right to left because of the direction of the stitch) on the grounding.

The heart card was positioned as the central emblem, around which I arranged the other motifs. Besides plain suits, I added two face cards, the French King robed in ermine and the double Queen, resplendent in court dress. The sun face bursts across an azure sky, and its rays streak out in two shades of gold. In Tarot, the sun represented an awakening excitement or marriage.

The tight scales of the hooked fish are clearly picked out in yarns of sage and gold, and surmounted with small rose gills. Behind the plain diamond card lies the denarii, or money card which shares the same color scheme as the acorn card, with its gold acorns and green spotted cups. The heraldic crossed swords and the plain sword card are both worked on a blue background with the steel shaft embroidered in pale blue and cream. A simple, structured design, the Italian cups, which look like urns, are one of the oldest suits of cards, and I have deliberately made each one slightly different. Finally, the particolored jester, with bells and ribbons, jauntily dominates the center of the design.

MAKING THE PLAYING CARD CUSHION

Needlepoint Yarns and Materials
- Tapestry/Persian yarn in 14 colors
- 10-mesh écru double-thread canvas
 21 × 25" (55 × 65cm)
- Size 18 tapestry needle
- ³/₄yd (70cm) furnishing fabric for backing and cording

IMAGE OF THE HANGED MAN, ONE OF THE CARDS IN A TAROT PACK, WHICH DATE FROM THE 15TH-CENTURY.

- 2yd (1.9m) filler cord or furnishing cord
- 16″ (40cm) zipper
- Pillow form 16 × 20″ (40 × 50cm)

Finished cushion: 15 × 19″ (38 × 48cm)

C ARDS WERE USED NOT ONLY
FOR GAMES OF CHANCE OR
AMUSEMENT AND FOR FORTUNE-
TELLING, BUT ALSO TO ILLUSTRATE
RELIGIOUS, SATIRICAL, AND
POLITICAL STORIES. THEY WERE
ALSO USED IN THE STUDY OF
SCIENCE, MYTHOLOGY, GEOGRAPHY,
ASTRONOMY, ARITHMETIC, LATIN,
HERALDRY, POETRY, PROVERBS,
MORALS, MUSIC, AND EVEN MEAT
CARVING!

Working the Needlepoint

The chart is 190 stitches wide and 160 stitches
high. Mark the outline on the canvas, and,
if you like, stretch the canvas onto a frame.
See page 116 for technical tips and stitch
instructions. Using a single strand of tapestry
yarn, or two of Persian yarn, work the needlepoint
in tent stitch, working the background last. When
the needlepoint is complete, block the canvas and
sew on the backing and cording (or furnishing
cord) as instructed on page 120.

Color Key

This project was made in Appletons' yarn, but you
could use Paternayan or the other brands listed
on page 124. The alternatives will give a slightly
different effect from that shown in the picture.

Ap 227 (Pa 900) – dark rose	5 skeins	
Ap 226 (Pa 930) – medium rose	5 skeins	
Ap 225 (Pa 931) – light rose	4 skeins	
Ap 696 (Pa 731) – dark gold	3 skeins	
Ap 695 (Pa 732) – gold	4 skeins	
Ap 691 (Pa 444) – oyster	3 skeins	
Ap 912 (Pa 442) – fawn	2 skeins	
Ap 901 (Pa 443) – pale brown	3 skeins	
Ap 545 (Pa 691) – green	1 skein	
Ap 293 (Pa 603) – dusty green	1 skein	
Ap 328 (Pa 510) – dark blue	2 skeins	
Ap 853 (Pa 501) – blue	3 skeins	
Ap 967 (Pa 200) – dark gray	4 skeins	
Ap 963 (Pa 202) – light gray	1 skein	

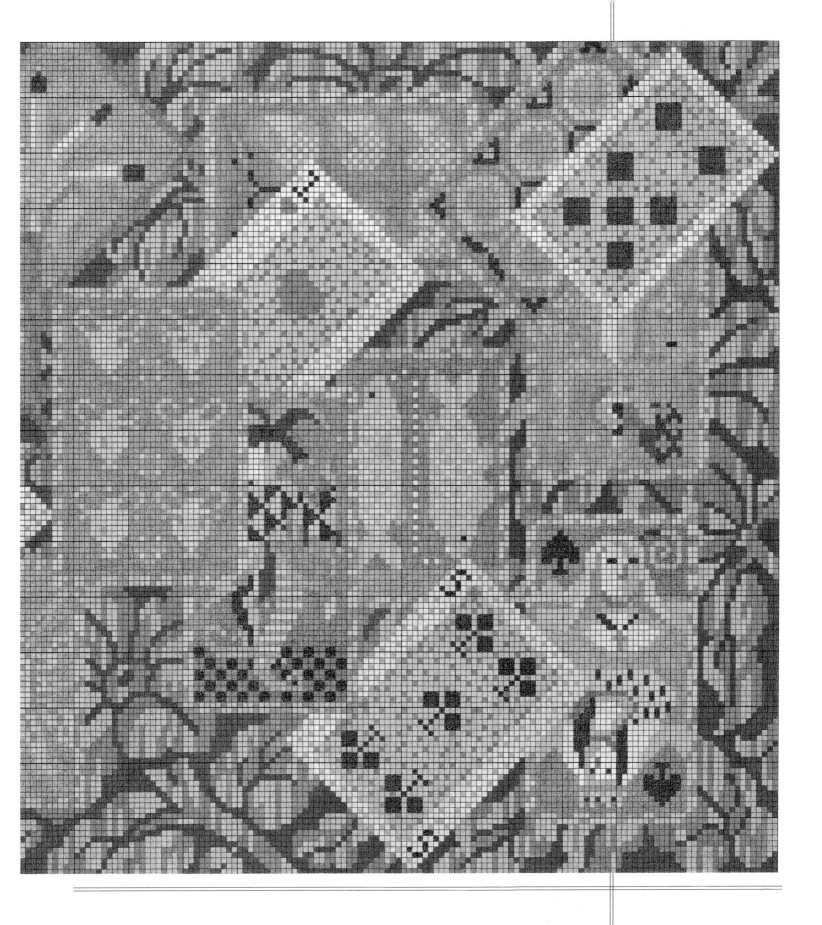

THE ILLUMINATED MANUSCRIPT CUSHION

Medieval artists expressed themselves most articulately and beautifully through their illuminated manuscripts. In fact, the word "illuminated" comes from the Latin *illuminare*, which means "to adorn." And the ecclesiastical passages that monks painstakingly copied were indeed adorned with miniature pictures, swirling border decorations and elaborate initial letters.

The art of illumination developed in much the same way as other European painting in the Middle Ages. Scribes first echoed the artistic simplicity of the twelfth century, then the romanticism of the fourteenth century, and finally the extravagance of the fifteenth and sixteenth centuries.

The pages of early medieval manuscripts were made of vellum, which is the skin of sheep or calves. Though already invented, paper was not produced in large quantities until the early fifteenth century. The pigments used for the illuminations were made from animal, vegetable, and mineral substances. One of the most exotic and costly colors was lapis lazuli, a deep blue stone from the Orient. *Verte de flamme*, a green dye, was extracted from the wild iris; vermilion, the brightest of reds, was made from cinnabar; a darker red came from the mineral red ochre; and violet, a precious vegetable color, extracted from sunflowers. Fine gold leaf was often added to these vibrantly colored miniatures to indicate wealth and status.

Packed into the margins of the manuscripts was a great tangle of Nature, all executed in perfect detail – a huge swarm of beasts, birds, angels, and insects, laced with flowers and fronds of foliage. The illuminated margin that inspired my needlepoint cushion has a graceful, flowing

The Illuminated Manuscript Cushion was influenced by my enthusiasm for pages such as this – I love the pattern the calligraphy makes in conjunction with the 3-dimensional flowers and insects.

rhythm produced with fanciful leaves and blue columbines, which give a particular lightness and caprice to the composition. A columbine plant "is very near akin to the color of doves;" so, like the *columba* or dove, it was one of the symbols of the Holy Spirit and, in the language of flowers, suggests fertility and fidelity.

My needlepoint design is powdered all over with "seeds" or curlicues to evoke a sense of spontaneity. To frame this creamy, elegant vision I chose from a variety of medieval borders with swirls and whorls of gold leaves with individual fantasy flowers and pansies, chosen for their intensity of color, poking out of an unusual bright green ground.

MAKING THE ILLUMINATED MANUSCRIPT CUSHION

Needlepoint Yarns and Materials
- Tapestry/Persian yarn in 14 colors
- 10-mesh écru double-thread canvas 22" (56cm) square
- Size 18 tapestry needle
- ³/₄yd (70cm) furnishing fabric for backing and cording
- 2yd (1.8m) filler cord or furnishing cord
- 13" (33cm) zipper
- Pillow form 16" (40cm) square

Working the Needlepoint
The chart is 160 stitches wide and 160 stitches high. Mark the outline on the canvas, and, if you like stretch the canvas onto a frame. See page 116 for technical tips and stitch instructions. Using a single strand of tapestry yarn, or two of Persian yarn, work the needlepoint in tent stitch. When the needlepoint is complete, block the canvas and sew on the backing and cording (or furnishing cord) as instructed on page 120.

Color Key
This project was made in Appletons' yarn, but you could use Paternayan or the other brands listed on page 124. The alternatives will give a slightly different effect from that shown in the picture.

Ap 904 (Pa 412) – sienna	2 skeins	
Ap 695 (Pa 732) – gold	4 skeins	
Ap 473 (Pa 733) – light gold	4 skeins	
Ap 851 (Pa 745) – pale gold	11 skeins	
Ap 254 (Pa 692) – medium green	6 skeins	
Ap 343 (Pa 603) – light green	2 skeins	
Ap 241 (Pa 653) – pale green	2 skeins	
Ap 525 (Pa 592) – turquoise	1 skein	
Ap 746 (Pa 560) – medium blue	2 skeins	
Ap 743 (Pa 562) – light blue	2 skeins	
Ap 626 (Pa 851) – rust	1 skein	
Ap 223 (Pa 931) – rose	1 skein	
Ap 976 (Pa 451) – dark brown	1 skein	
Ap 912 (Pa 442) – light brown	1 skein	

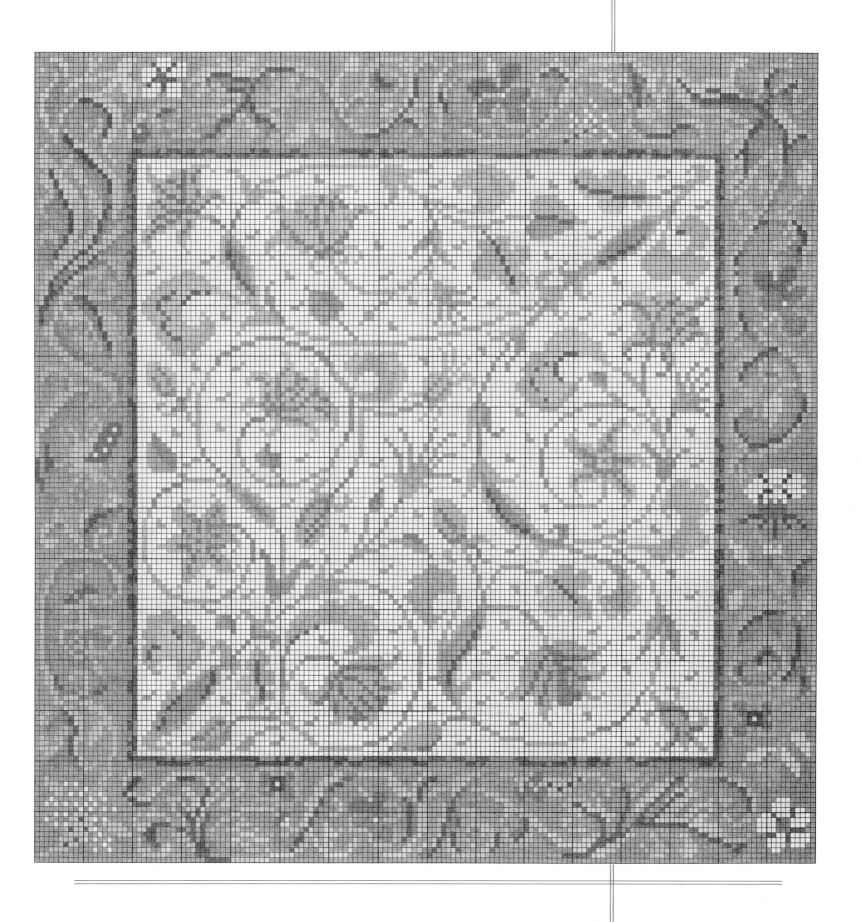

THE STARRY NIGHT VEST

With my Starry Night Vest, I would like to entice you into the magical world of a medieval town. I have created a panoramic view of conical mountains, hills, flags, towers, battlements, pinnacles, weathervanes, roofs, domes, turrets, gables, arches, squares, gates, and walls, all inspired by medieval illuminated manuscripts and Italian painting. The whole scene extends upward to the sky, which, since the beginning of time, has intrigued and influenced man. The heavenly vault above is full of spectacular, potentially catastrophic, events: shooting stars, comets, eclipses, thunder, lightning, violent rains, and storms. These seemingly miraculous phenomena filled the medieval mind with awe and wonder, because it was believed that disorder in the heavens foretold disorder on earth.

In the starlit sky, on opposite sides of my vest, I placed a majestic sun and moon to represent day and night. The moon, mistress of water, is crescent waxing. The sun, in his splendor, has a round, kindly face, with straight, slender, spiky rays of light alternating with longer wavy ones. I lavishly "painted" the sky with tones of ultramarine and "sprinkled" the heavens with gold-threaded constellations of Aries, Libra, Leo, Cancer, Virgo, Aquarius, Cassiopeia, and Pegasus.

To enclose the medieval landscape and star-studded firmament I added a border loosely based on hanging textiles seen in manuscripts. I arranged these flowing, stylized patterns around the edge of the townscape, deliberately choosing muted colors, so as not to compete with the magnificence within.

OPPOSITE: The Starry Night Vest – with its lavishly "painted" sky of deep blue, spangled with gold luminous metallic thread.

A MEDIEVAL TOWN DEPICTED IN THIS OUTSTANDING FRESCO, *THE EFFECTS OF GOOD GOVERNMENT*. I LOVE ITS LYRICAL ATMOSPHERE AND THE SOFT, DUSTY COLORING OF THE BUILDING.

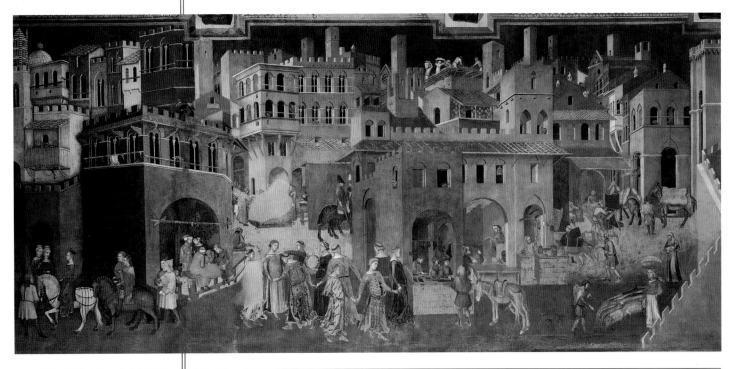

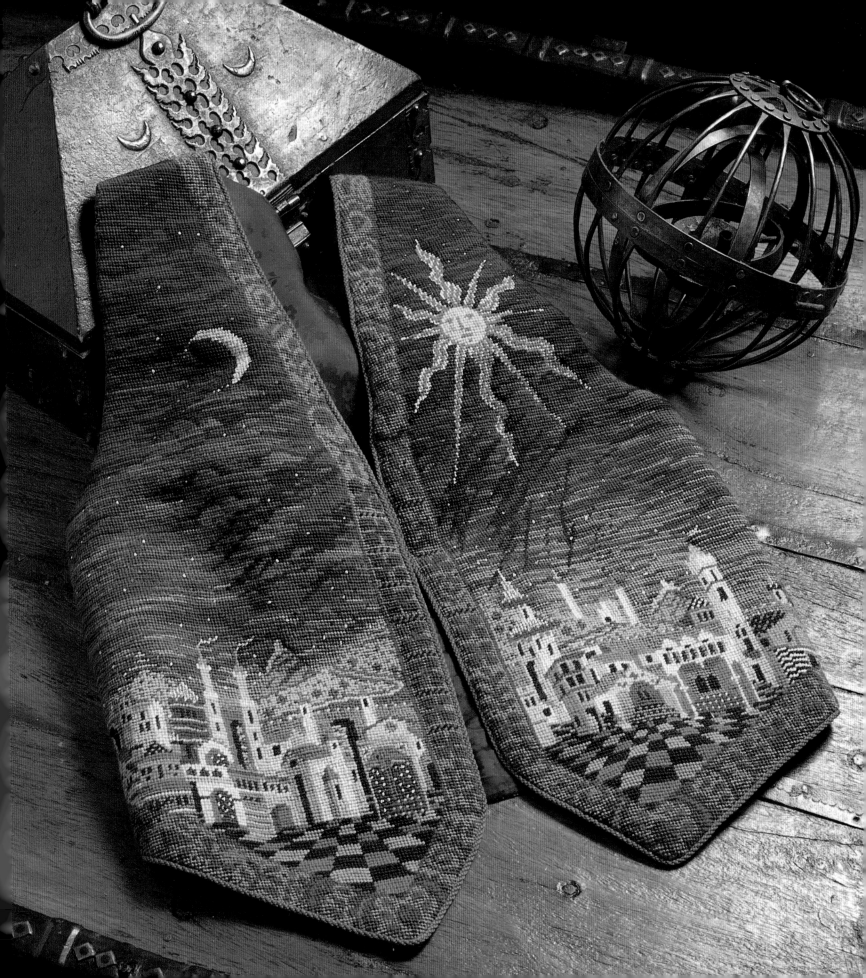

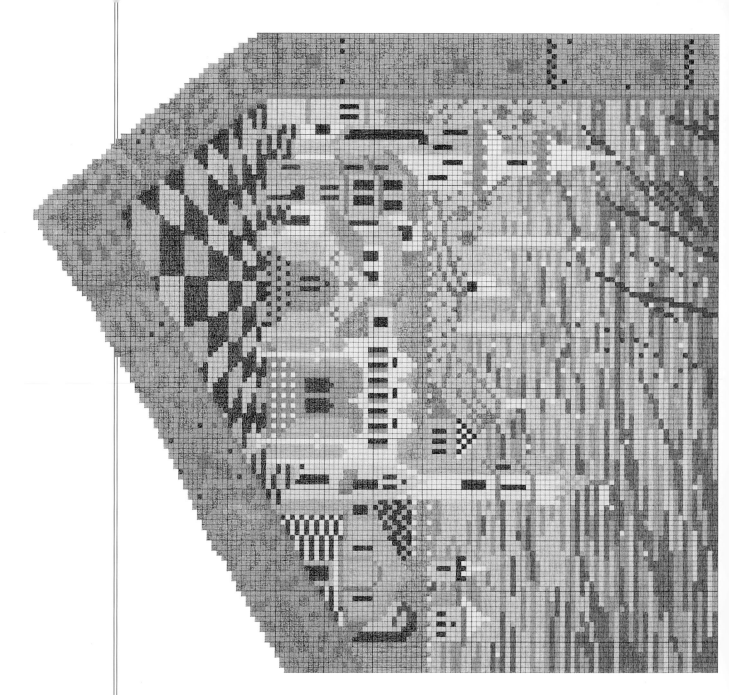

Color Key

This project was made in Appletons' yarn, but you could use Paternayan or the other brands listed on page 124. The alternatives will give a slightly different effect from that shown in the picture.

Ap 929 (Pa 530) – deep blue 4 skeins
Ap 825 (Pa 540) – deep royal blue 6 skeins
Ap 823 (Pa 541) – dark royal blue 12 skeins

Ap 464 (Pa 543) – medium blue 6 skeins
Ap 745 (Pa 561) – light blue 3 skeins
Ap 921 (Pa 534) – pale blue 1 skein
Ap 336 (Pa 640) – deep dusty olive 5 skeins
Ap 333 (Pa 643) – light dusty olive 2 skeins
Ap 294 (Pa 601) – dark gray-green 1 skein
Ap 543 (Pa 693) – light green 1 skein
Ap 155 (Pa 533) – green-blue 6 skeins
Ap 696 (Pa 731) – dark gold 4 skeins

	Ap 693 (Pa 734)	light gold	2 skeins
	Ap 207 (Pa 870) – brick red		1 skein
	Ap 126 (Pa 480) – dark terracotta		2 skeins
	Ap 124 (Pa 483) – terracotta		1 skein
	Ap 222 (Pa 873) – pale rose		1 skein
	Ap 315 (Pa 641) – olive brown		1 skein
	Ap 964 (Pa 201) – medium gray		1 skein
☐	Ap 181 (Pa 464) – pale beige		2 skeins
☐	gold thread		

MAKING THE STARRY NIGHT VEST

Needlepoint Yarns and Materials

- Tapestry/Persian yarns in 20 colors
- 44yd (40m) of metallic gold thread
- 12-mesh écru double-thread canvas 32 × 30″ (82 × 76cm)
- Size 18 tapestry needle
- ³/₄yd (70cm) 36″ (90cm) - wide fabric for back
- 1¹/₂yd (1.4m) 36″ (90cm) - wide fabric for lining
- 4¹/₄yd (4m) narrow cord for edging
- Buckle for back belt (optional)

Finished vest: measures approximately 42″ (107cm) around bust/chest at underarm

C HART FOR LEFT SIDE OF THE STARRY NIGHT VEST. AGAIN, THE VEST CAN BE SHORTENED FROM THE SHOULDERS OR TAKEN IN AT THE SIDES FOR A NARROWER FIT.

C HART FOR RIGHT SIDE OF THE
STARRY NIGHT VEST.

Working the Needlepoint

Each chart is 126 stitches across the widest point
and 320 stitches across the longest point. Mark
the outlines on the canvas and stretch the canvas
onto a frame. See page 116 for technical tips and
stitch instructions. Using a single strand of
tapestry yarn, or two of Persian yarn (or four
strands of gold thread), work the needlepoint in
tent stitch, working the background last. When
the needlepoint is complete, block the canvas and
complete the vest as instructed on page 122.

Color Key

This project was made in Appletons' yarn, but you
could use Paternayan or the other brands listed
on page 124. The alternatives will give a slightly
different effect from that shown in the picture.

Ap 929 (Pa 530) – deep blue
Ap 825 (Pa 540) – deep royal blue
Ap 823 (Pa 541) – dark royal blue

Ap 464 (Pa 543) – medium blue
Ap 745 (Pa 561) – light blue
Ap 921 (Pa 534) – pale blue
Ap 336 (Pa 640) – deep dusty olive
Ap 333 (Pa 643) – light dusty olive
Ap 294 (Pa 601) – dark gray-green
Ap 543 (Pa 693) – light green
Ap 155 (Pa 533) – green-blue
Ap 696 (Pa 731) – dark gold

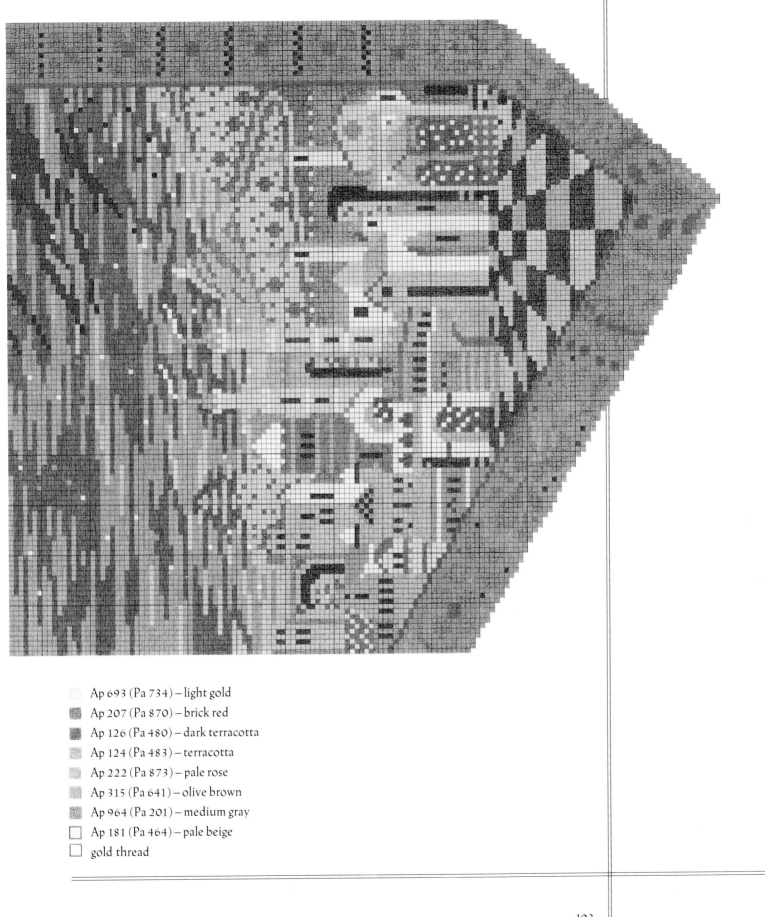

Ap 693 (Pa 734) – light gold

Ap 207 (Pa 870) – brick red

Ap 126 (Pa 480) – dark terracotta

Ap 124 (Pa 483) – terracotta

Ap 222 (Pa 873) – pale rose

Ap 315 (Pa 641) – olive brown

Ap 964 (Pa 201) – medium gray

Ap 181 (Pa 464) – pale beige

gold thread

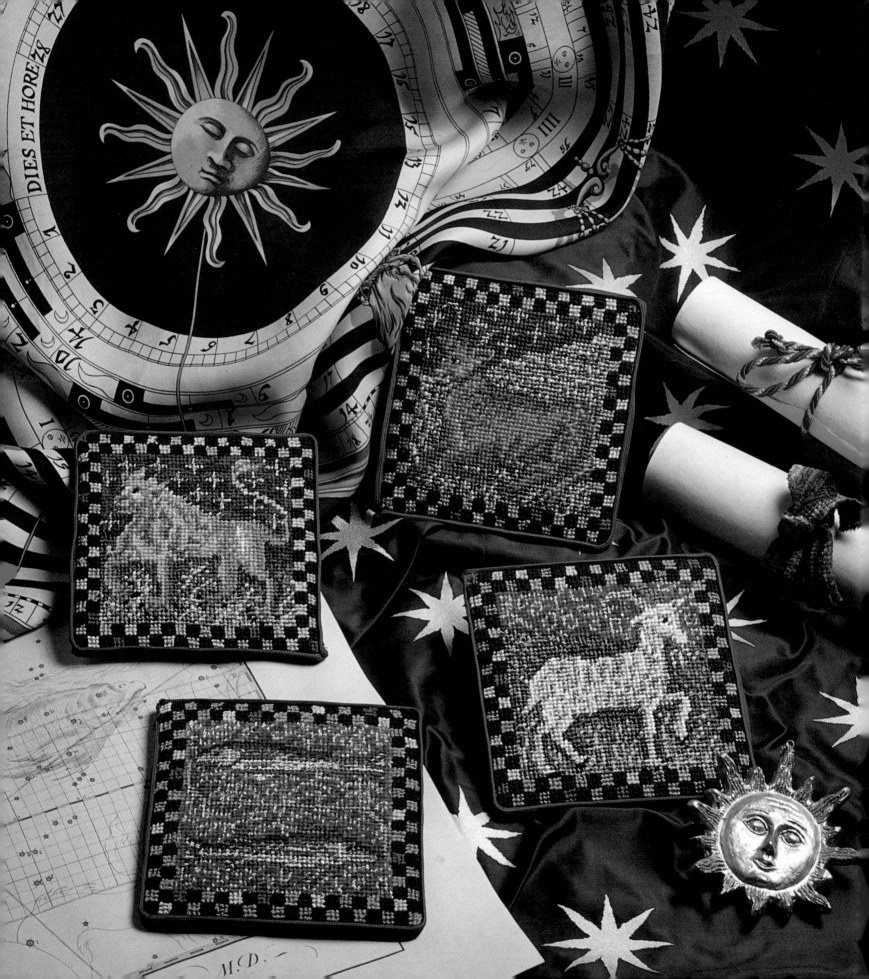

THE ASTROLOGICAL AND WYVERN MOTIFS

The twelve signs of the zodiac are named after the constellations, the stars that inhabit the night sky, each of which the sun takes a full month to cross. I chose to design needlepoints of the lion, the goat, the bull, and the fish, because of their bold ornamental quality. Since astrology played such a dominant role in the division and arrangement of time in the Middle Ages, I was compelled to add it to my collection inspired by medieval art. In the medieval period the stars were thought to determine the order of the universe, owing to their influence on the seasons, the plant cycle, animal life, and human behavior.

When looking for suitable stylized medieval renderings for my astrological motifs, I came across another fascinating imaginative creature – the mythological wyvern. The wyvern is an absurdly fanciful beast, more serpentine than the dragon. He has two legs, bat-like wings, and a dog-like head. The name "wyvern" is derived from the Saxon word "viper" and is the ancient symbol of Wessex (the old kingdom of the Saxons).

The source for my arresting Wyvern design was a very fine French illuminated manuscript of the fourteenth century. I cannot overemphasize the mastery of technique of these exquisite little illuminated manuscripts. It is now almost impossible to capture their delicacy, because medieval illuminators used extremely fine brushes and lenses to magnify their work, and

OPPOSITE: The astrological motifs: Leo, Capricorn, Pisces, and Taurus.

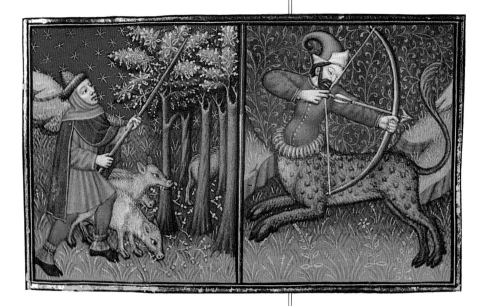

gold leaf as light as an angel's wing. With infinite patience and love, they instilled a vivid sense of the celestial and fabled world into their work. These illuminated manuscripts really are breathtakingly beautiful.

To stitch all five of my magical animals I used rayon threads because of their brilliant luster. However, I suggest in the instructions that you use a shiny pearl cotton instead, as the rayon proved difficult and slippery to work with.

Because I did not want the borders of these motifs to interfere with the central design or its main colors, I chose a checkerboard surround – almost always effective, bold and yet so simple. For the Wyvern motif I used black and gold thread to accent the beguiling and ferocious qualities of the beast.

These alluring little motifs could be put to many uses. For instance, I made the Wyvern into an evening bag, complete with bells, and I framed the other motifs. But they could also be sewn as patches onto jeans or a deeply colored velvet jacket, or you could incorporate them all into a much larger design of your own creation.

MEDIEVAL DETAILS FROM A FRENCH BOOK OF HOURS BY FALSTOLF THE MASTER, AND REPUTEDLY OWNED BY HENRY VII AND HENRY VIII. A PEASANT STRIKES AN OAK TREE TO BRING DOWN ACORNS FOR HIS PIGS AGAINST A STAR-STUDDED SKY WHILE SAGITTARIUS THE ARCHER AIMS AGAINST A BACKDROP OF SWIRLING PATTERN.

MAKING THE ASTROLOGICAL AND WYVERN MOTIFS

Needlepoint Yarns and Materials

- One 27yd (25m) skein each of DMC *No. 5 Pearl Cotton* in 13 colors for Lion, 12 colors for Fish, 18 colors for Ram, 14 colors for Bull, and 17 colors for Wyvern
- One 1-oz (25g) ball of metallic gold thread
- 12-mesh écru double-thread canvas 11" (28cm) square for each motif
- Size 18 tapestry needle
- ¼yd (20cm) fabric for backing
- 30" (76cm) narrow cord for edging each motif

BELOW: Wyvern motif chart.

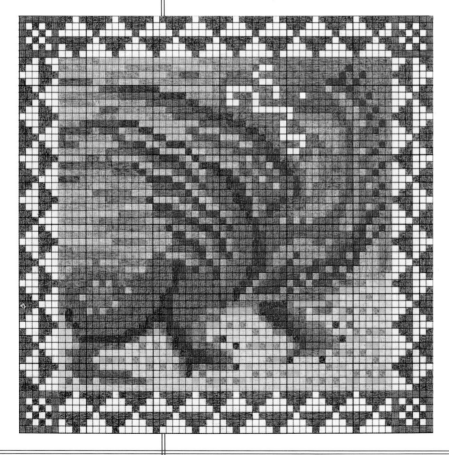

- 1¼yd (1.1m) narrow cord for purse strap (optional)
- Tassels for each motif (optional)

Each finished motif: 5" (13cm) square

Working the Needlepoint

The Lion, Fish, Goat, and Bull charts are each 60 stitches wide and 60 stitches high. The Wyvern chart is 62 stitches wide and 60 stitches high. Mark the outline on the canvas, and, if you like, stretch the canvas onto a frame. See page 116 for technical tips and stitch instructions. Using two strands of pearl cotton (or two strands of gold thread), work the needlepoint in tent stitch. When the needlepoint is complete, block the canvas and sew on the backing, cord, and tassels as instructed on page 120.

Color Key for Wyvern

■	DMC *Pearl Cotton* 815
■	DMC *Pearl Cotton* 321
■	DMC *Pearl Cotton* 606
■	DMC *Pearl Cotton* 356
■	DMC *Pearl Cotton* 783
■	DMC *Pearl Cotton* 919
■	DMC *Pearl Cotton* 436
■	DMC *Pearl Cotton* 319
■	DMC *Pearl Cotton* 469
■	DMC *Pearl Cotton* 470
■	DMC *Pearl Cotton* 993
■	DMC *Pearl Cotton* 820
■	DMC *Pearl Cotton* 797
■	DMC *Pearl Cotton* 799
■	DMC *Pearl Cotton* 208
■	DMC *Pearl Cotton* 310
☐	DMC *Pearl Cotton* 762
☐	gold thread

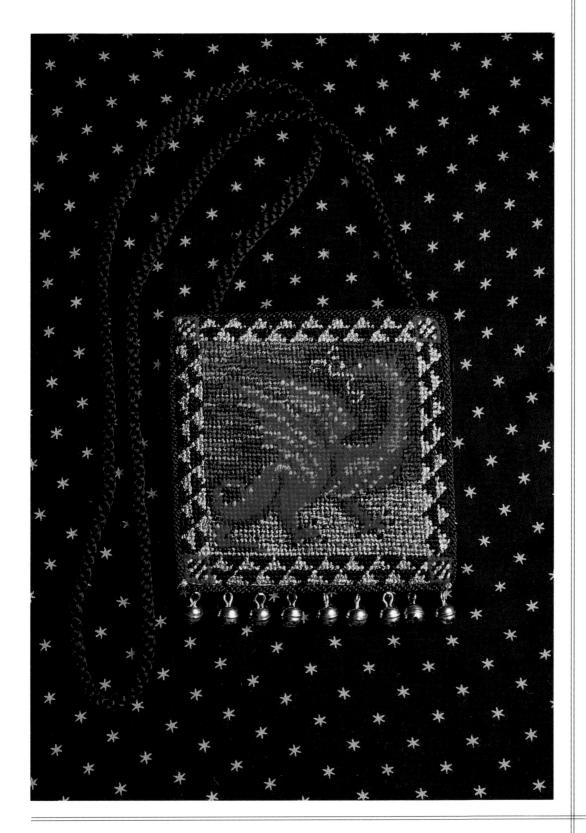

ONE OF TWO TAPESTRY
BANNERS I WOVE FOR
SOMERSET COUNTY COUNCIL.
A GLOWING RAMPANT WYVERN
STANDING AMONG FLOWERS AND
FAUNA OF THE REGION, BENEATH A
SPANGLED SKY.

THE WYVERN MOTIF, FINISHED
OFF AS A PURSE WITH A FRINGE
OF BELLS.

S CORPIO AND LIBRA – TWO
DETAILS FROM THE FRENCH
BOOK OF HOURS BY FASTOLF THE
MASTER. WHICH I DREW UPON FOR
MY OWN FOUR ASTROLOGICAL
MOTIFS.

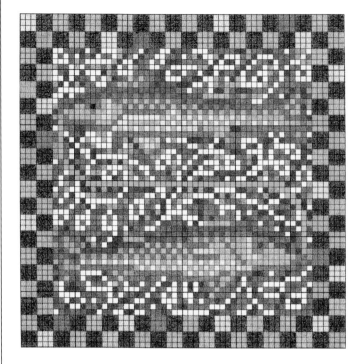

Color Key for Pisces

■	DMC *Pearl Cotton* 816
■	DMC *Pearl Cotton* 349
■	DMC *Pearl Cotton* 919
■	DMC *Pearl Cotton* 920
■	DMC *Pearl Cotton* 783
■	DMC *Pearl Cotton* 743
■	DMC *Pearl Cotton* 912
■	DMC *Pearl Cotton* 820
■	DMC *Pearl Cotton* 798
■	DMC *Pearl Cotton* 809
■	DMC *Pearl Cotton* 775
■	DMC *Pearl Cotton* 310
☐	gold thread

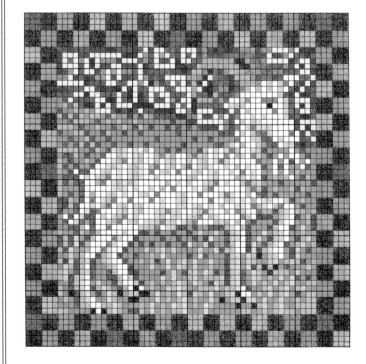

Color Key for Capricorn

■	DMC *Pearl Cotton* 816
■	DMC *Pearl Cotton* 349
■	DMC *Pearl Cotton* 919
■	DMC *Pearl Cotton* 920
■	DMC *Pearl Cotton* 945
■	DMC *Pearl Cotton* 783
■	DMC *Pearl Cotton* 725
■	DMC *Pearl Cotton* 743
■	DMC *Pearl Cotton* 319
■	DMC *Pearl Cotton* 910
■	DMC *Pearl Cotton* 954
■	DMC *Pearl Cotton* 943
■	DMC *Pearl Cotton* 798
■	DMC *Pearl Cotton* 809
■	DMC *Pearl Cotton* 310
■	DMC *Pearl Cotton* 415
■	DMC *Pearl Cotton* 762
☐	DMC *Pearl Cotton* 746
☐	gold thread

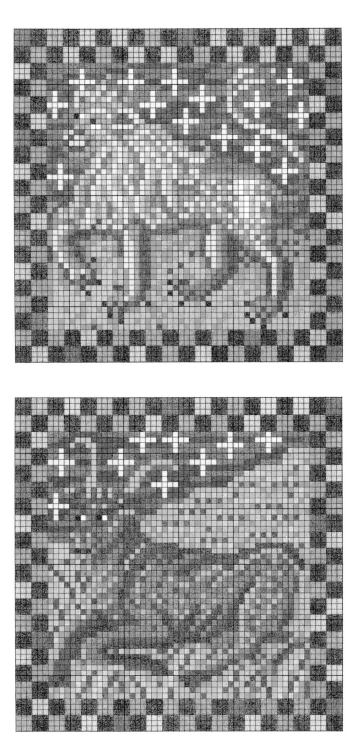

Color Key for Leo

- DMC *Pearl Cotton* 730
- DMC *Pearl Cotton* 783
- DMC *Pearl Cotton* 725
- DMC *Pearl Cotton* 743
- DMC *Pearl Cotton* 444
- DMC *Pearl Cotton* 319
- DMC *Pearl Cotton* 912
- DMC *Pearl Cotton* 954
- DMC *Pearl Cotton* 943
- DMC *Pearl Cotton* 820
- DMC *Pearl Cotton* 798
- DMC *Pearl Cotton* 310
- ☐ DMC *Pearl Cotton* 746
- ☐ gold thread

Color Key for Taurus

- DMC *Pearl Cotton* 869
- DMC *Pearl Cotton* 919
- DMC *Pearl Cotton* 920
- DMC *Pearl Cotton* 971
- DMC *Pearl Cotton* 725
- DMC *Pearl Cotton* 743
- DMC *Pearl Cotton* 319
- DMC *Pearl Cotton* 906
- DMC *Pearl Cotton* 954
- DMC *Pearl Cotton* 943
- DMC *Pearl Cotton* 820
- DMC *Pearl Cotton* 798
- DMC *Pearl Cotton* 310
- ☐ DMC *Pearl Cotton* 746
- ☐ gold thread

GOLDEN MOTIFS

For my Golden series I used the four motifs I felt best illustrated the medieval period – the lion, the fleur-de-lys, the griffin, and the teasel.

Medieval man's most compelling need after food was clothing. The teasel, which is the head of a thistle, was used for carding or straightening out fibers before and after weaving. The word "card" comes from the Latin word for thistle, which is *cardus*. The thistle seems to have been a popular plant for the herbalist, too. Pliny says that the wild thistle boiled in water "affects the womb in such a way that the male children are engendered!" And, of course, the thistle is the symbol for Scotland.

Finding a drawing of a griffin from Olympia from the seventh century B.C., I realized that the roots of heraldic language are pre-Christian. The griffin, or gryphon, has pointed ears, an eagle's head, chest, four claws, and wings, and a lion's body, hind legs, and tail. He symbolizes not only luxury but also control.

The very essence of ancient heraldic design is the rampant lion. The earliest documented heraldic evidence, dating from 1127, is a shield decorated with six lions. Early writers of bestiaries endowed the lion with an enormous range of symbolism – courage, boldness, magnanimity, and mercifulness! My rampant lion motif with forepaws raised is rearing up with clawing feet and gnashing teeth.

The graceful fleur-de-lys is a medieval motif as illustrious as the lion. Its form goes back to ancient Egypt and it is a symbol of life and resurrection. My inspiration for the Golden Fleur-de-lys needlepoint and the other three ornamental Golden motifs comes from a book of medieval ornament, which had an inexhaustible abundance of creative borders and symbols. I worked with only two golds and two other shades in each piece and enlivened them all with gold thread. The medieval period is all about the imaginative flowering of the decorative, with its explosion of elaborate pattern – all just waiting to be adapted for contemporary designs. I was determined to create four very different edgings, despite using only four shades and having a border only five stitches wide.

RIGHT: The Golden series – Pineapple, Fleur-de-lys, Griffin, and Lion. The motifs can be made up as glasses cases, pin cushions, or small bags.

H ERALDIC BORDER FROM A PATTERN BOOK OF MEDIEVAL DESIGNS, MADE FOR THE GOTHIC REVIVAL BY THE VICTORIAN DESIGNERS W. AND G. AUDSLEY.

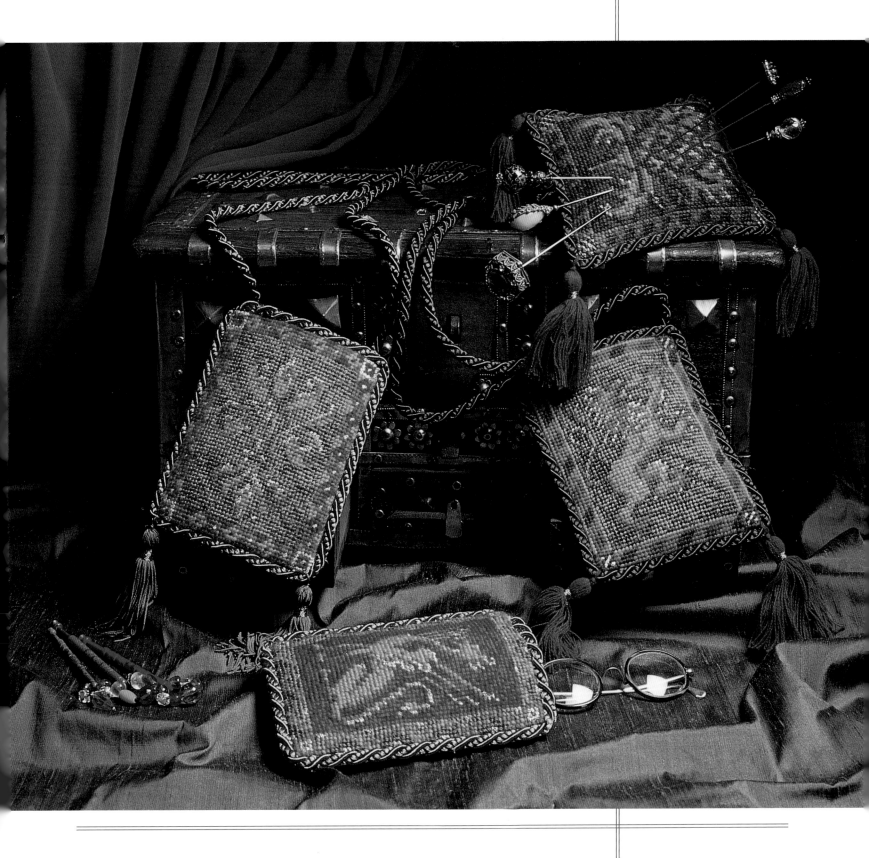

G OLDEN MOTIF CHARTS FOR TEASEL AND FLEUR-DE-LYS MOTIFS *(RIGHT)*.

MAKING THE GOLDEN MOTIFS

Needlepoint Yarns and Materials

- One skein of tapestry/Persian yarn in each of 6 colors for Lion, Griffin, and Fleur-de-lys, and in 5 colors for Teasel
- One 1-oz (25g) ball of metallic gold thread
- 10-mesh écru double-thread canvas 10 × 12″ (25 × 30cm)
- Size 18 tapestry needle

- ¼yd (20cm) fabric for backing
- ¾yd (70cm) narrow cord for edging each motif
- 1¼yd (1.1m) narrow cord for purse strap (optional)
- Tassels for each motif

Finished motif: 4½ × 6″ (12 × 15cm)

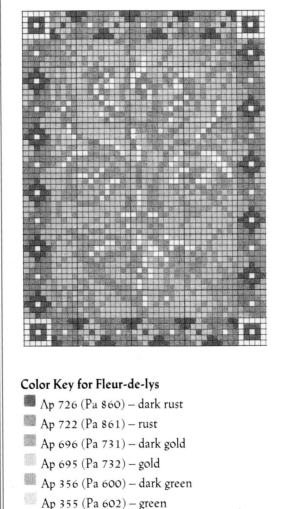

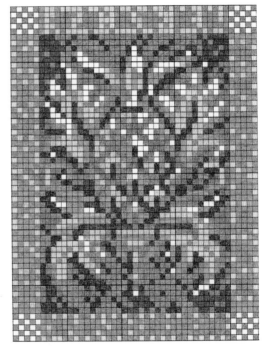

Color Key for Fleur-de-lys
- Ap 726 (Pa 860) – dark rust
- Ap 722 (Pa 861) – rust
- Ap 696 (Pa 731) – dark gold
- Ap 695 (Pa 732) – gold
- Ap 356 (Pa 600) – dark green
- Ap 355 (Pa 602) – green
- ☐ gold thread

Color Key for Teasel
- Ap 934 (Pa 920) – dark burgundy
- Ap 714 (Pa 910) – burgundy
- Ap 696 (Pa 731) – dark gold
- Ap 695 (Pa 732) – gold
- Ap 156 (Pa 532) – dark green-blue
- ☐ gold thread

Working the Needlepoint

Each chart is 45 stitches wide and 60 stitches high. Mark the outline on the canvas and, if you like, stretch the canvas onto a frame. See page 116 for technical tips and stitch instructions. Using a single strand of tapestry yarn, or two of Persian yarn (or two of gold thread), work the needlepoint in tent stitch. When the needlepoint is complete, block the canvas and sew on the backing, decorative cord, and tassels as instructed on page 120.

As with the Astrological motifs (page 105) these little needlepoints could be simply framed or made into evening bags. But my idea would be to keep herbs, love tokens, letters, or computer disks in them. You could also give them as favors to your own brave knight or peerless damsel. These projects were made in Appletons' yarn, but you could use Paternayan or the other brands listed on page 124. The alternatives will give a slightly different effect from that shown in the pictures.

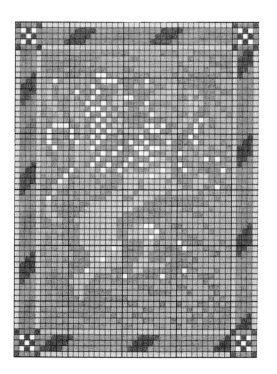

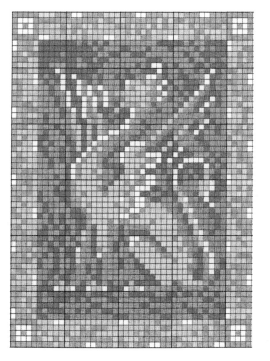

GOLDEN MOTIF CHARTS FOR LION AND GRIFFIN *(LEFT)*.

Color Key for Lion

■ Ap 934 (Pa 920) – dark burgundy
■ Ap 714 (Pa 910) – burgundy
■ Ap 696 (Pa 731) – dark gold
Ap 695 (Pa 732) – gold
■ Ap 156 (Pa 532) – dark green-blue
■ Ap 643 (Pa 602) – gray-green
□ gold thread

Color Key for Griffin

■ Ap 726 (Pa 860) – dark rust
■ Ap 722 (Pa 861) – rust
■ Ap 696 (Pa 731) – dark gold
Ap 695 (Pa 732) – gold
■ Ap 356 (Pa 600) – dark green
■ Ap 355 (Pa 602) – green
□ gold thread

C LASP OF PRECIOUS STONES,
REPUTEDLY WORN BY LOUIS IX
OF FRANCE.

T HE JEWELED MOTIF ADAPTED
AS A HAT DECORATION
COVERED WITH JEWELS, AND ALSO
AS A PLAINER BELT BUCKLE.

THE JEWELED MOTIF

Musing over the fleur-de-lys, I came across a
picture of a jeweled clasp reputedly belonging to
Louis IX, embellished with amethysts, emeralds,
garnets, and sapphires. The fleurs-de-lys fitted
beautifully into the diamond shape. I worked
both motifs with rayon and gold threads and
encrusted one with some luscious beads. If you
are tempted to embroider these jeweled motifs,
first stitch the design, then attach the beads
temporarily with pins. In this way you can play
around with beads of various shapes, sizes,
and colors until you strike on the desired
combination. Then sew them on firmly with
thread.

MAKING THE JEWELED MOTIFS

Needlepoint Yarns and Materials

- One 27yd (25m) skein each of DMC *No. 5
 Pearl Cotton* in 10 colors
- One 1-oz (25g) ball of metallic gold
 thread
- Paste jewels and beads
- 10-mesh écru double-thread canvas 10″
 (25cm) square for each motif
- Size 18 tapestry needle
- ³⁄₈yd (30cm) fabric for backing
- 22″ (56cm) narrow cord for edging each motif
- One tassel for each motif

Finished motif: 4″ (10cm) square

Working the Needlepoint

Each chart is 54 stitches wide and 54 stitches
high. Mark the outline on the canvas, and, if you
like, stretch the canvas onto a frame. See page 116
for technical tips and stitch instructions. Using
two strands of pearl cotton (or two strands of
gold thread), work the needlepoint in tent stitch.
When the needlepoint is complete, block the
canvas and sew on the jewels and beads, backing,
cord, and tassel as instructed on page 121.

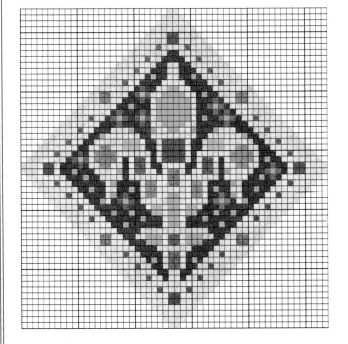

Color Key

- DMC *Pearl Cotton* 815
- DMC *Pearl Cotton* 666
- DMC *Pearl Cotton* 351
- DMC *Pearl Cotton* 699
- DMC *Pearl Cotton* 701
- DMC *Pearl Cotton* 943
- DMC *Pearl Cotton* 992
- DMC *Pearl Cotton* 797
- DMC *Pearl Cotton* 208
- DMC *Pearl Cotton* 414
- gold thread

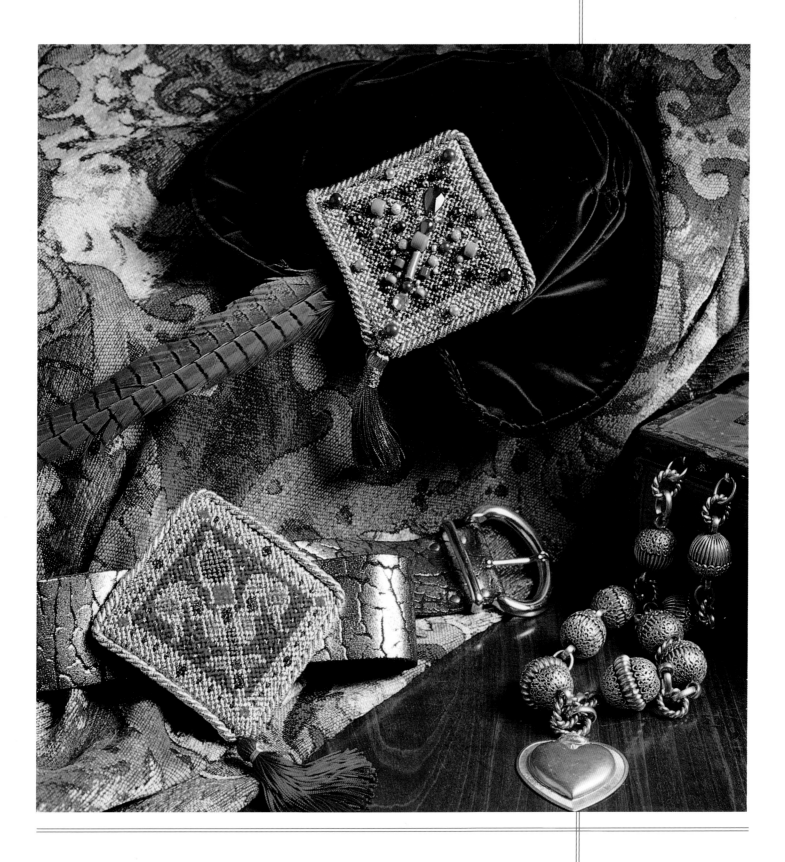

NEEDLEPOINT
TECHNIQUES

Approaching needlepoint from the perspective of a designer, I was not initially trained in the technical how and why. Because I was eager to translate my visions rapidly into needlepoint and had only just grasped the basic stitch, I jumped right in. Moving arbitrarily from one area of the canvas to the next, I scrunched up the canvas in my hand and scooped up my stitches in a single movement. Needless to say, the back of my early canvases ended up a real mess, but my delight at seeing my imaginings realized overcame this minor detail!

Though my technique has improved since, I am still impatient for quick results, which means that my way of working may not seem quite "proper" to the more meticulous embroiderer. Hopefully the following simple tips and pointers, which I have picked up along the way, will help you if you are a beginner. But if you know of, or find, an easier way to work, do not hesitate to use it.

When stitching, try to be patient with yourself, using as much of the technical information as you can without feeling constrained by rules. Do not make your stitching arduous for yourself; instead, work in the way that is the most comfortable and enjoyable. In my experience, needlepoint can be so gratifying and fruitful!

NEEDLEPOINT MATERIALS

Needlepoint Yarns

Many different yarns can be used in needlepoint: wool, cotton, linen, silk, rayon, and even metallic threads. In this book I have used mainly Appleton tapestry yarn because of its superb range of colors, and I would strongly encourage you to order it through Appletons' mail-order suppliers if you fail to get it locally. However, if you do prefer to use another brand of yarn, the color conversion chart on page 124 lists equivalent shades for three of the main yarn manufacturers.

Yarn colors vary from brand to brand, so if you do use an alternative yarn, the finished result will not match my original design exactly. But when preparing the conversion chart, I tried to keep the shades in tune with the spirit of my originals.

Wool needlepoint yarn most commonly comes in three different weights – crewel, Persian yarn, and tapestry. Tapestry yarn is the thickest and crewel the finest. The aim in choosing the correct yarn for your work is to buy one that will adequately cover the canvas.

A single strand of tapestry yarn is fine for a 12- or 10-mesh canvas. Persian yarn comes in three strands which are easily separated; two strands are required for a 12-mesh canvas and three for a 10-mesh canvas. Crewel yarn is only slightly finer than Persian. Three strands of crewel yarn should cover a 12-mesh canvas and four strands a 10-mesh.

For my small motifs, I have used wool yarn, rayon yarn, and metallic threads. The Golden motifs (page 110) are worked in a combination of metallic threads and wool yarns. The Astrological, Wyvern, and Jeweled motifs were worked in rayon.

The rayon yarn I used is called "Marlitt" (see page 126), and I chose it for its jewel-like quality. Unfortunately it is slippery to work with and quickly becomes tangled, which makes it an unwise choice for the beginner or the impatient needleworker. In its place, I have suggested that you use DMC pearl cotton. This embroidery cotton is easier to use and has a luminous quality much like the rayon. Two strands are sufficient for the 10-mesh or 12-mesh canvas on which the designs are worked.

The gold metallic thread used in the Golden motifs is washable and will not tarnish. On my Starry Night vest I have added "drops" of gold fingering, which has a luscious brilliance. These golden touches on my designs were inspired by medieval illuminated manuscripts, decorative work, and textiles which were embellished with rare and precious gold leaf and threads.

Canvas

There are three different types of needlepoint canvas to choose from – mono (or single-thread), interlock, and double-thread (or Penelope). My preferred canvas is écru double-thread canvas. I find a double-thread canvas more convenient, as it allows me to work any of the tent stitch techniques. An écru double-thread canvas is also easier to draw on, and the resulting lines are clearer. But, *most importantly*, if any canvas does show through your finished stitches, the écru color is less harsh and obvious than a glaring white.

When I do use a mono canvas, it is for a specific reason. For

instance, for the Starry Night vest I needed a soft canvas and smaller stitch details, so I chose a 12-mesh interlock canvas. Beginners might find mono canvas better, as double-thread canvas can be confusing. Mainly I suggest that you use what you can find.

Frames

One of the beauties and luxuries of needlepoint for me is that I can carry it around; for that reason alone, I usually do not use a frame. I am quite hard on my work, rolling and folding it, taking it here, there, and everywhere – on planes and trains, outside in the garden, or at the beach and in waiting rooms. But because my tension is even and not too tight, and because I stretch my canvases afterward, all turns out brilliantly flat! If you stitch with a tighter tension, this haphazard way of working may not suit your needs. In this case, you should stretch your work on an embroidery frame.

For my vests and my shaped Seated Lion cushion, I did use a frame. I would strongly advise you to use a frame for any design like these that is other than square or rectangular. The frame ensures that the work remains in shape and does not require excessive blocking.

NEEDLEPOINT STITCHES

Before Beginning

Before you begin your embroidery, make sure that you will be working in a comfortable situation with good light. Anyone involved professionally in the fine or decorative arts will tell you that the most important element in your working conditions is good light. One item I highly recommend (and wonder how I ever lived without) is a daylight simulation bulb. It is essential for working at night, and I even use mine during the day. If you have not used one, I beg you to try one; close colors will never baffle you again! These bulbs can be found in craft and art shops.

Working from a Chart

The advantage of working needlepoint from a chart is being able to see your plain canvas develop as your design grows. Also, you avoid the confusion that you may sometimes encounter on a printed canvas, where a color falls between two holes. Those of you who prefer working on a printed canvas, however, will be pleased to find that many of the designs featured in this book are available as kits (see page 125).

When working from a chart, note that each square on the graph equals one stitch on your canvas. You simply count the number of squares of a particular color on the chart, then work this number of stitches onto the canvas.

If the chart is split across two pages in the book and you find this difficult to read, you could have a color photocopy made of each page and then tape the two copies together. Also, if the squares are too small for you to read with ease, have a color enlargement made or use a magnifier or magnifying strip.

Preparing the Canvas

You should always allow 2 to 3 inches (5 to 8 centimeters) of extra canvas all around the needlepoint design. This is later trimmed when the backing is sewn on. Before beginning your needlepoint, it is a good idea to fold masking tape over the raw edges of the canvas. This stops the canvas from fraying and ensures that your yarn will not catch on rough edges.

If you are working from a chart, begin by marking the outside dimensions of the whole design on the canvas with a brightly colored thread or a permanent ink pen (never use a pencil, as it soils the work). For another point of reference, you could also run contrasting threads through the center of the canvas, vertically and horizontally.

It is usually better to work the various motifs in a design first, leaving the background till last. You can either work from the center outward, or from the upper left-hand corner diagonally downward so that you are not rubbing over areas already worked.

Tent Stitch

Because I am interested in the color and design of needlepoint first and foremost, rather than in the stitches used, I work only with the most familiar, small, basic stitch, known as "tent stitch." This stitch can be worked in three different ways – the half-cross technique, the continental technique, and the basketweave technique.

The right side of the embroidery looks the same with all three techniques, but the appearance of the back of the work varies. Each method has its advantages and disadvantages, so use whichever you

are used to or, if you are a beginner, try all three and use whichever you are most comfortable with. You can use different techniques on the same canvas, but when filling in large areas in a solid color, always stick to one technique or you will create visible ridges.

Beginning Your Stitching

One thing I am quite definite about is the length of yarn one should use – between 14 to 18 inches (35 to 45 centimeters). If the yarn is used in lengths that are too long, it gets twisted and also frays and becomes thinner toward the end of the strand, especially with the darker colors. Measure a 16-inch (40-centimeter) length only once, just to get a feel for the correct length. Thereafter you will be able to judge automatically how long to cut the following strands.

Always use a tapestry needle, which has a blunt point; a needle with a sharp point will split the yarns and canvas. The eye of the needle must be big enough to accommodate the thickness of the yarn easily, but not so thick that you have to force it through the canvas. I suggest you use a size 18 needle for all the designs.

Instructions for how to work the three different tent stitch techniques follow; but the method of starting and finishing the ends of the yarn is the same for each of the techniques. To start, knot the end of the yarn. Then, about 1 inch (2.5 centimeters) from where you want to start, insert the needle through the canvas from the right side to the wrong side. Pull the yarn through, leaving the knot on the front surface. As stitching progresses, the yarn underneath will be secured. When the length of yarn is finished, secure the end by running the needle through a line of stitches at the back. Alternatively, you can bring the yarn back to the front 1 inch (2.5 centimeters) away from the last stitch, leaving it to be secured underneath with more stitching. The knots and loose ends on the surface of the work should be snipped away as secured.

When you re-thread the needle to continue in the same area, there is no need to knot the yarn; simply run the needle and yarn through a few stitches at the back, and bring the yarn to the front in the correct position. When doing this, avoid bringing the needle up through a hole already partially filled with yarn, as needles can split the thread. Try to work down into partially filled holes in order to smooth the yarn. If you have to unpick any mistakes, use small pointed scissors, being careful not to inadvertently cut the canvas.

Half-Cross Stitch

The half-cross technique for working tent stitch is the easiest of the three techniques and uses the least yarn. Because it forms short vertical stitches on the back, which do not entirely cover the back of the canvas, the resulting embroidery is not as thick as needlepoint worked in the other two tent-stitch techniques. It is ideal for filling in just a few isolated stitches in a particular color; but if used on a large area of a solid color, the canvas may distort. This technique must be worked on a double-thread or interlock canvas.

When beginning your stitching, work over the loose end at the back of the work as described above. Cross the yarn over each intersection of the double canvas threads, making short vertical stitches at the back.

Work the rows of stitches from left to right and from right to left alternately, with the needle pointed alternately upward and downward with each row as shown.

Continental Tent Stitch

This can be worked on any type of canvas. It forms a firmer fabric than half-cross stitch and the back of the work is entirely covered with yarn.

Basketweave Tent Stitch

Basketweave tent stitch is worked in diagonal rows. It is good for covering large areas of background. The resulting needlepoint is very stable and will not distort. This can be worked on any type of canvas.

When beginning, work over the loose end at the back of the canvas as described above. Work the first row of stitches from right to left as shown, making diagonal stitches at the back.

At the beginning, work over the loose end as described above. Work the first row downward from left to right as shown, forming vertical stitches at the back of the canvas.

Work the next row of stitches above or below the first, but moving in the opposite direction. If you are working without a frame and using only one hand to make the stitches, you will have to turn the canvas upside down after each row so that you are always working from right to left.

Work the following row upward, forming horizontal stitches at the back of the canvas as shown. Work downward and upward alternately.

FINISHING YOUR NEEDLEPOINT

Blocking and Stretching

If you have worked your needlepoint with the canvas stretched very tautly in a frame, it may not need stretching. But if you have worked it in the hand, it will definitely need to be smoothed out and may even need to be pulled vigorously into shape.

If the task of stretching seems a bit daunting to you, ask a friend for help. You may even prefer to have your needlepoint stretched and backed professionally if you are worried about ruining the work or if you do not have the necessary sewing skills. A decorator fabric store or art store may be able to help.

If you are blocking and stretching your work at home, you will need a clean board on which to stretch the needlepoint and, of course, rustproof tacks and a hammer. Wool yarns, especially, are very amenable to being stretched. The canvas is very strong, so you can pull quite hard when stretching the finished work.

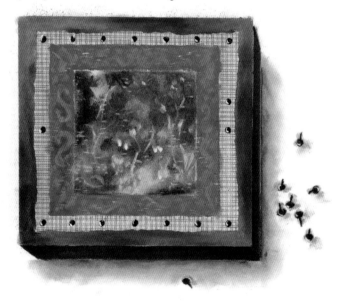

Place the finished canvas face down on the board. Spray the back with a fine mist of water, or dampen the back with a sponge. Then stretch the canvas into shape, nailing into the raw canvas as you stretch. Begin with a tack at the center of each of the four sides, then work outward from the center, placing the tacks about 1" (2.5cm) apart. Allow the needlepoint to dry completely before removing it from the board. This may take a whole day. After blocking, trim the unworked canvas to within ³/₄" (2cm) of the stitching.

Backing Your Cushion

Choose the color of your backing fabric with care. If you are in doubt, choose a color that matches the background color of your needlepoint.

If you do not wish to insert a zipper in your backing, you can merely leave an opening by overlapping two pieces of backing by 4" (10cm) across the center.

The easiest way to insert a zipper into your cushion backing is to position it in a center seam. In this case, you should cut two pieces of

Begin by joining each end of the center seam, leaving an opening for the zipper. Then pin the zipper to the wrong side and sew it in place using a sewing machine or working by hand in backstitch.

Press the completed center seam, then pin the backing to the needlepoint with the right sides facing. Stitch close to the embroidery all around the edge, using backstitch or a sewing machine. Clip the corners of the seam allowance diagonally, and turn the cover right side out.

fabric of equal size, allowing a ³/₄″ (2cm) seam allowance around all sides. Use your needlepoint to determine the size of the backing.

A shaped cushion is backed in the same way as an ordinary cushion. So for the Seated Lion cushion on page 36, begin by cutting two pieces of backing fabric which, when sewn together up the center, will be large enough to form a rectangle covering the back of the finished embroidery, with 1″ (2.5cm) extra all around the outer edge. Insert the zipper in the center seam, and press the backing. Trim the backing to the same size and shape as the blocked and trimmed needlepoint, allowing for a ³/₄″ (2cm) seam.

If the shaped embroidery has a gusset (like the Seated Lion on page 36), pin the gusset to the needlepoint with right sides facing. (The Seated Lion charts are marked with letters which should be matched when pinning the gusset to the lion.) Sew the gusset in place close to the tent stitches, using a sewing machine or backstitch. Clip the seam allowance along the curves to ease the canvas.

Backing a Small Piece of Needlepoint

You can back a small piece of needlepoint in the same way as a cushion but omitting the zipper and leaving one side open for turning right side out. The opening is then sewn up by hand.

If you want to hang a small needlepoint picture on the wall, you may want to stiffen it. For my Astrological motifs (page 104), I inserted a piece of acid-free cardboard before sewing up the last edge of the backing. Alternatively, you could have your work framed.

I made my Wyvern motif (page 104) and two of my Golden motifs into small purses. Before sewing on a backing for a purse, you should line the embroidery with a separate piece of fabric.

Next pin the backing to the needlepoint (or the gusset) with right sides facing. Stitch around the edge close to the needlepoint. Before turning the work right side out, clip the seam allowance along the curves to ease the backing fabric and canvas.

Attaching Furnishing Cord

It is best to take your finished needlepoint with you when you are choosing the furnishing cord or braid. The wrong color could ruin the overall effect. Pick one that does not overpower the design.

When sewing on the cord, place it over the seam between the needlepoint and the backing (or lining), and taper the ends into the

seam. To add a decorative touch I often form loops with the cord at the corners of the needlepoint.

Making Cording

If you cannot find a cord or braid in a suitable color, you can make your own cording to edge the work. When you purchase a backing fabric, you will need to buy a little extra to make matching cording. Filler cord is available in fabric shops and in notions departments.

Cut bias strips of fabric wide enough to cover the cord allowing ⁵/₈″ (1.5cm) seam allowance on either side. Join enough strips to cover the length of cord required. The seams should be made with the grain of the fabric and should be pressed open before covering the cord. Fold the bias strip around the cord, and baste it in place close to the cord.

Pin the covered cord to the right side of the needlepoint with the seam allowance running along the bare canvas, tapering the ends into the seam. Then pin the backing fabric in position over the cording, and sew it in place using a sewing machine with a zipper foot or backstitch. Clip the corners diagonally as for a plain backing and turn the cover right side out.

Making Tassels

Tassels can be purchased ready-made, but are sometimes very expensive. However, you can make your own tassels quite easily, and the advantage of this is that they can be any color you wish. The most effective tassels are made with threads that drape well, such as pearl cotton, or with metallic thread.

Wrap the chosen yarn many times around a piece of cardboard which is slightly longer than the desired length of the finished tassel. With a separate length of yarn, tie the strands together at one end of the piece of cardboard, leaving long, loose ends. Then cut the strands along the other end of the cardboard.

Make a loop at one end of a long piece of thread and place it so that the looped end is about 1¼" (3cm) below the top of the tassel, with the cut end extending upward. Wrap the other end tightly round and round the top of the tassel as shown. Then slip the end of the thread through the loop and pull both ends of the yarn in order to pull the final end under the yarn wrappings. Cut off the loose ends, and trim the end of the tassel.

CLEANING YOUR NEEDLEPOINT

A wool needlepoint will not require very frequent cleaning. If you do need to clean it, however, it is best to have it dry cleaned. Be sure to take it to a reputable dry cleaner, and if there is any metallic thread in the work, follow the manufacturer's dry cleaning advice.

MAKING A NEEDLEPOINT VEST

If you are not an accomplished seamstress, be sure to seek help when sewing together your needlepoint vest. The needlepoint will have taken you a great deal of time and effort, and it would not be wise to risk damaging it. You might even prefer to have a local seamstress back and line the vest for you, which is what I did.

If you do decide to assemble the vest yourself, you will find that lining the needlepoint fronts of the vest designs is done in much the same way as a backing is made for a shaped cushion, with the finished fronts serving as the templates for cutting the front lining. The patterns for the backs of the waistcoats are given here.

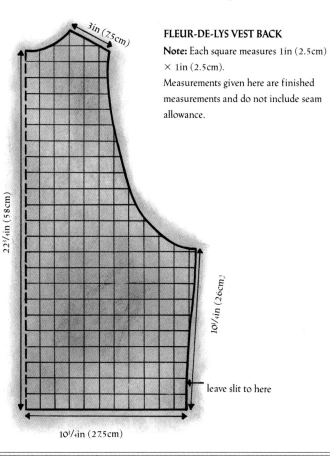

FLEUR-DE-LYS VEST BACK

Note: Each square measures 1in (2.5cm) × 1in (2.5cm).
Measurements given here are finished measurements and do not include seam allowance.

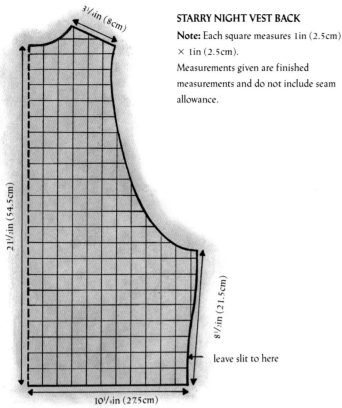

STARRY NIGHT VEST BACK

Note: Each square measures 1in (2.5cm) × 1in (2.5cm).
Measurements given are finished measurements and do not include seam allowance.

3¹/₄in (8cm)

21¹/₂in (54.5cm)

8¹/₂in (21.5cm)

leave slit to here

10³/₄in (27.5cm)

Sewing on the Back of the Vest

Begin by drawing one half of the vest back on a piece of pattern paper marked with 1″ (2.5cm) squares. Use the diagram as your guide. Then draw a line around the outline, ³/₄″ (2cm) from the edge of the neck, shoulder armhole, side edge, and lower edge, for the seam allowance. Cut out the pattern piece and place it on the fold of the fabric, with the fold running with the grain of the fabric. Cut along the edge of the paper pattern.

Also, if a back belt is desired, cut two pieces of fabric 13″ × 3″ (34cm by 8cm). Fold each piece in half lengthwise with the right sides facing. Stitch across one short end and along the long side, ¹/₂″ (1.5cm) from the edge. Turn belt pieces right side out and press.

With right sides facing, pin the shoulders of the vest back to the shoulders of the finished blocked and trimmed needlepoint fronts, and stitch together close to the needlepoint. Then press open the seams. Join the side seams in the same way, but inserting the ends of the belts 5″ (13cm) above the lower edge and leaving the lower edges open to allow for a 1³/₄″ (4.5cm) finished slit.

Making the Lining

Using the pattern for the back of the vest, cut a back from the lining fabric. Then using the finished fronts as your guide, cut out a lining for each of the fronts, leaving a ³/₄″ (2cm) seam allowance around all the edges. Sew the pieces of the back and front linings together in the same way as the back was sewn to the needlepoint fronts. Trim and press the seams.

Sewing the Lining to the Vest

With the right sides together, pin the lining to the vest around the front edges and neck only. Machine stitch the pieces together along this edge, close to the embroidery. Where necessary clip the curved edges of the seam just made. Turn the vest right side out; press.

Turn the seam allowance to the wrong side around the armholes of the lining and the vest. Sew the lining to the vest all along the armholes by hand.

In the same way as for the armholes, turn under the seam allowance along the lower edge of the lining and the vest, making a slit at each side seam. Sew the lining to the vest along the lower edge (including the slit) by hand and press.

Finishing

If necessary, fill in any empty canvas along the edges of the needlepoint with tent stitch. Then sew the ready-made cord along the edge of the embroidery. Sew a buckle to one end of the belt if you like.

NEEDLEPOINT CHAIR COVERS

Although covering a chair with needlepoint may take a long time, it is well worth the effort. My fleur-de-lys chair cover on page 88 is worked with the same colors and in the same pattern as the Fleur-de-lys vest (see chart on pages 84–87). If you want to attempt this project, you will first have to make a paper template of the correct size to cover the chair.

Some shops that offer the service of stretching the finished needlepoint onto the chair will also make your template for you. The template outline is then drawn onto the canvas. After the needlepoint has been completed, the canvas should be stretched and blocked to match the template.

YARN CONVERSION CHART

The following color conversion chart is provided for readers who wish to use an alternative yarn. All of the Appleton shades used in the book are given, and each shade is followed by the closest equivalent available in Paternayan, DMC, and Anchor yarns. These alternatives, however, are only approximate equivalents.

Appleton tapestry yarn comes in 11yd (10m) skeins. If you buy an alternative yarn which comes in a smaller skein, be sure to allow for this. All of the alternative yarns are tapestry yarn except for Paternayan Persian yarn, which consists of 3 strands. When using Paternayan and working tent stitch on a 10-mesh canvas, use 2 or 3 strands of the yarn. For a 12-mesh canvas use 2 strands and for a 7-mesh canvas use 4 strands.

Note: The yarn amounts given in the instructions are for continental and basketweave tent stitch. You will need 30% less yarn if the needlepoint is worked entirely in the half-cross tent stitch technique.

Ap = Appleton (tapestry yarn) – 11yd (10m) per skein
Pa = Paternayan (Persian yarn) – 8yd (7.4m) per skein
DMC = DMC (tapestry yarn) – 8.8yd (8m) per skein
An = Anchor (tapestry yarn) – 11yd (10m) per skein

Ap	Pa	DMC	An	Ap	Pa	DMC	An	Ap	Pa	DMC	An	Ap	Pa	DMC	An
102	312	7709	8588	328	510	7289	8840	691	444	7501	9322	872	715	7905	8012
124	483	7165	9598	333	643	7363	9306	692	735	7579	8054	882	756	7746	8034
126	480	7167	9600	336	640	7425	9314	693	734	7472	8040	893	343	7711	8606
142	924	7224	8504	342	643	7373	9258	694	733	7473	8042	895	340	7243	8610
152	534	7692	8894	343	603	7362	9260	695	732	7506	8024	901	443	7511	9328
155	533	7326	8880	351	605	7371	9058	696	731	7780	8104	902	442	7513	9406
156	532	7701	8882	354	693	7384	9164	714	910	7228	8510	903	740	7477	9406
157	532	7701	8882	355	602	7376	9176	722	861	7446	8262	904	412	7845	8106
158	531	7329	8884	356	600	7427	9178	726	860	7447	8264	912	442	7524	9388
181	464	7271	9482	401	604	7424	9074	743	562	7798	8626	913	441	7513	8048
207	870	7178	8264	402	612	7384	9018	745	561	7314	8628	914	440	7514	8048
208	870	7447	8264	464	543	7317	8690	746	560	7317	8630	921	534	7292	9064
209	870	7448	8242	465	571	7823	8694	747	540	7318	8794	929	530	7299	8840
222	873	7215	8326	472	734	7472	8058	755	932	7759	8400	934	920	7375	8514
223	931	7354	8368	473	733	7473	8022	759	900	7218	8426	947	902	7640	8440
224	930	7196	8262	525	592	7861	8920	765	495	7767	8062	951	454	7523	9364
225	931	7758	8400	543	693	7770	9166	821	542	7316	8630	954	641	7487	8048
226	930	7147	8402	545	691	7988	9168	823	541	7797	8692	956	451	7490	9332
227	900	7218	8404	548	600	7379	9208	824	541	7769	8692	963	202	7617	9064
241	653	7361	9306	566	500	7650	8822	825	540	7820	8634	964	201	7275	9776
254	692	7547	9168	581	470	7938	9648	832	662	7909	8972	967	200	7622	9764
292	602	7394	9066	588	420	7535	9666	841	715	7905	8052	973	451	7416	9372
293	603	7394	9076	626	851	7850	8238	851	745	7503	8054	976	451	7529	9332
294	601	7396	9078	642	604	7404	9076	853	501	7591	8792	981	464	7520	9654
315	641	7487	9290	643	602	7406	9078	865	831	7850	8238	984	645	7491	9402
324	502	7295	8834	645	661	7540	8974	866	850	7920	8236	993	220	NOIR	9800
327	531	7288	8838	646	660	7389	9026	871	716	ECRU	8006	994	851	7360	8162

RETAILERS AND DISTRIBUTORS

KITS FROM EHRMAN

Many Candace Bahouth designs are available as Ehrman needlepoint kits. The designs can be seen stitched up in the Ehrman shop in Kensington Church Street in London (see address below). The shop stocks the full range of Bahouth designs, many of which do not appear in this book.

The Candace Bahouth designs that are featured in this book and are available as kits from Ehrman are as follows:

page 62:	Bruges Cushion
page 52:	Caprice Cushion
page 17:	Dog Cushion
page 25:	Falcon Cushion
page 79:	Fleur-de-lys Cushion
page 23:	Hunting Rug
page 94:	Illuminated Manuscript
page 54:	Maytime Cushion
page 63:	Meadow Garden Cushion
page 53:	Medieval Flowers Rug
page 26:	Monkey Cushion
page 72:	Mosaic (also called Italia) Cushion
page 68:	Orange Tree Cushion
page 24:	Pheasant Cushion
page 90:	Playing Card Cushion
page 15:	Rabbit Cushion
page 21:	Shelduck and Teal Cushion
page 24:	Squirrel Cushion
page 30:	Standing Lion Cushion (both colorways)
page 43:	Unicorn Cushion

Ordering Kits

To order kits, contact Ehrman at one of the following addresses:

U.S.A.: EHRMAN, 5 Northern Boulevard, Amherst, New Hampshire 03031. Tel: 1 800 433 7899.
U.K.: EHRMAN (shop), 14–16 Lancer Square, Kensington Church Street, London W8 4EP, England. Tel: 071 937 8123.
CANADA: POINTERS, 1017 Mount Pleasant Road, Toronto, Ontario M4P 2MI. Tel: 416 322 9461.
AUSTRALIA: TAPESTRY ROSE , P.O. Box 366

Canterbury, 3126 Victoria.
Tel: 818 6022
NEW ZEALAND: QUALITY HANDCRAFTS, P.O. Box 1486, Auckland.
FRANCE: ARMADA, Collanges, Lournand, Cluny 71250. Tel: 85 59 1356.
GERMANY: OFFERTY VERSAND, Bruneckerstrasse 2a, D-6080 Gross-Gerau. Tel: 06152 56964.
ITALY: SYBILLA, D&C Spa Divisione Sybilla, via Nannetti, 40069 Zola Predosa.
Tel: 051 750 875.
SPAIN: OSWALDO-CRUZ, Calle Principe, 15 – Esc. 2, 28012 Madrid.
SWEDEN: WINCENT, Luntmakargatan 56, S-113 58 Stockholm. Tel: 08 673 7060.
FINLAND: NOVITA, P.O. Box 59, 00211 Helsinki. Tel: 358 067 3176.
ICELAND: STORKURINN, Kjorgardi, Laugavegi 159, 101 Reykjavik. Tel: 01 18258.

NEEDLEPOINT YARNS

Appleton tapestry wool has been used for most of the designs in this book. If you wish to use Anchor, Paternayan yarn, or DMC yarn as an alternative, see YARN CONVERSION CHART on page 124.

Appleton, Anchor, Paternayan yarn, and DMC wool needlepoint yarns are all widely available in needlework shops and department stores. To find a retailer near you, see below or contact the yarn companies or their overseas distributors listed below:

APPLETON (see also MAIL ORDER NEEDLEPOINT YARNS).
U.K.: APPLETON BROS. LTD., Thames Works, Church Street, Chiswick, London W4 2PE, England. Tel: 081 994 0711.

APPLETON RETAILERS IN THE U.S.A.:
ACCESS DISCOUNT COMMODITIES, P.O. Box 156, Simpsonville, Maryland 21150.
CHAPARRAL, 3701 West Alabama, Suite 370, Houston, Texas 77027.
DAN'S FIFTH AVENUE, 1520 Fifth Avenue, Canyon, Texas 79015.
THE ELEGANT NEEDLE LTD., 7945 MacArthur

Boulevard, Suite 203, Cabin John, Maryland 20818.
EWE TWO LTD., 24 North Merion Avenue, Bryn Mawr, Pennsylvania 19010
HANDCRAFT FROM EUROPE. 1201-A Bridgeway, Sausalito, California 94965.
THE JOLLY NEEDLEWOMAN, 5810 Kennett Pike, Centreville, Delaware 19807.
LOUISE'S NEEDLEWORK, 45 North High Street, Dublin, Ohio 43017.
NATALIE, 144 North Larchmont Boulevard, Los Angeles, California 90004.
NEEDLEPOINT INC., 251 Post Street, 2nd Floor, San Francisco, California 94108.
NEEDLE WORKS LTD., 4041 Tulane Avenue, New Orleans, Louisiana 70119.
POTPOURRI ETC., P.O. Box 78, Redondo Beach, California 90277.
PRINCESS AND THE PEA, 1922 Parminter Street, Middleton, Wisconsin 53562.
SIGN OF THE ARROW – 1867 Foundation Inc., 9740 Clayton Road, St. Louis, Missouri 63124.
VILLAGE NEEDLECRAFT INC., 7500 South Memorial Pkwy., Unit 116, Huntsville, Alabama 35802.

APPLETON RETAILERS IN AUSTRALIA:
CLIFTON H. JOSEPH & SON (AUSTRALIA) PTY. LTD., 391–393 Little Lonsdale Street, Melbourne, Victoria 3000.
ALTAMIRA, 34 Murphy Street, South Yarra, Melbourne, Victoria 3141. Tel: 3 867 1240.
P. L. STONEWALL & CO. PTY. LTD. (Flag Division), 52 Erskine Street, Sydney.

APPLETON RETAILERS IN CANADA:
DICK AND JANE, 2352 West 41st Avenue, Vancouver, British Columbia V6M 2A4.
FANCYWORKS, 104–3960 Quera Street, Victoria, British Columbia V8X 4A3.
JET HANDCRAFT STUDIO LTD., 1847 Marine Drive, West Vancouver, British Columbia V7V 1J7.
S. R. KERTZER LTD., 105A Winges Road, Woodbridge, Ontario L4L 6C2.
ONE STITCH AT A TIME, Box 114, Picton, Ontario K0K 2T0.
THE SILVER THIMBLE INC., 64 Rebecca Street, Oakville, Ontario L6J 1J2.

POINTERS, 1017 Mount Pleasant Road, Toronto, Ontario M4P 2M1.

APPLETON RETAILERS IN NEW ZEALAND:
NANCY'S EMBROIDERY LTD., 326 Tinakori Road, P.O. Box 245, Thorndon, Wellington.

ANCHOR
U.S.A.: COATS AND CLARK, Susan Bates Inc., 30 Patewood Drive, Greenville, South Carolina 29615. Tel: 1 800 241 5997
U.K.: COATS PATONS CRAFTS, McMullen Road, Darlington, County Durham DL1 1YQ, England. Tel: 0325 381010.
AUSTRALIA: COATS PATONS CRAFTS, 89–91 Peters Avenue, Mulgrave, Victoria 3170. Tel: (0325) 381010.
CANADA: COATS PATONS CANADA, 1001 Roselawn Avenue, Toronto, Ontario M6B 1B8. Tel: (416) 782 4481.
NEW ZEALAND: COATS PATONS (New Zealand) Ltd., 263 Ti Rakau Drive, Pakuranga, Auckland. Tel: (09) 274 0021.

DMC
U.S.A.: DMC CORPORATION, 10 Port Kearny, South Kearny, New Jersey 07032. Tel: 201 589 0606.
U.K.: DMC CREATIVE WORLD, Pullman Road, Wigston, Leicester LE8 2PY. Tel: 0533 813 919.
AUSTRALIA: DMC NEEDLECRAFT PTY. LTD., 51–56 Carrington Road, Marrickville, NSW 2204. Tel: 2 559 3088.

PATERNAYAN
U.S.A.: JCA, Inc., 35 Scales Lane, Townsend, Massachusetts 01469. Tel: 508 597 8794.
U.K.: PATERNA LTD., P.O. Box 1, Ossett, West Yorkshire WF5 9SA, England. Tel: 0924 276744.
AUSTRALIA: ALTAMIRA, 34 Murphy Street, South Yarra, Melbourne, Victoria 3141. Tel: 3 867 1240.
NEW ZEALAND: THE STITCHING CO LTD., P.O. 74–269 Market Road, Auckland. Tel: (09) 524 9739.

MAIL ORDER NEEDLEPOINT YARNS
Specific yarn companies (see above) may give advice on how to purchase needlepoint yarns by mail order, but you can also find out about mail order services by reading the small ads in needlecraft magazines.

CORDS AND TASSELS
Cords and tassels can be found in shops and department stores that offer decorator fabrics.

GOLD, RAYON, AND COTTON THREADS
Cotton, rayon, and metallic threads can be found in shops and department stores that sell knitting or crochet yarns and threads.

The following threads have been used in the designs in this book:
DMC *No. 5 Pearl Cotton* (100% cotton)
Twilley's *Goldfingering* (20% metallized polyester and 80% viscose – washable)
Marlitt *Viscose Rayon* (100% viscose)
Madeira *Metallic Effect Yarn* (60% metal 40% polyester – washable)

BEADS AND PASTE JEWELS
Beads and paste jewels can be found in art and craft shops and the craft and needlework departments of department stores.

STRETCHING AND BACKING
If you wish to have your needlepoint stretched and backed, inquire at a decorator fabric shop, art shop, or needlework shop to see if they offer this service.

AUTHOR'S ACKNOWLEDGMENTS

Although I am the figurehead on this "boat," it really has been produced by a team – all of whom were indispensable in some way or other. And so a heartfelt, very grateful "thank you" to: Anne Furniss for the initial idea; Louise Simpson, who, with her unruffled and diplomatic manner, has patiently and brilliantly steered and guided the "boat;" Sue Storey for her evocative design; Pippa Lewis for fulfilling my desires and delving deep and finding captivating medieval images; Colin Salmon for the meticulous charts; and Sally Harding for her calmness, organizational powers, editing, and ability to cope with a "scatty" designer.

Jeremy Cooper for his clear thought and belief in my ability; Brandon Mabeley and Kaffe Fassett for their generous, inspirational enthusiasm; and to Annie Firbank, a special "thank you."

John Fletcher, the wordsmith, for his time and effort in structuring and struggling with my "gushes." Michael and Hillie Cansdale, Georgia and David Langton, Kathleen Bull and Stephen Weeks of Penhow Castle (Wales), Pamela Lady Harlech, Michael Whiteway, Lord Bath of Longleat, Paul Reeves, De Winter Ltd., Ceila Birtwell, David Wainwright, John Oliver, and Belinda Coote for their help and for allowing us to disrupt their lives.

Maggie Perry for beautiful styling and Clay Perry, the master photographer, for his elegant vision.

Hugh Ehrman for his sustained confidence and trust in my creativity, especially in the early learning years. Lindsay Clarke, my hermeneut friend.

A special "thank you" to all the "girls" for the hours of stitching (and unpicking): Talitha Blythe-Lord, Louise Milton, Polly Meynell, Helen Pritchard, Charlotte Gunning-Legg, Julia Clow, Petra Boase, Vicky Viner, Vicki Paxton, Donnamaria Davis, and, particularly, to Julia De Salis for her commitment and care and Kerry Buxton, the mistress of perfect stitching.

BIBLIOGRAPHY

BASING, Patricia. *Trades and Crafts in Medieval Manuscripts*. London: The British Library, 1990.

BLACKHOUSE, Janet. *The Illuminated Manuscript*. Oxford: Phaidon Press, 1979.

BLACKHOUSE, *Book of Hours*. London: The British Library, 1988.

DIGBY, George Wingfield. *The Devonshire Tapestries*. London: Victoria and Albert Museum, 1971.

CHILD, Heather. *Heraldic Designs*. London: G. Bell and Sons, 1965.

CONDÉ CHANTILLY, Musée. *Les Très Riches Heures*. London: Thames and Hudson, 1959.

DENNYS, Rodney. *Heraldry and the Heralds*. London: Jonathan Cape, 1982.

ERLANDE-BRANDENBURG, Alain. *The Lady and the Unicorn*. Paris: Éditions de la Réunion de Musées Nationaux, 1979.

EVANS, Joan, ed. *The Flowering of the Middle Ages*. London: Thames and Hudson, 1966.

FREEMAN, Margaret B. *The Unicorn Tapestries*. New York: Metropolitan Museum of Art, 1976.

HALLAM, Elizabeth, ed. *Chronicles of the Age of Chivalry*. London: Weidenfeld and Nicolson, 1987.

HINZE, Virginia. *The Physic Garden*. Sussex, England: Sussex Archaeological Society, 1992.

HOBHOUSE, Penelope. *The History of the Garden*. London: Pavilion, 1992.

HOLME, Bryan. *Medieval Pageant*. London: Thames and Hudson, 1987.

LEWIS, C. S. *Allegory of Love: A Study of Medieval Tradition*. Oxford: Oxford University Press, 1936 (reprint 1992).

MORLEY, H. T. *Old and Curious Playing Cards*. London: Bracken Books, 1989.

NEUBECKER, Ottfried. *Heraldry: Sources, Symbols and Meaning*. Maidenhead, England: McGraw-Hill, 1977.

VERDET, Jean Pierre. *The Sky: Mystery, Magic and Myth*. New York: Harry N. Abrams, 1992.

ACKNOWLEDGMENTS

5 top and centre Bibliothèque Nationale, Paris; 5 above Musée Cluny, Paris/Giraudon; 5 below The British Library, London; 6 Common Ground/Kathleen Basford; 11 David Cripps; 12 Martin Richardson; 15 Musée Condé, Chantilly/Giraudon; 16-17 Ashmolean Museum, Oxford; 19 Metropolitan Museum of Art, New York, gift of John D. Rockeller Jr, The Cloisters Collection; 20 The British Library, London; 22 Musée Cluny, Paris/Giraudon; 27 right Musée Cluny, Paris/Giraudon; 29 The Bodleian Library, Oxford; 31 Museo Correr, Venice; 34 Archivio Veneziano; 42 Bibliothèque Nationale; 44 Musée Cluny, Paris/Giraudon; 47 The Bodleian Library, Oxford; 48 The British Library, London; 50 Musée Cluny, Paris; 51 Bodleian Library, Oxford; 53 Hugh Ehrman; 55 Bodleian Library, Oxford; 59 British Library, London; 64 Musée Cluny, Paris/Giraudon; 66 Bodleian Library, Oxford; 69 Camposanto, Pisa/Scala; 70 Sir John Soane's Museum/E. T. Archive; 73 Bibliothèque Nationale, Paris; 74-5 Bodleian Library, Oxford; 77 Victoria & Albert Museum, London; 83 The Bodleian Library, Oxford; 91 Images Colour Library; 94-6 The Bodleian Library, Oxford; 98 Palazzo Pubblico, Siena/Scala; 105 The Bodleian Library, Oxford; 108-9 The Bodleian Library, Oxford; 110, 112 and 113 plates from W. & G. Audsley's *Polychromatic Decoration*; 114 Musée du Louvre, Paris/RMN. The following photographs were specially taken for Conran Octopus by Clay Perry: 1-3, 8-9, 10, 13-14, 17-18, 20-27, 30-31, 32, 36-37, 40, 43, 46, 49, 51-52, 54, 56, 58-60, 62-3, 64-5, 68, 72, 76, 78-79, 80, 82, 84, 87, 88-9, 90, 95, 99, 104, 107, 111, 115.

INDEX